The Distaff Side

According to the *Oxford English Dictionary*, the first known use of the word *distaff*, which refers to the staff around which wool or flax was wrapped in the traditional practice of spinning fibers to produce yarn or thread, dates to as early as circa AD 1000. The term also refers to women's work or occupations, as in William Shakespeare's *King Lear* (first published 1608): "I must change armes at home, and giue the distaffe / Into my husbands hands."

Distaff is also used to describe the female side of a house or family, which is known as the "distaff side," in contrast to the "spear side," as the male side is sometimes known. In his 1656 translation of Jean-Nicolas de Parival's *The History of This Iron Age*,

Bartholomew Harris writes, "The King-dome is hereditary; and for want of an heir male, it falls to the Distaff." In this vein, *distaff* can also refer to a female heir as well as to female authority and dominion.

Distaff's Day or Saint Distaff's Day, also called Rock Day, is January 7, the day after the Twelfth Day or the Feast of the Epiphany. On this day, women resumed their spinning and other ordinary employments after the holidays.

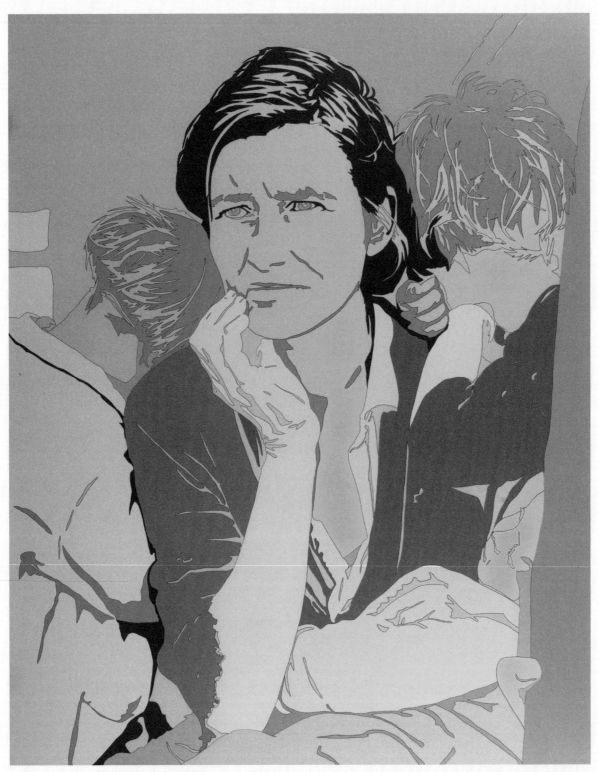

Lisa Ruyter, *Dorothea Lange "Destitute peapickers in California. Mother of seven children. Age thirty-two. Nipomo, California,"* 2009

The Distaff Side

Curated by Melva Bucksbaum

With contributions by
Ryan Frank
Steven Learner
Joan Simon
Caitlin Smith
Elisabeth Sussman

The Granary
Sharon, Connecticut

Shinique Smith, *the step and the walk*, 2010 (detail)

Contents

Shinique Smith, *the step and the walk*, 2010 (detail)

This catalogue is not only about an exhibition but also about a shared passion that has become central to our lives together. We met through the intermediary of art and learned to love each other even more deeply as we ventured with ever-greater commitment into the wonders, joys, anguish, and ecstasy of the art world. It became our cathedral, anchoring our lives. We experienced the pleasures of discovery, not only of the works of art but also of the artists we have been privileged to count as friends and of the extraordinary institutions with which we have become associated. All of them have added a miraculous dimension to our lives.

The Granary, the gallery in which *The Distaff Side* is displayed, is but an extension of our home, allowing us to keep our collection close by and to visit it and enjoy it in moments of "mutual" solitude. This exhibition is Melva's homage to her sisters in art. It is a very personal message, a statement of celebration and of respect for their artistic achievement, and it reflects a shared lifetime of collecting their wondrous work.

Melva Bucksbaum and Ray Learsy

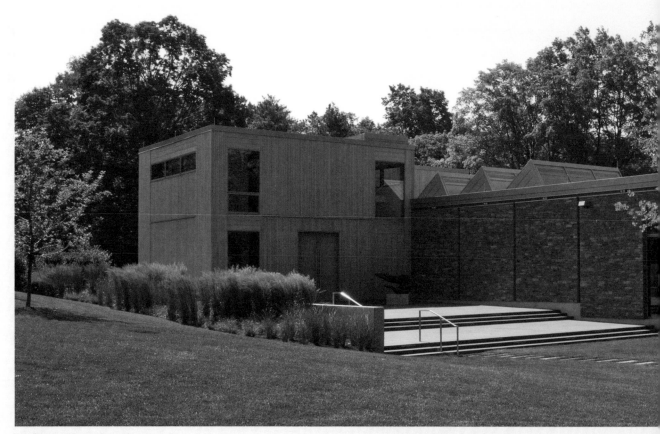

The Granary, Sharon, Connecticut

In The Story Below, Ryan Frank discusses the genesis of The Granary as well as the building's public and private roles.

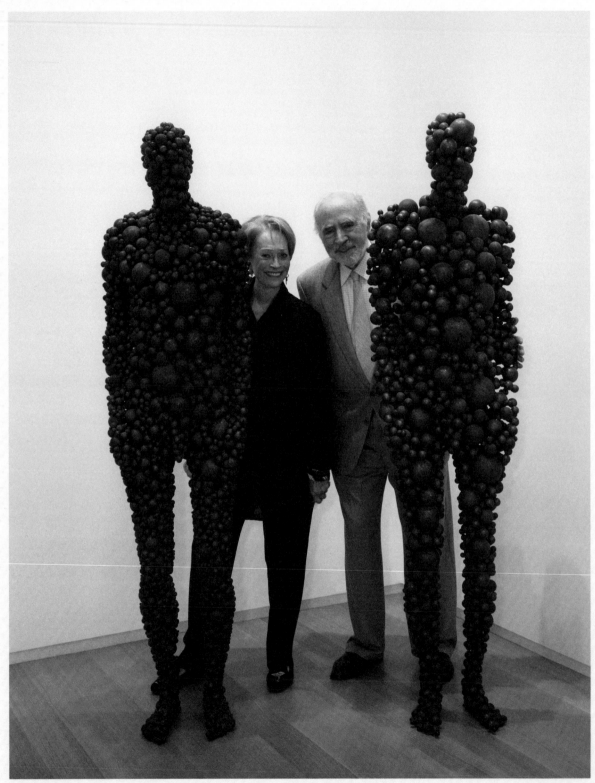

Melva Bucksbaum and Ray Learsy at The Granary with Antony Gormley's *Foreign Bodies* (2000)

The Granary takes its name from the traditional grain storehouses that once served a vital function in rural communities. When Melva Bucksbaum and Ray Learsy conceived of building their own private exhibition and storage facility on the site of their home in Sharon, Connecticut, they did so with the intention of making their art collection more accessible to themselves as well as to others: family, friends, artists, curators, students, and fellow collectors. Though technically a private exhibition space located on a residential property, The Granary, since its opening in 2009, has welcomed countless groups and individuals for a unique and intimate experience of viewing art and of the subsequent dialogue and discovery that come with it.

When I first started working for Melva and Ray, the idea of The Granary had not yet been hatched, but their Tribeca loft functioned as a base of operations for their shared passion for art. The apartment's living space served as an informal gallery for rotating selections from their constantly growing collection—not only for the enjoyment of its owners but also for that of the greater art community at annual holiday parties and on private tours of their home. The upper level of the space was used almost exclusively for storing artworks, and specially designed storage racks hidden behind the downstairs walls allowed for larger works to be stored on-site but discreetly out of view. The loft was and still is their home in New York City, and it was an incubator, on a small and domestic scale, for what The Granary would become. It is the place where I first saw their art collection as an active part of their lives and as an expression of who they are as individuals: thoughtful, creative, eclectic, and eccentric. Each piece of art in their home had personal significance, a purpose, and a backstory that Melva and Ray took great pride in sharing with others.

← Agnes Martin, *Untitled #2*, 1997. Acrylic and graphite on canvas. 60 × 60 in. (152.4 × 152.4 cm)
→ Ray Learsy and Melva Bucksbaum viewing Shepard Fairey's *You Don't Need a Weather Man (Red)* (2010) in The Granary's storage area with Laurie Simmons's *Walking Cake* (1989) visible at right

Pages 16–17: Installation view of *The Distaff Side* with (from left) Carla Arocha and Stéphane Schraenen's *Chris, Untitled (Crosses)* (2006); Jorinde Voigt's *Botanic Code—M. M. Gryshko National Botanical Garden, Kiev (August 2010)* (2010); Rachel Whiteread's *Daybed* (1999); Katy Schimert's *Female Torso* (2001); and Shinique Smith's *the step and the walk* (2010)

Both Melva and Ray assembled significant collections of art in the decades before they met, and they have individually and jointly acquired a considerable quantity of art. Throughout much of their lives the majority of their art—like much of the art that exists in the world—was kept in storage because of the limited amount of space for display in their homes. The bulk of the collection remained in its packaging, out of sight, and was for the most part inaccessible. The creation of The Granary marked a new phase of rediscovery and engagement with the collection: not only was there a proper gallery in which to present it, but there was also a dedicated art storage space in which to see firsthand the entirety of what they had acquired. *Storage* is a dirty word in the world of art, a place where treasured items are thought to be out of sight and out of mind, but at The Granary the opposite is true. Artwork is stored on open racks

and shelving to allow for easy viewing and access. It is a fully active space that Ray and Melva visit frequently and that has facilitated the reuniting of the objects they have spent their lifetimes collecting. The Granary's basement storage is a staging ground for the exhibitions that take place in the galleries above. The proximity of these spaces, as well as the fact that our exhibitions involve no loans, allows for a curatorial process that is well researched yet improvisational.

This was certainly the case with *The Distaff Side*, an exhibition conceived by Melva and developed over a yearlong process of reviewing the entirety of the collection in digital form and then more selectively in person. I had the pleasure of collaborating with Melva on this laborious and fascinating project. She would reminisce about how she learned about particular artists, explaining why she had acquired their work and how, in retro-

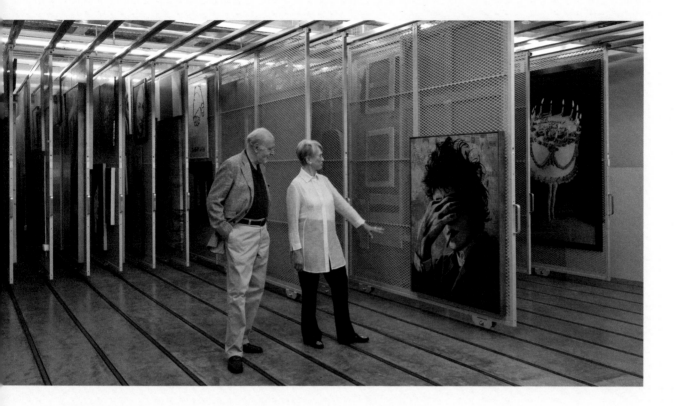

spect, it spoke to her. Through thoughtful and lively discussion, we developed a blueprint for the exhibition and began assembling the show through a playful and experimental installation process. In a month's time the exhibition came to life, with many challenges and surprises along the way, and it was shaped throughout by Melva's energy, passion, and singular vision. Curating an exhibition with as broad a theme as art by women is a daunting task, but it is one that Melva pursued with enthusiasm and rigor. In the end I believe that *The Distaff Side* aptly and beautifully captures her personality: vibrant, full of life, open to new ideas, humble yet confident in its identity.

For a collector, having a space like The Granary is no doubt a luxury, and given its rural setting and limited accessibility for the general public, visitors are often baffled by its existence. As strange as it may seem to have a building full of art

that is not open to the public, it would be more absurd to spend countless resources assembling an art collection and never be able to appreciate its significance fully. The Granary gives the collection a proper home and is a concrete expression of Melva and Ray's dedication to the artwork that is intrinsic to their lives. In its four years of existence, the space has slowly developed its own identity and grown in its ambitions to reach new audiences. Perhaps the most tangible evidence of this is this very catalogue, the first in The Granary's history. In years to come, The Granary will continue to evolve, and future exhibitions within its walls will explore and reveal the richness and diversity of the collection and the period of art history that it encompasses. ◉

Ryan Frank is the director of Melva Bucksbaum and Ray Learsy's collection.

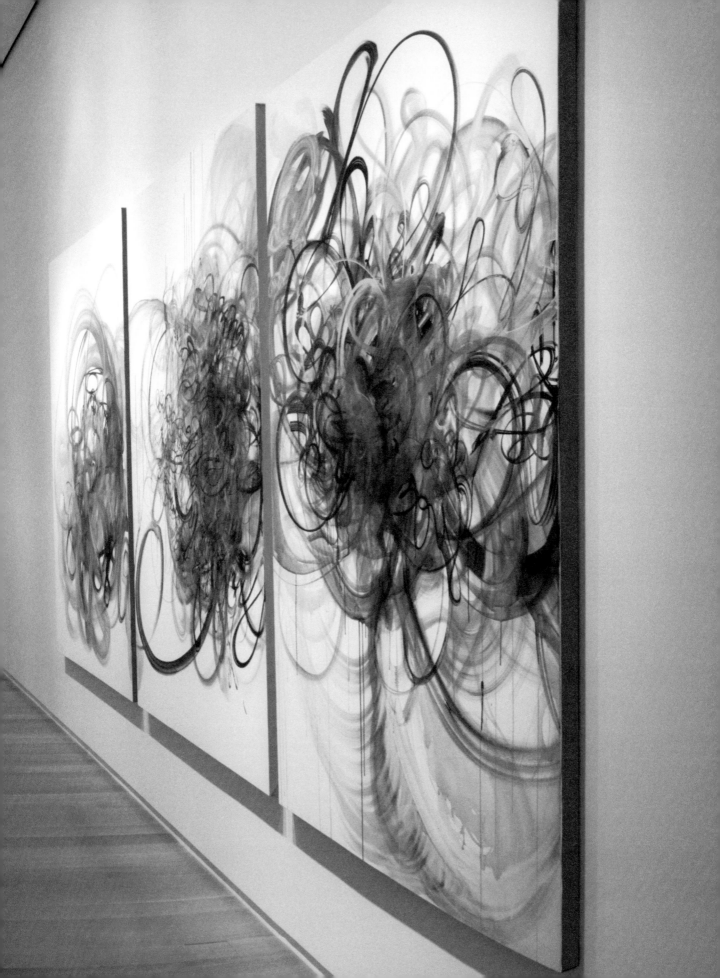

Louise Bourgeois,
Ode à l'oubli, 2004 (detail)

In *The Distaff Side*: Woven Together, which originally served as an exhibition statement and has been adapted for this publication, Caitlin Smith details the show's inspiration, creation, and format.

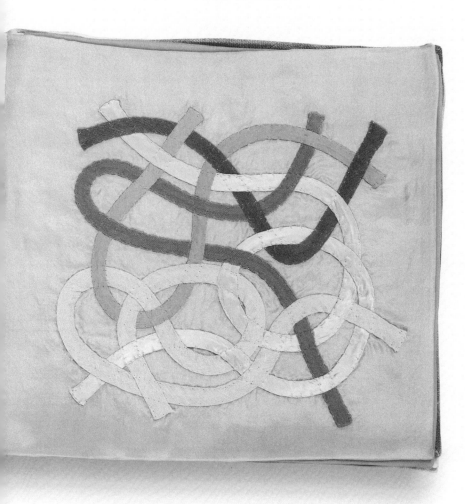

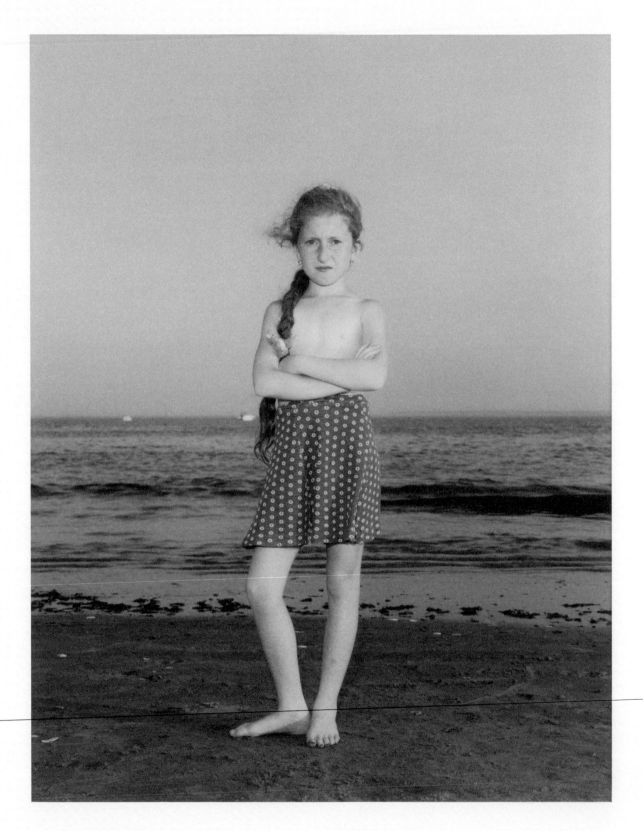

C omposed entirely of works by women artists from the collections of Melva Bucksbaum and Ray Learsy, the exhibition *The Distaff Side* is a culmination of ideas and interests that Melva has been exploring for many years. It was in the early years of the women's movement—that pivotal moment when Linda Nochlin asked, "Why have there been no great women artists?"—that Melva became seriously engaged in the art world.[1]

Melva became involved with the Des Moines Art Center in the early 1970s, and her own collecting was influenced early on by her friend Louise Noun, an art collector and feminist activist who was acquiring works by women artists. Although none of the works in Melva's collection have been acquired specifically because of the artist's gender, she witnessed firsthand the decades during which the art world began to offer women increased representation and recognition. She has been a longtime collector and an ardent patron of the arts, but this exhibition at The Granary marks her curatorial debut. It includes works in various mediums by more than one hundred women artists, emerging artists as well as established figures, those known locally and those of international renown. As a whole, *The Distaff Side* weaves together the unique story of Melva's experience as a collector over the past four decades.

The feminist rallying cry "the personal is political" has been transformed in many ways as women artists have expanded the boundaries and even the definition of art. They have appropriated images, inverted stereotypes, undermined

Rineke Dijkstra, *Coney Island, NY, July 9, 1993*, 1993

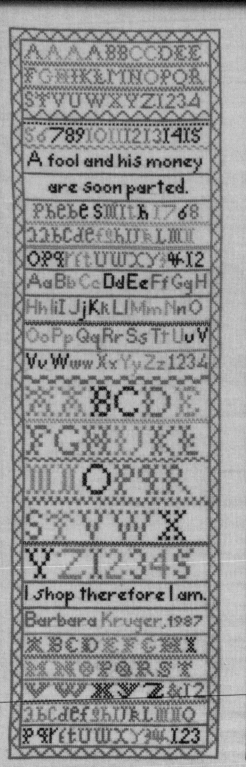

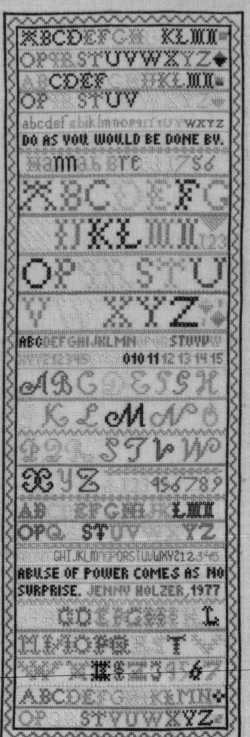

← Elaine Reichek, *Sampler (Kruger/ Holzer)*, 1998
→ Barbara Kruger, *"Untitled" (When was the last time you laughed?)*, 2011

assumptions, and renegotiated the very terms of identity—female, feminine, and feminist—and the body and its representations, as theoretical positions and as subject matter. Despite the advances that have been made since the 1970s, however, women artists still remain underrepresented in exhibitions in most art institutions, a circumstance that contributed to Melva's interest in curating *The Distaff Side*.

The exhibition takes its title from an expression used colloquially to describe the maternal side of a family. The word *distaff*, derived from the Old English *distæf*, refers to a tool used in spinning, a task traditionally done by women in the home and therefore associated with "women's work." While some of the works included offer insights into the lives and experiences of women, *The Distaff Side* did not originate as a thematic exhibition. As it took shape, however, curatorial connections arose. Melva's effort to bring together diverse artists, each with a singular view

of the world, will give viewers a sense of the extraordinary richness and scope of "women's work" that she has witnessed in the field of contemporary art.

A conceptual piece by Elaine Reichek that takes the unassuming form of an embroidered sampler embodies the spirit of *The Distaff Side*. For Reichek, the sampler "is this fascinating, pregnant combination of text and image."[2] In Europe and the United States, needlework was historically an integral part of the education of young women, for whom embroidery would be a pastime or source of income in adult life. Samplers made as demonstrations of skill commonly contained religious or moral verses. Amid the needlework alphabet in Reichek's *Sampler (Kruger/Holzer)* (1998; left), traditional proverbs ("A fool and his money are soon parted," "Do as you would be done by") are juxtaposed with texts from well-known works by Barbara Kruger ("I shop therefore I am") and Jenny Holzer ("Abuse of power comes as no surprise").

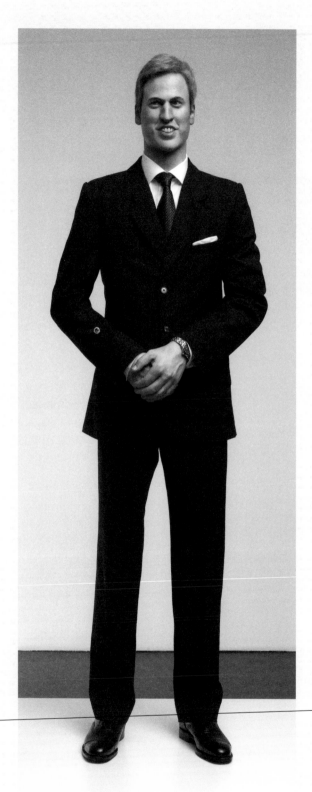

By incorporating her contemporaries—both known for their nontraditional text-based works that encourage viewers to question dominant cultural values—Reichek has masterfully altered the message of the medium.

Individual works by Holzer and Kruger are on view in *The Distaff Side* as well. Directly addressing the audience, Holzer's LED projections and Kruger's bold typeset one-liners are reminiscent of propaganda or advertising but instead ask viewers to think for themselves and to reconsider the status quo. Holzer's *Stripes* (2007; pp. 36, 109) features statements from her *Truisms* and other series, including "A man can't know what it's like to be a mother." Kruger's *"Untitled" (When was the last time you laughed?)* (2011; p. 23) poses an unsettling question.

Several works in *The Distaff Side* reveal a sly wit. Upon entering The Granary, the visitor encounters Jennifer Rubell's *'Engagement (with Prince William sculpted by Daniel Druet)'* (2011; left), a life-size sculpture of Prince William placed slightly off-center on its base. It becomes a participatory work: in a twist on the "glass slipper," a visitor can step onto the pedestal, take William's arm, and slip her finger through the replica of a sapphire engagement ring attached to his sleeve. A piece by Sophie Calle, *La cravate* (1992; pp. 166–67), also plays on the idea of the female fantasy of the perfect man, this time using a man's accessory, a tie, as the signifier.

Louise Bourgeois's artist's book *Ode à l'oubli* (2004; pp. 18–19, 30) takes its materials from the

domestic realm, or the distaff side. The pages of the book are made of linen hand towels from the artist's 1938 wedding to the art historian Robert Goldwater; her monogram, LBG, is visible on many of them. Collaged onto the pages are pieces of clothing and other recuperated textiles, fragments of Bourgeois's past, which are stitched together using various needlework techniques.

The most prominent work in the exhibition is Mika Rottenberg's video installation *Cheese* (2008; right), which was first seen at the 2008 Whitney Biennial. The work presents a fictionalized portrayal of the Sutherland Sisters, seven sisters from upstate New York who toured with P. T. Barnum in the late nineteenth century, performing a musical sideshow act, and became famous for their floor-length hair. They made their fortune by selling a hair elixir whose ingredients supposedly included their own Rapunzel tresses and the mist of Niagara Falls. Mika Rottenberg's wooden installation houses six video projections on which we watch long-haired women at work on a farm tending to small livestock and engaging in laborious hair-care routines. Standing in the middle of the low, dark structure amid barnyard sounds, the visitor is made to experience the close quarters within which the women work while watching them humorously milk their locks, herd goats with their hair, and stare at the cheese that they have produced.

Rottenberg's agrarian-themed videos resonate with the rural surroundings for which The Granary itself is named. Within the walls of The

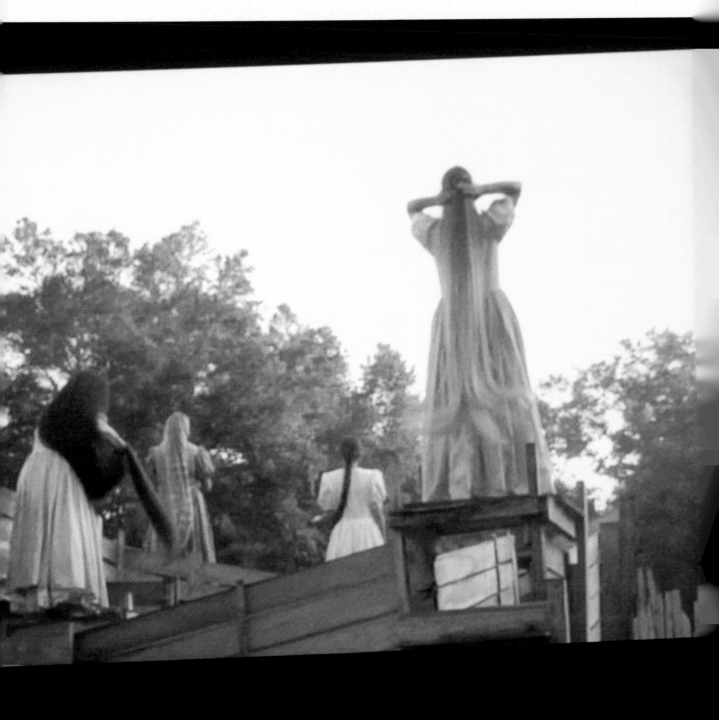

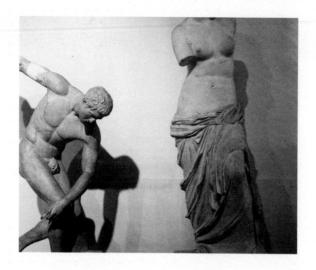

← Louise Lawler, *Discus and Venus*, 1997/2002
→ Marina Abramović, *The Kitchen V, Carrying the Milk*, from the series *The Kitchen, Homage to Saint Therese*, 2009

Granary, one video, featuring wandering chickens, is projected outside the wooden structure and is seen beneath Louise Lawler's *Discus and Venus* (1997/2002; above), a fitting curatorial choice given that Lawler herself is interested in the area around a work of art, often taking photographs of art in its "natural habitat" or behind the scenes of the installation process. For logistical reasons, the *Cheese* structure was installed before the other works in *The Distaff Side* due to its scale, and accordingly, the works placed around it take on associated meanings when seen through its apertures.

Viewed through one of the Rottenberg "windows" is a conceptual garden: Jorinde Voigt's *Botanic Code—M. M. Gryshko National Botanical Garden, Kiev (August 2010)* (2010; p. 16), comprising twenty-four painted aluminum rods, represents the artist's walks through a garden in Ukraine, one of many all over the world in which she has documented the plants and flowers. Louise Nevelson's *December Wedding* (1984; p. 81), somewhat obscured by Rottenberg's installation, shares with it a material similarity. In contrast to Rottenberg's abundant use of pallet wood, Nevelson, who preferred to install her work in dark spaces, includes a single piece of wood within this dark assemblage,

which is enclosed in a wooden frame. Adjacent to the Nevelson but best seen through another Rottenberg "window" is Cindy Sherman's untitled photograph (1982; p. 83), which is shrouded in its own shadows. Sherman's face is nearly hidden in this work, an atypical turn from the multitude of faces and personas that she has adopted throughout her career, and her attire is akin to that of the long-haired women of Rottenberg's videos, whom we watch through the shadows of the structure. As one exits the installation, the migrant mother portrayed in Lisa Ruyter's *Dorothea Lange "Destitute peapickers in California. Mother of seven children. Age thirty-two. Nipomo, California"* (2009; p. 4) comes into view. Although Ruyter's colorful palette wipes away the grit of the original black-and-white Depression-era photograph, the pathos of Lange's iconic image is hardly lost.

Posing a stark contrast to the spirited cacophony of *Cheese* is Marina Abramović's *The Kitchen V, Carrying the Milk* (2009; right) which quietly presides over the opposite end of the main gallery. Here Abramović performs her own version of women's work, appearing in the video as a solitary figure holding a bowl of milk, on which her gaze is fixed. The video belongs to a series inspired

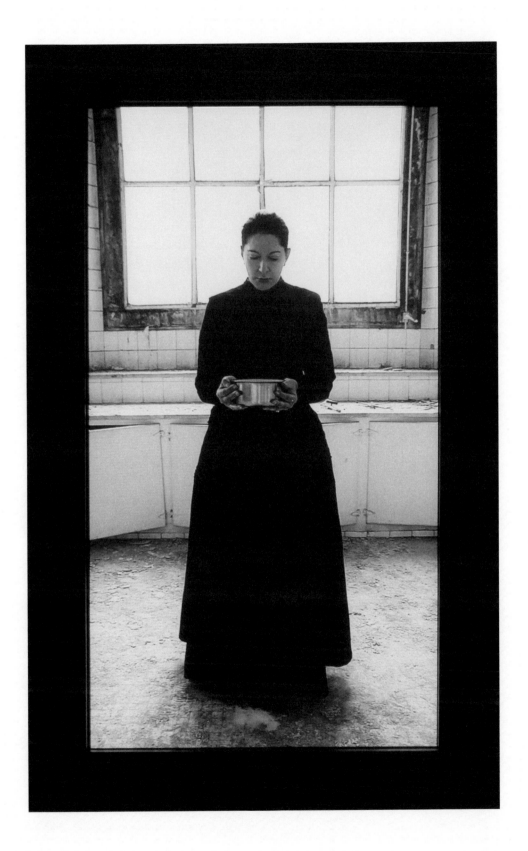

by Saint Teresa of Ávila, a sixteenth-century nun who is said to have levitated once in the kitchen while making soup. Filmed in a former orphanage kitchen in Spain, this work was influenced by the artist's own childhood; she was raised by her grandmother, and the kitchen was their sacred space, a place where advice was doled out, stories and secrets shared, and as Abramović explains, "all the future-telling through the cups of black coffee took place."[3]

Two portraits by the Colombian artist Adriana Duque, who often explores childhood and fantasy in her work, flank *The Kitchen V, Carrying the Milk*. The large-scale photographs, titled *Felipe* and *Daniel* (both 2010; pp. 48, 49), depict two very serious little boys dressed in costumes with stiff collars resembling Elizabethan ruffs. Channeling the tradition of European portraiture, Duque's images evoke South America's colonial history. Against a stark black background, the opulent attire and pale, made-up faces with powerful gazes offer a dramatic contrast to Abramović's averted eyes and simple full-length black costume, set against the illuminated kitchen window.

Rosa Loy's *Das Essen* (2008; right) and Mamma Andersson's *About a Girl* (2005; pp. 186–87) share the same subject: women gathered around a table in a domestic setting. *Das Essen* includes a portrait of the artist, who surrounds herself with friends and her sister as well as a partner at her gallery and two fellow artists: Ena Swansea, the redhead, and Lisa Yuskavage, seated below her, who both have works exhibited in *The Distaff Side*. *About a Girl* shows nine women having coffee in a room in which pictures of geishas and Snow White hang on the wall. The women stare back as if the viewer is taking a snapshot of the group.

The Distaff Side does much more than bring together a varied group of works by women artists. Melva Bucksbaum's exhibition catalyzes thoughts about these innovative, intriguing, and provocative artists as they take their rightful places at the table in the grand narrative of art history. ◉

Caitlin Smith is the registrar and archivist of Melva Bucksbaum and Ray Learsy's collection.

NOTES

1. See Linda Nochlin, "Why Have There Been No Great Women Artists?," *Art News* 69 (January 1971): 22–39, 67–71.

2. Therese Lichtenstein, "An Interview with Elaine Reichek," *Journal of Contemporary Art* 5 (Winter 1993), http://www.jca -online.com/reichek.html.

3. Marina Abramović, quoted in "Luciana Brito Presents 'Back to Simplicity,' Including Historic Artworks, by Marina Abramović," Artdaily.com, http://artdaily.com/news/42767 /Luciana-Brito-Presents--Back-to-Simplicity---Including -Historic-Artworks--by-Marina-Abramovic#.

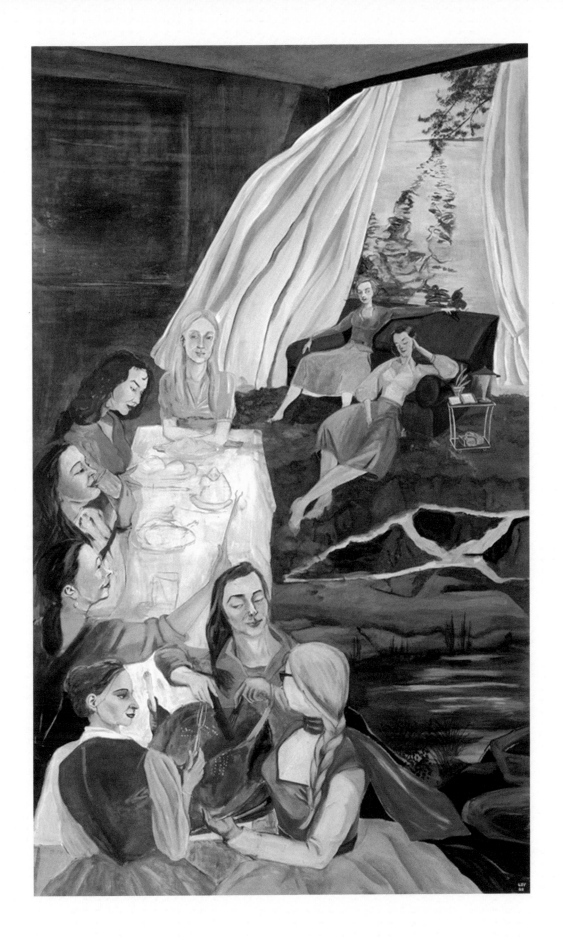

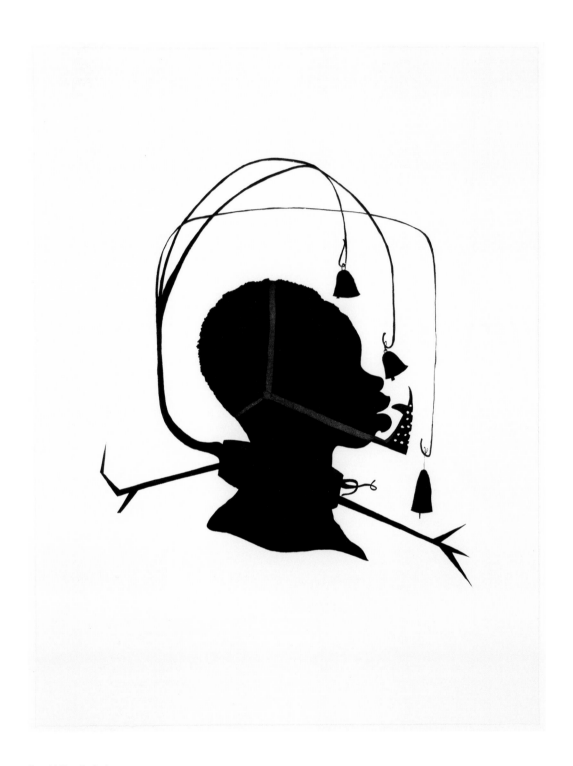

Kara Walker, *Restraint*, 2009

↑ Mona Hatoum, *Projection (abaca)*, 2006
→ Mona Hatoum, *Projection*, 2006

Pages 36–37: Installation view of *The Distaff Side* with
(from left) Jenny Holzer's *Stripes* (2007); Jennifer Rubell's
'*Engagement (with Prince William sculpted by Daniel Druet),*'
(2011); and Sarah Charlesworth's *Bride* (1983–84)

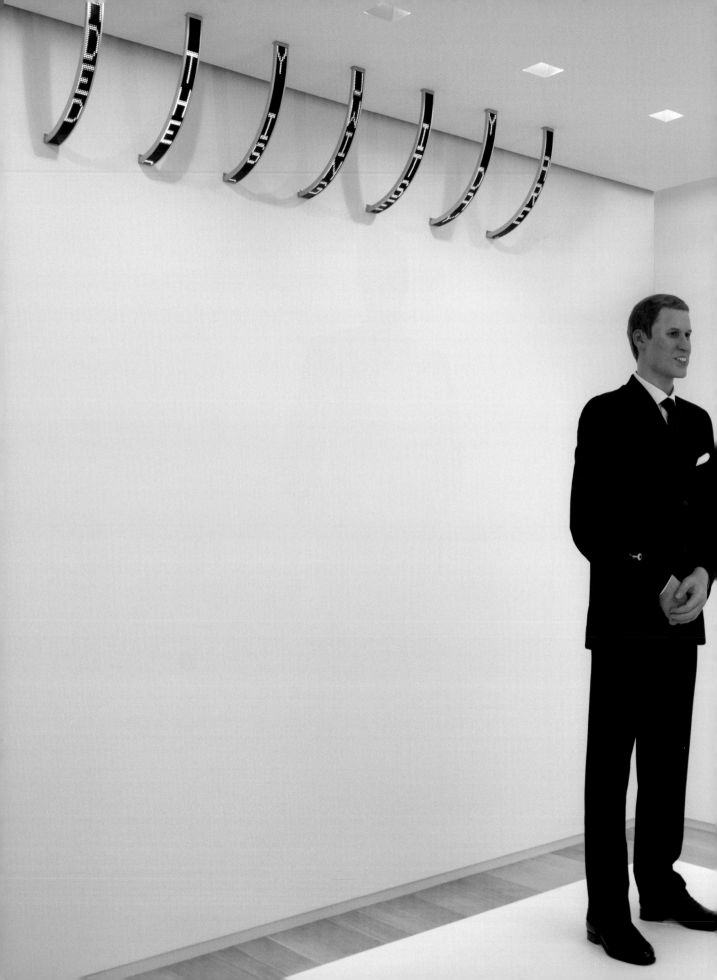

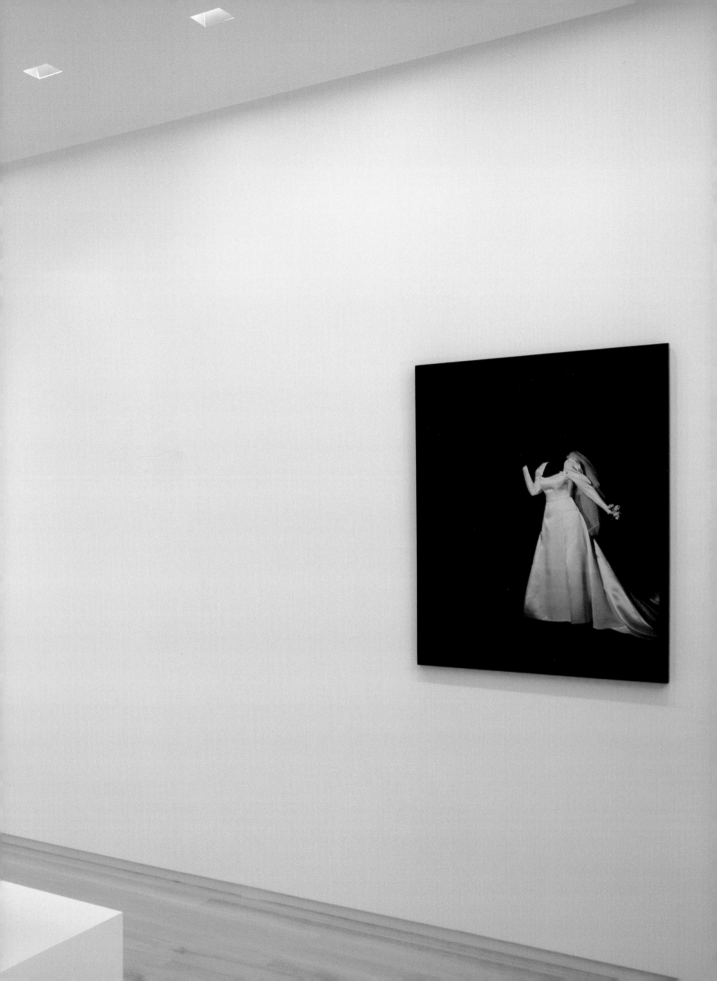

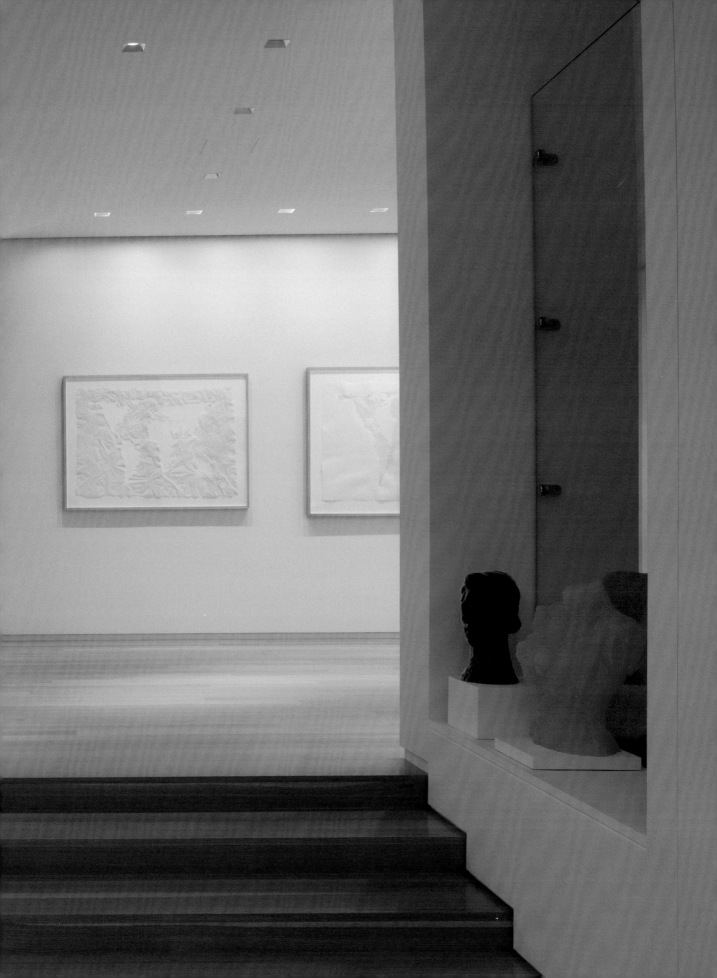

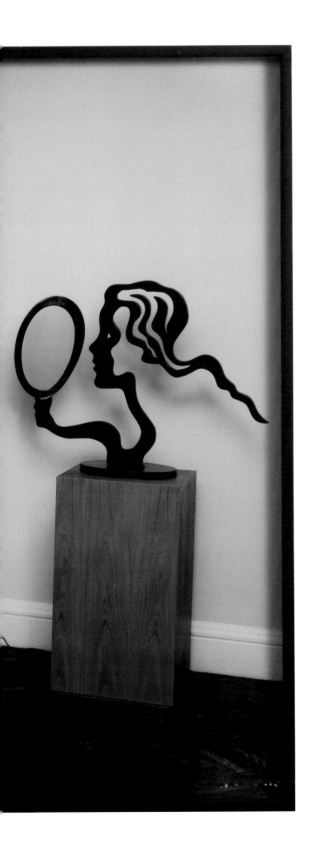

Tina Barney, *Mr. & Mrs. Leo Castelli*, 1998

Pages 38–39: Installation view of *The Distaff Side* with (from left) Tina Barney's *Mr. & Mrs. Leo Castelli* (1998); Elaine Reichek's *Sampler (Kruger/Holzer)* (1998); Kathleen Gilje's *Melva Bucksbaum as the Girl with the Pearl Earring* (2010); Su-Mei Tse's *Swing* (2007); Kara Walker's *Restraint* (2009); Mona Hatoum's *Projection (abaca)* and *Projection* (both 2006); Sarah Peters's *Descendants & Believers, #3* (2010); and Lee Bul's *Vanish (Orange)* (2001)

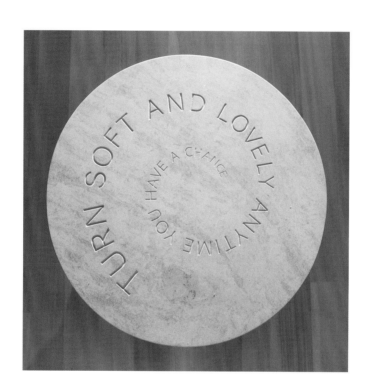

↑ Jenny Holzer, *Turn Soft*, 2011
⇢ Isca Greenfield-Sanders, *Gold Parachute*, 2008

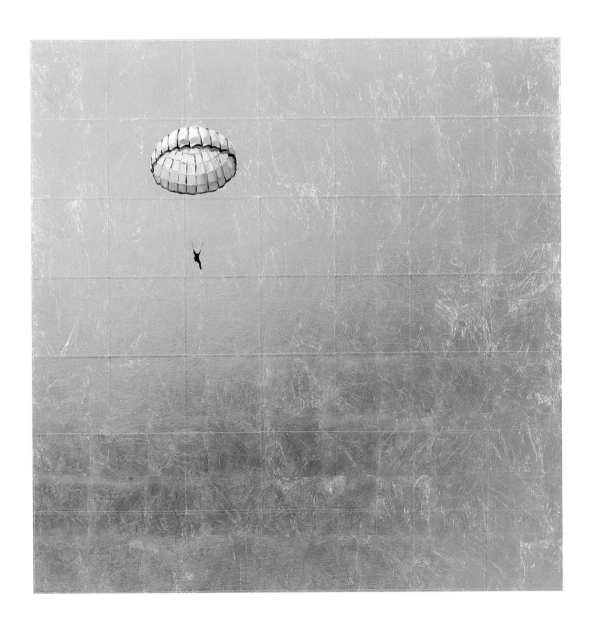

Pages 44–45: Installation view of *The Distaff Side* with (from left) Mika Rottenberg's *Cheese* (2008); Louise Lawler's *Discus and Venus* (1997/2002); Vera Lutter's *San Marco, Venice XIX: December 1, 2005* (2005); Vanessa Beecroft's *The Silent Service: Intrepid, New York* (2000); Jenny Holzer's *Turn Soft* (2011); Tina Barney's *Mr. & Mrs. Leo Castelli* (1998); Elaine Reichek's *Sampler (Kruger/Holzer)* (1998); Su-Mei Tse's *Swing* (2007); Kathleen Gilje's *Melva Bucksbaum as the Girl with the Pearl Earring* (2010); and Isca Greenfield-Sanders's *Gold Parachute* (2008)

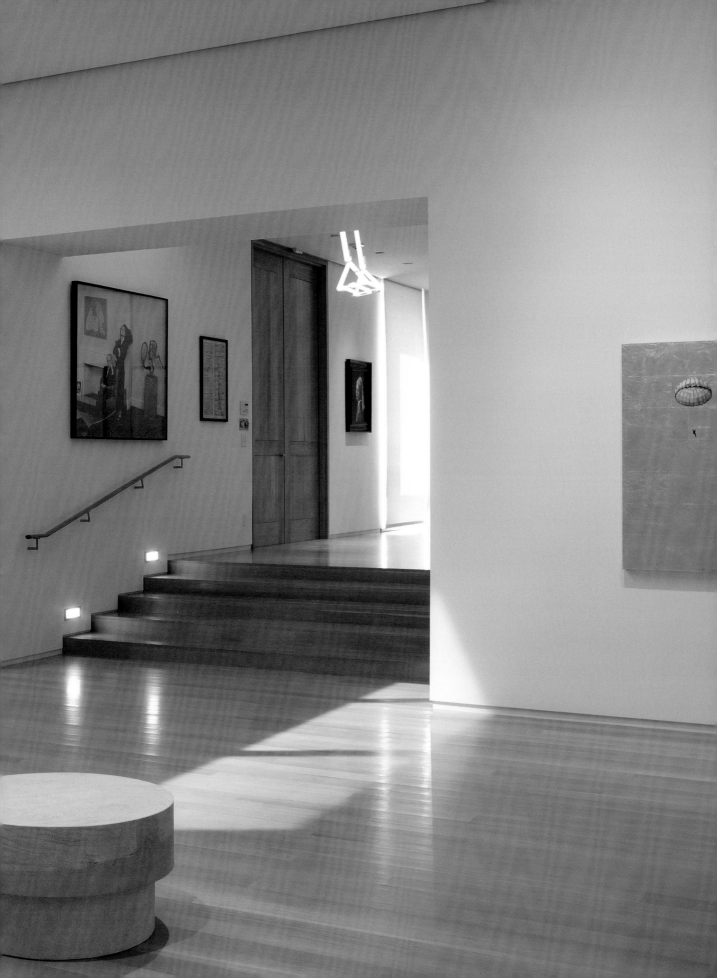

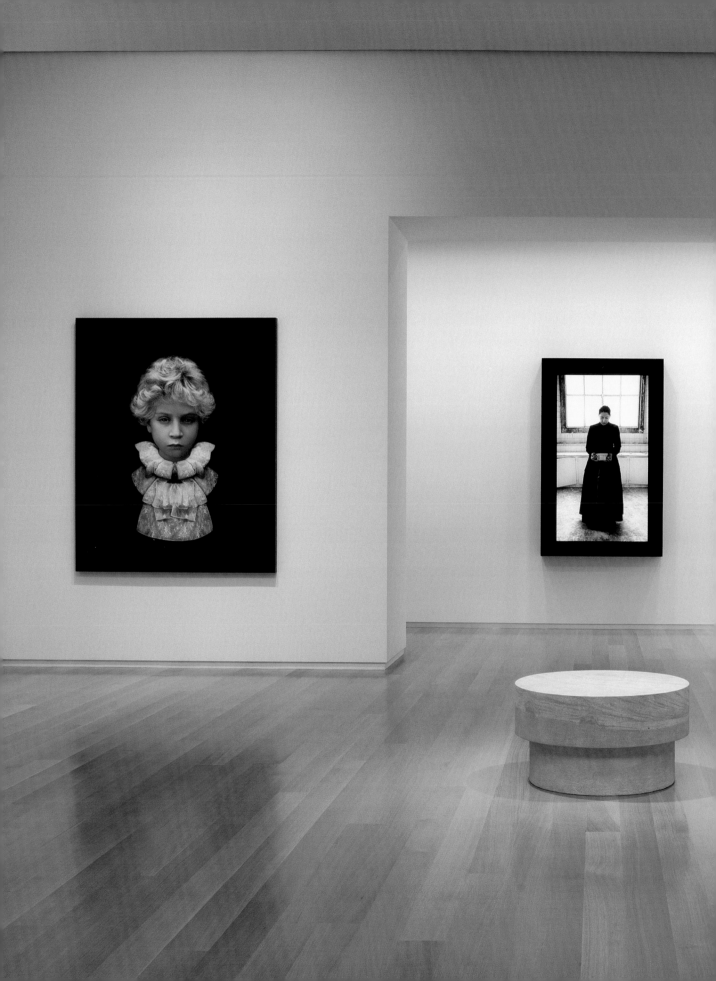

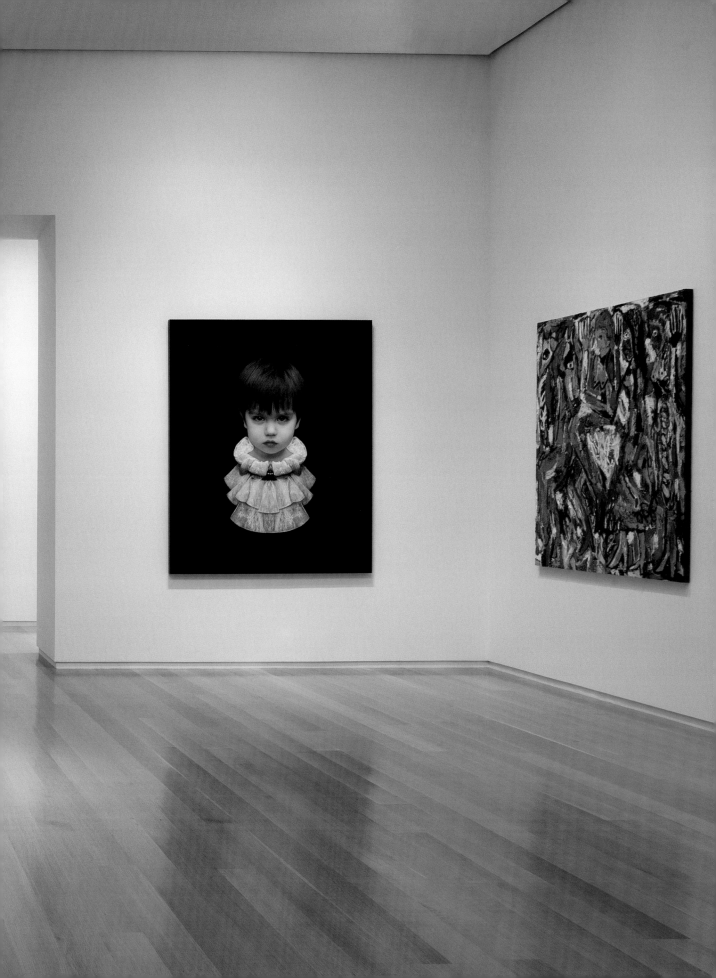

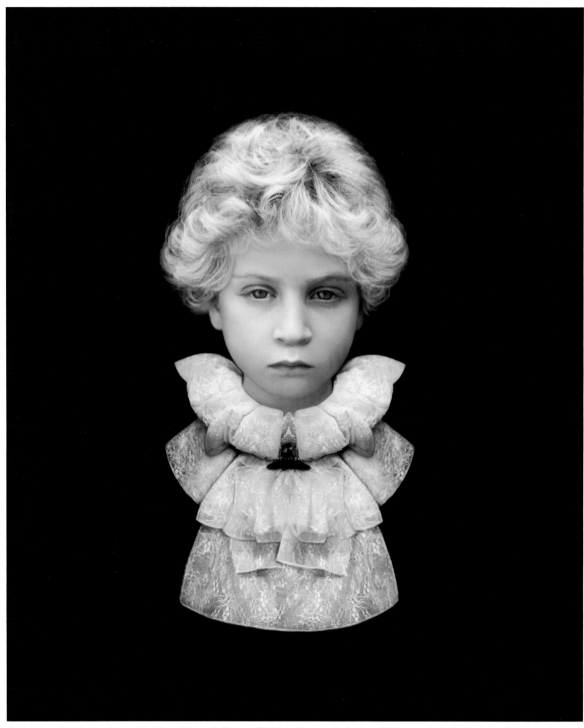

Pages 46–47: Installation view of *The Distaff Side* with (from left) Adriana Duque's *Daniel* (2010); Jenny Holzer's *Turn Soft* (2011); Marina Abramović's *The Kitchen V, Carrying the Milk* (2009); Adriana Duque's *Felipe* (2010); and Ruby Neri's Untitled (2011)

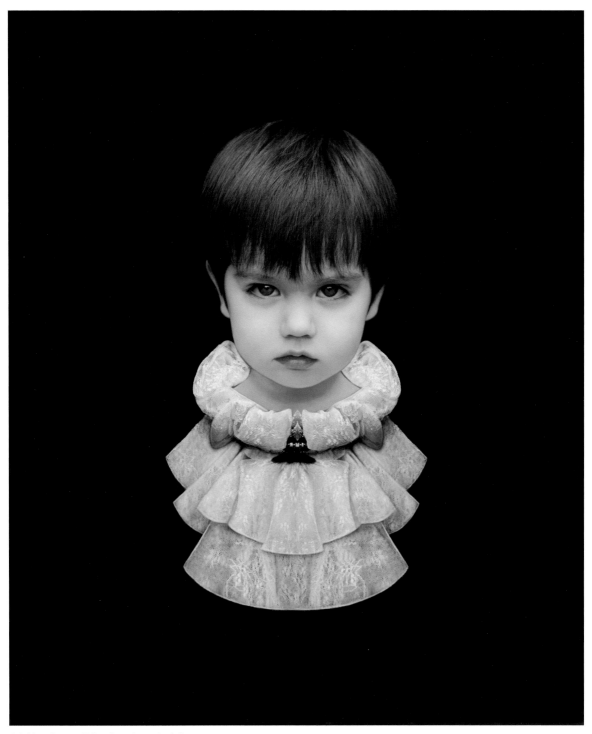

↑ Adriana Duque, *Felipe*, from the series *Infantes*, 2010
← Adriana Duque, *Daniel*, from the series *Infantes*, 2010

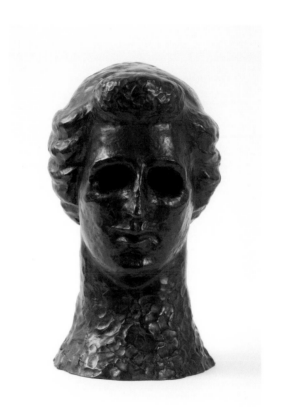

Sarah Peters, *Descendants & Believers, #3*, 2010

Inez van Lamsweerde and Vinoodh Matadin, *Anastasia*, 1994

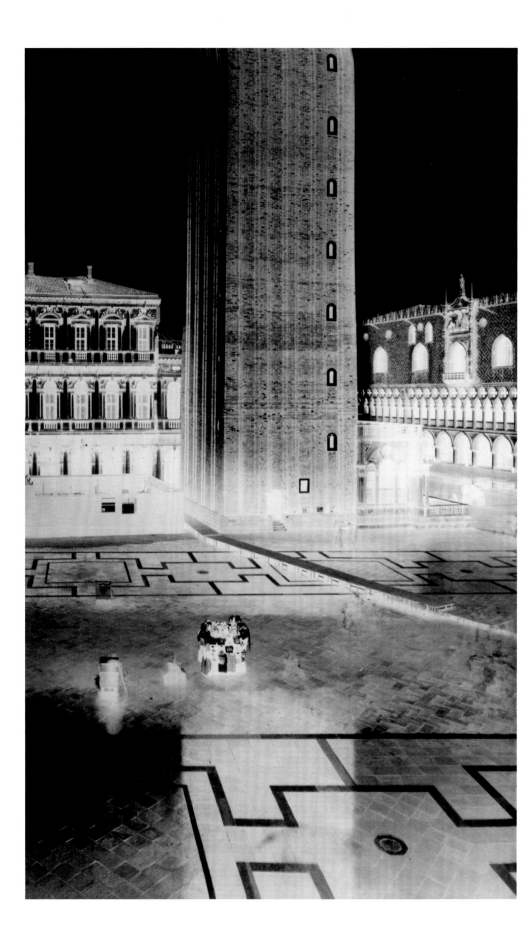

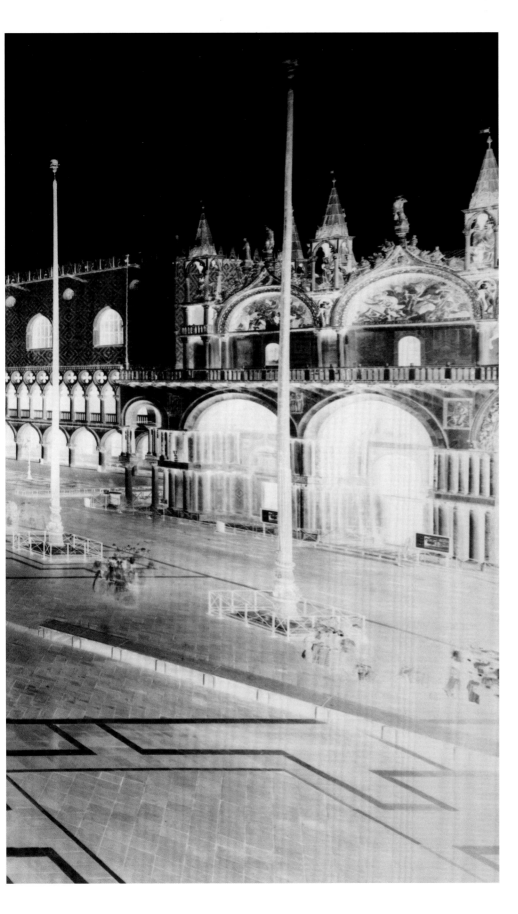

Vera Lutter, *San Marco,
Venice XIX: December 1, 2005*,
2005

Zanele Muholi, *Sunday Francis Mdlankomo, Vosloorus, Johannesburg*, from the series *Faces & Phases*, 2011

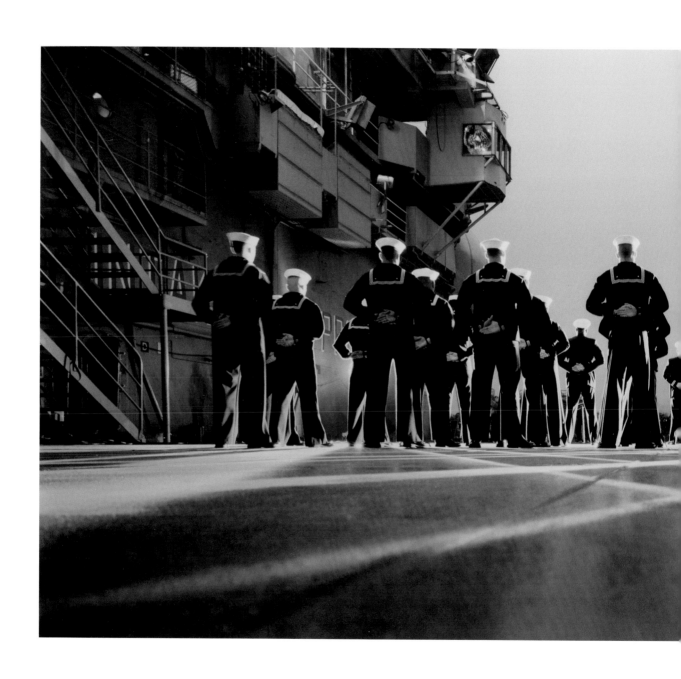

Vanessa Beecroft, *The Silent Service: Intrepid, New York*, 2000

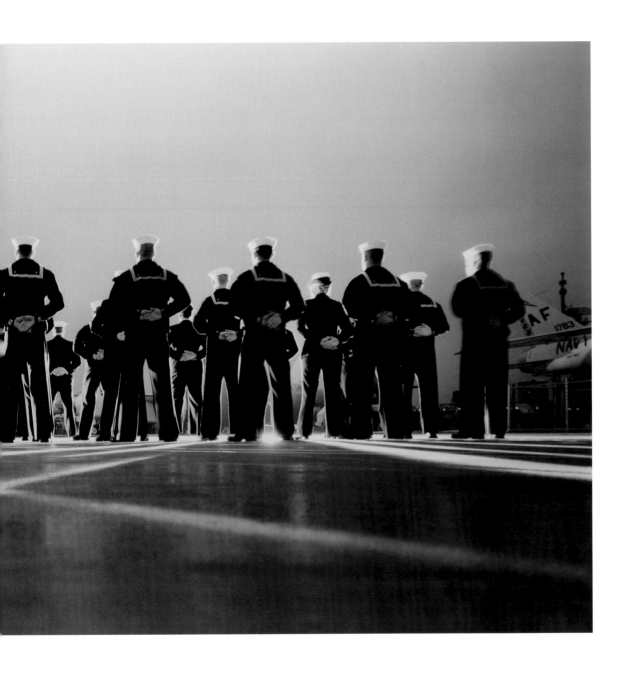

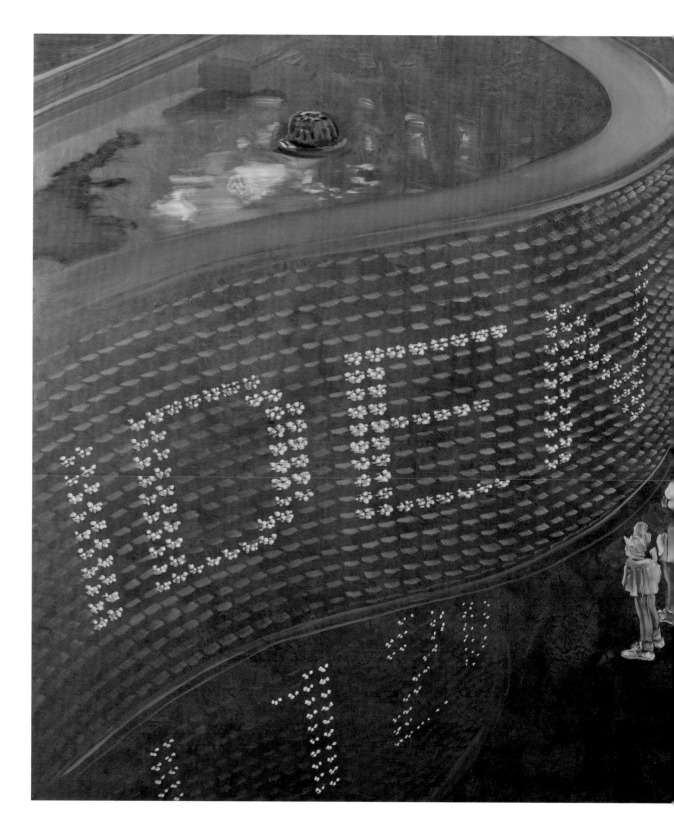

Ena Swansea, *Identity*, 2006

Ana Mendieta, *Untitled (Glass on Body Imprints)*, 1972

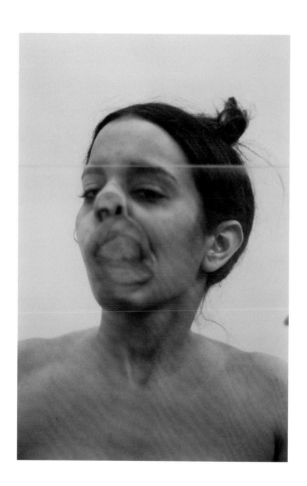

Ana Mendieta, *Untitled (Glass on Body Imprints)*, 1972

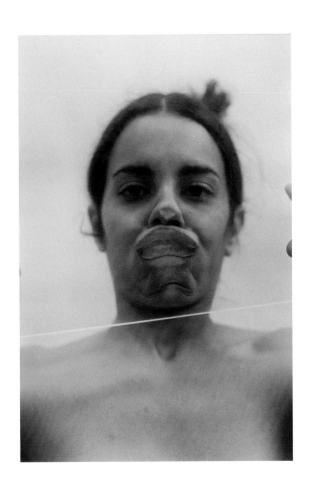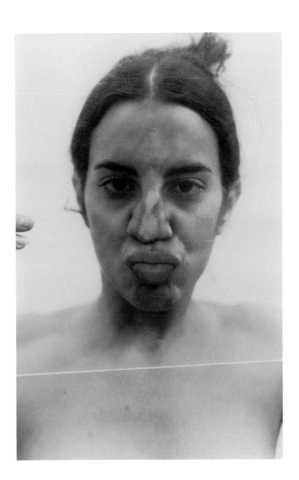

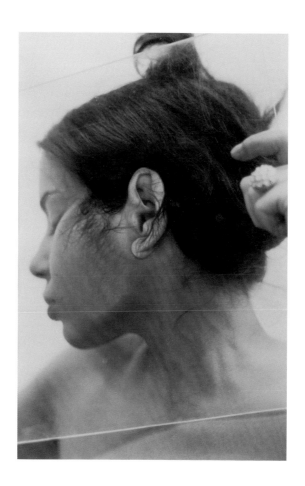

Ana Mendieta, *Untitled (Glass on Body Imprints)*, 1972

Jennifer Bartlett, *The Last Thing He Saw*, 2002

Pages 68–69: Installation view of *The Distaff Side* with
Mika Rottenberg's *Cheese* (2008) at center with (from left) Barbara
Kruger's *"Untitled" (When was the last time you laughed?)* (2011);
Louise Lawler's *Discus and Venus* (1997/2002); and Vera Lutter's
San Marco, Venice XIX: December 1, 2005 (2005)

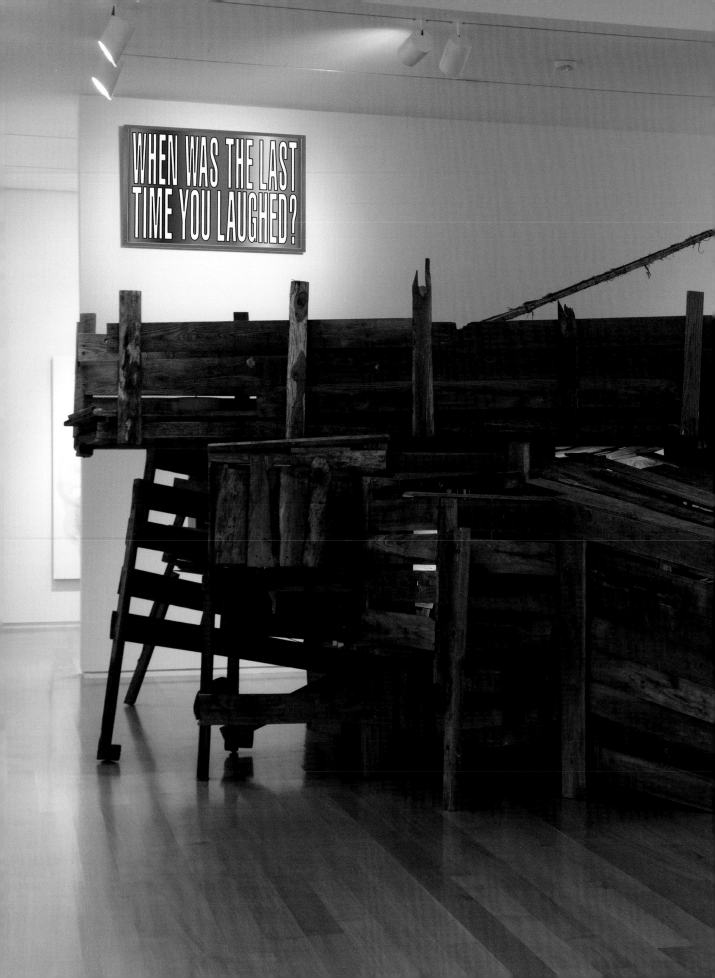

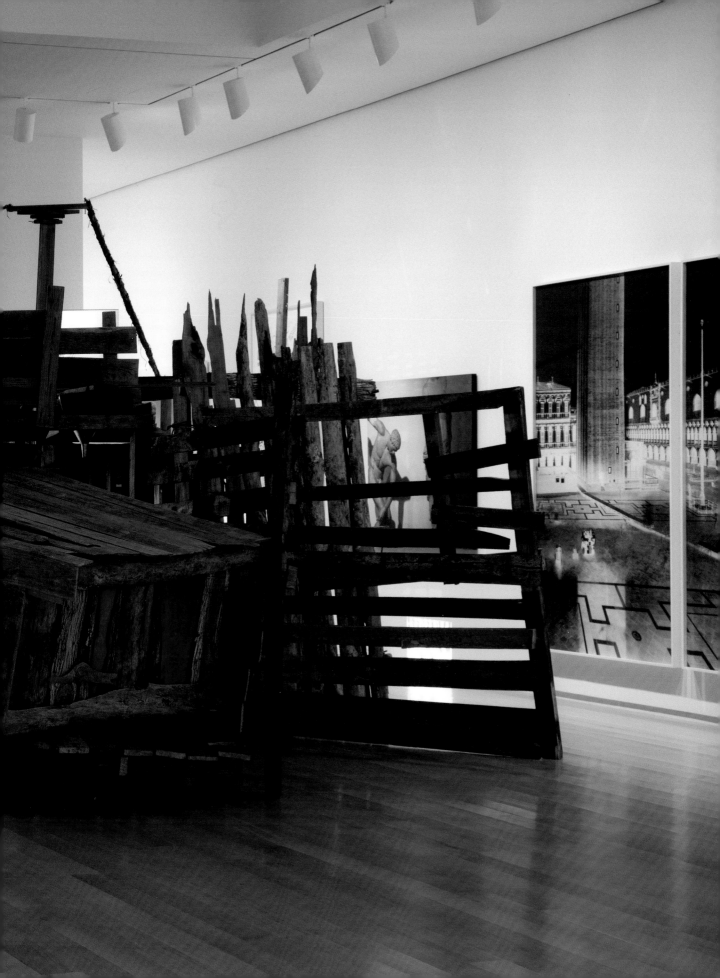

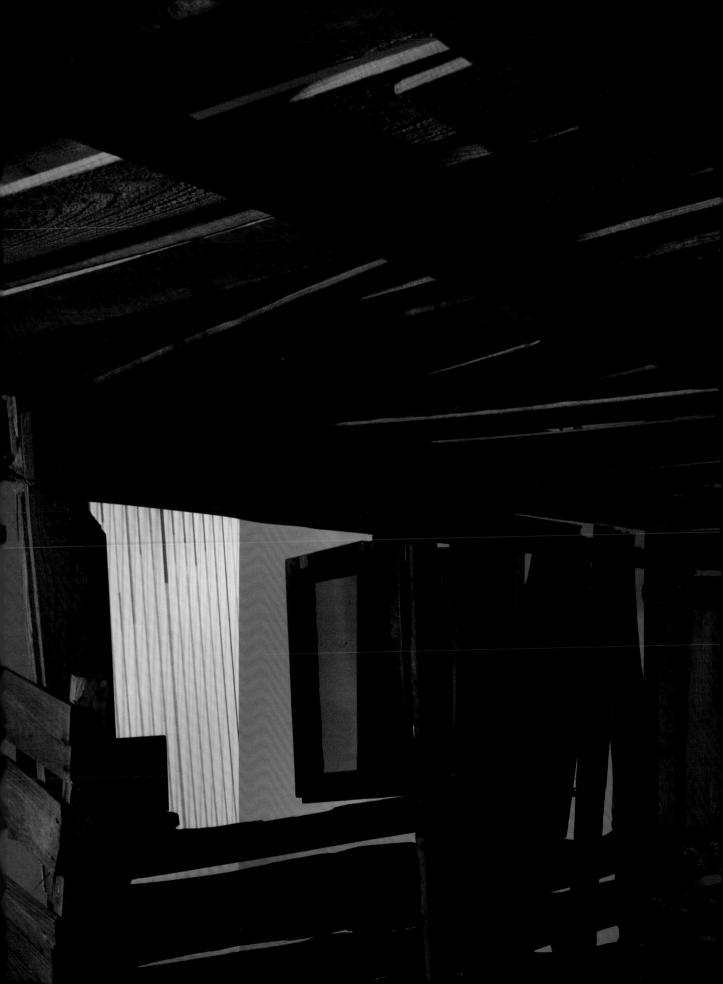

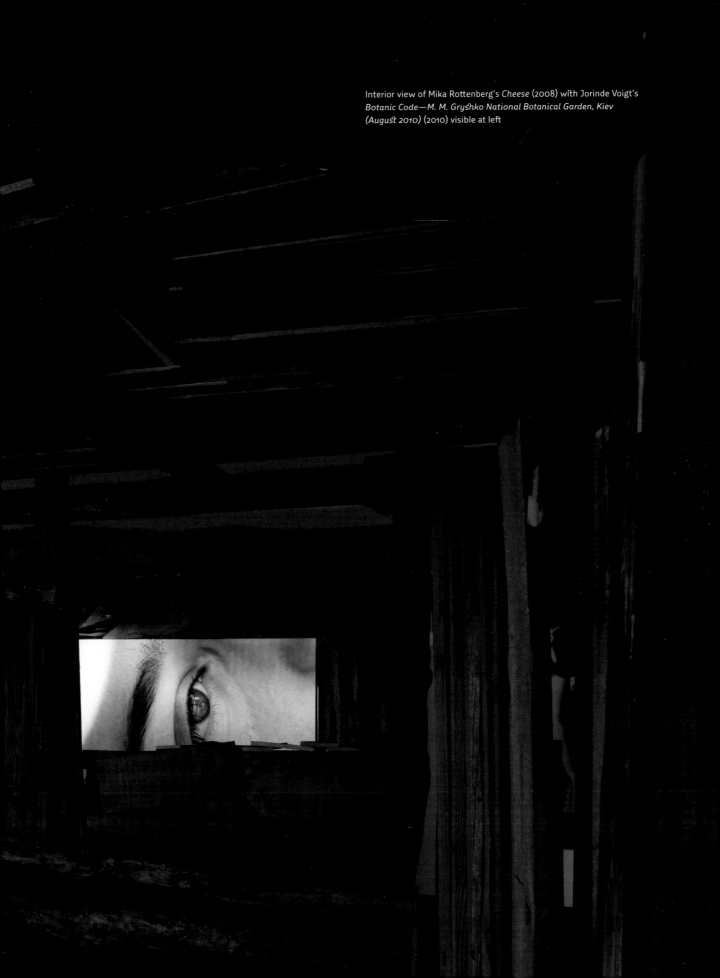

Interior view of Mika Rottenberg's *Cheese* (2008) with Jorinde Voigt's
*Botanic Code—M. M. Gryshko National Botanical Garden, Kiev
(August 2010)* (2010) visible at left

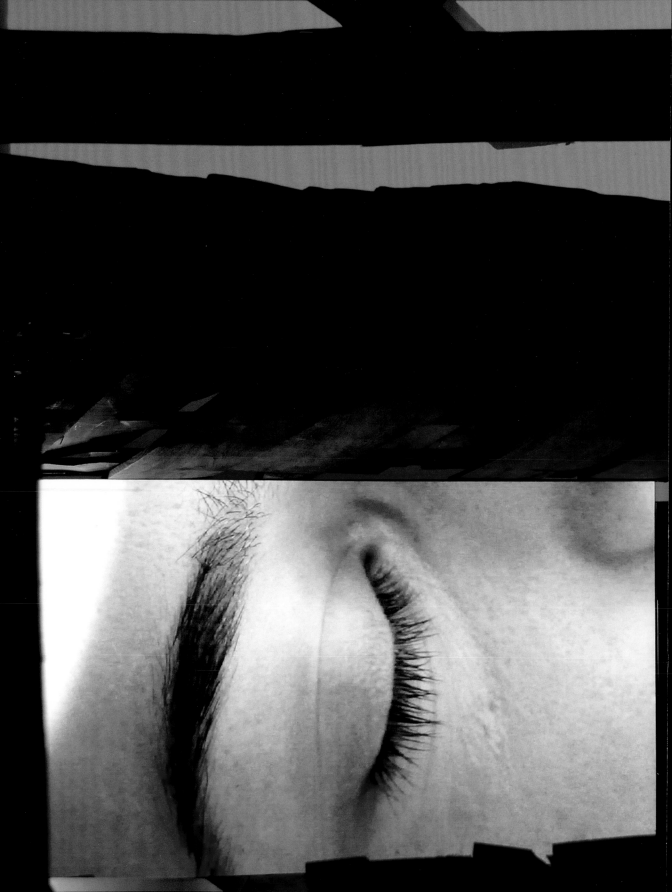

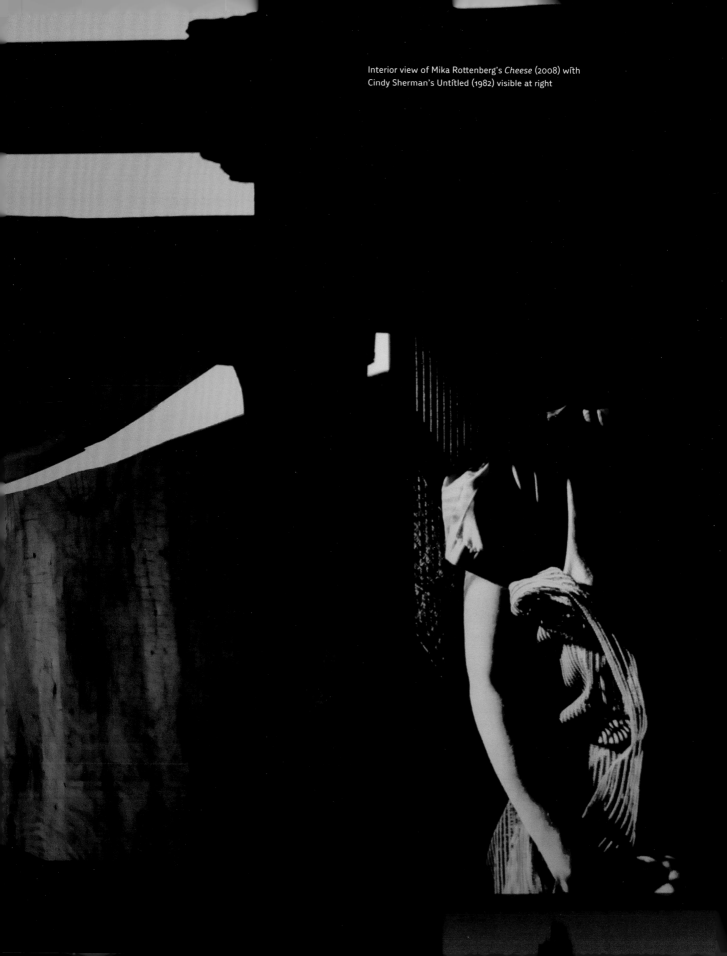

Interior view of Mika Rottenberg's *Cheese* (2008) with
Cindy Sherman's Untitled (1982) visible at right

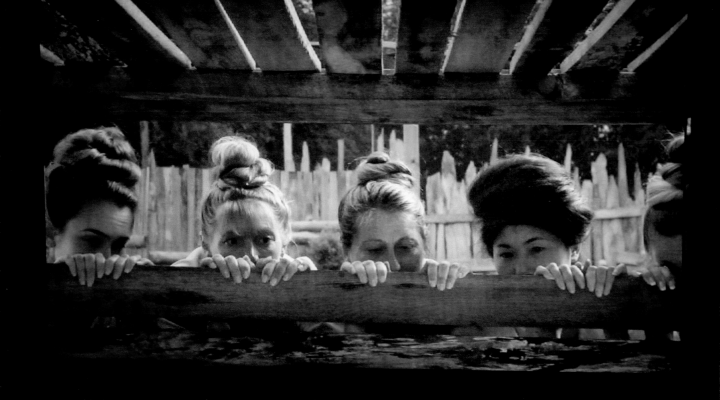

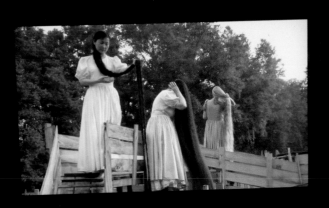

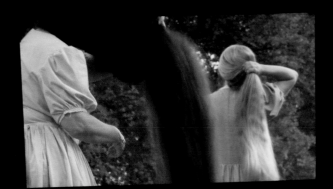

Mika Rottenberg, *Cheese*, 2008 (video stills)

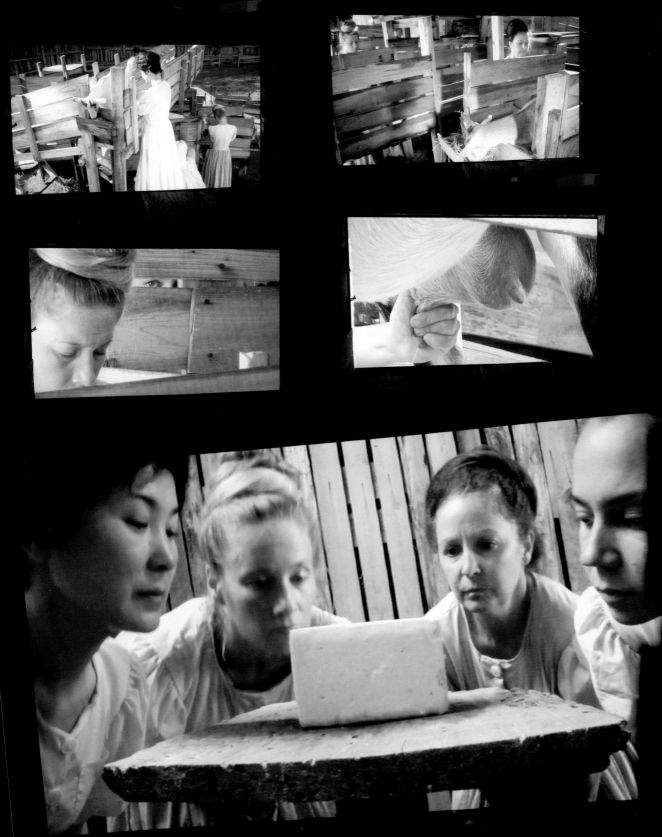

Mika Rottenberg, *Cheese*, 2008 (video still)

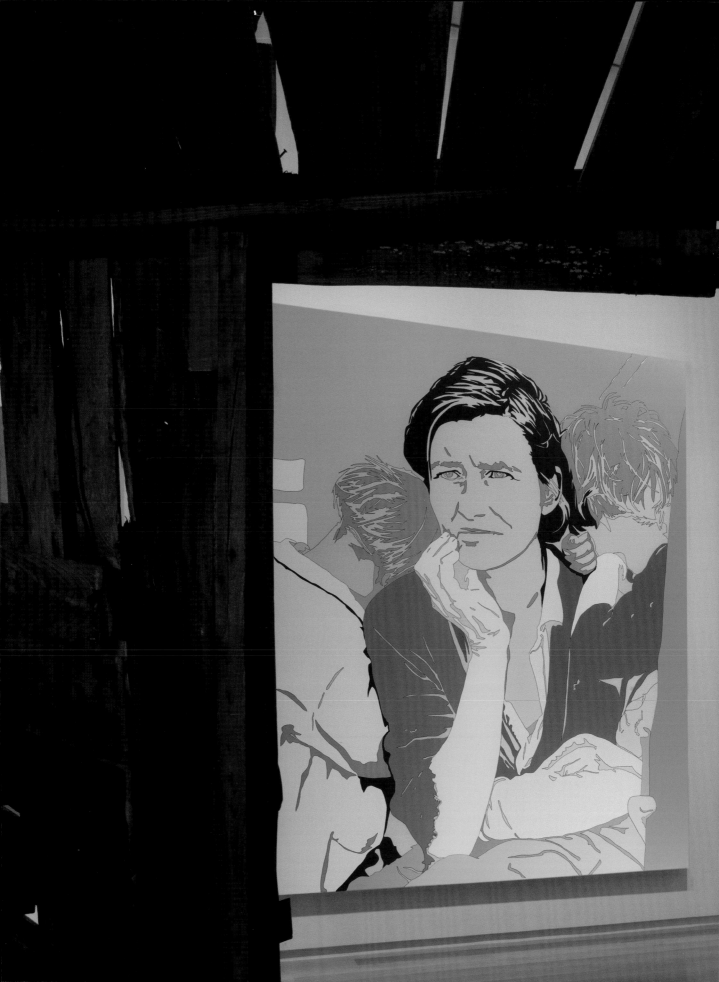

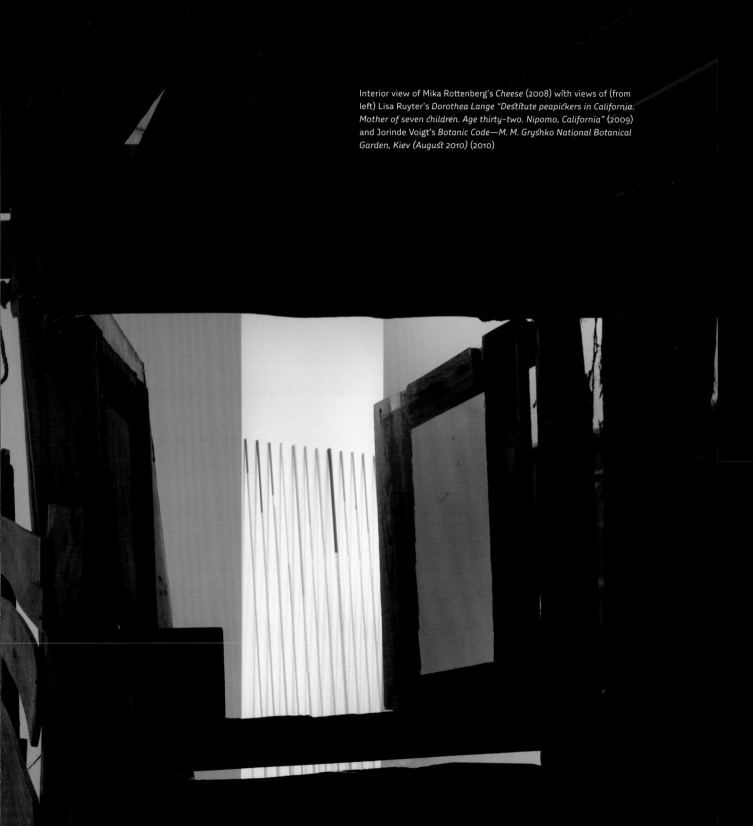

Interior view of Mika Rottenberg's *Cheese* (2008) with views of (from left) Lisa Ruyter's *Dorothea Lange "Destitute peapickers in California. Mother of seven children. Age thirty-two. Nipomo, California"* (2009) and Jorinde Voigt's *Botanic Code—M. M. Gryshko National Botanical Garden, Kiev (August 2010)* (2010)

↑ Louise Nevelson, *December Wedding*, 1984
← Installation view of *The Distaff Side* with (from left) Katy Schimert's
Female Torso (2001); Shinique Smith's *the step and the walk* (2010); Louise
Nevelson's *December Wedding* (1984); and Mika Rottenberg's *Cheese* (2008)

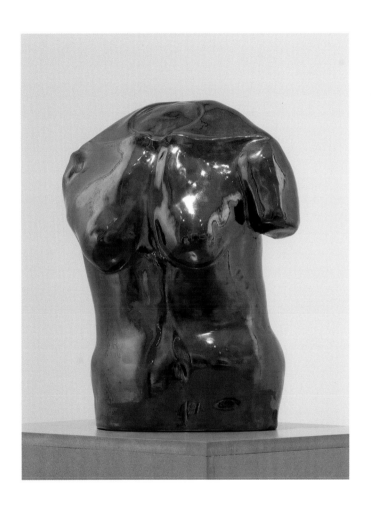

↑ Katy Schimert, *Female Torso*, 2001
→ Cindy Sherman, Untitled, 1982

Pages 84–85: Installation view of *The Distaff Side* with (from left) Carla Klein's
Untitled (2005); Rachel Whiteread's *Daybed* (1999); and Carla Arocha and Stéphane
Schraenen's *Chris, Untitled (Crosses)* (2006)

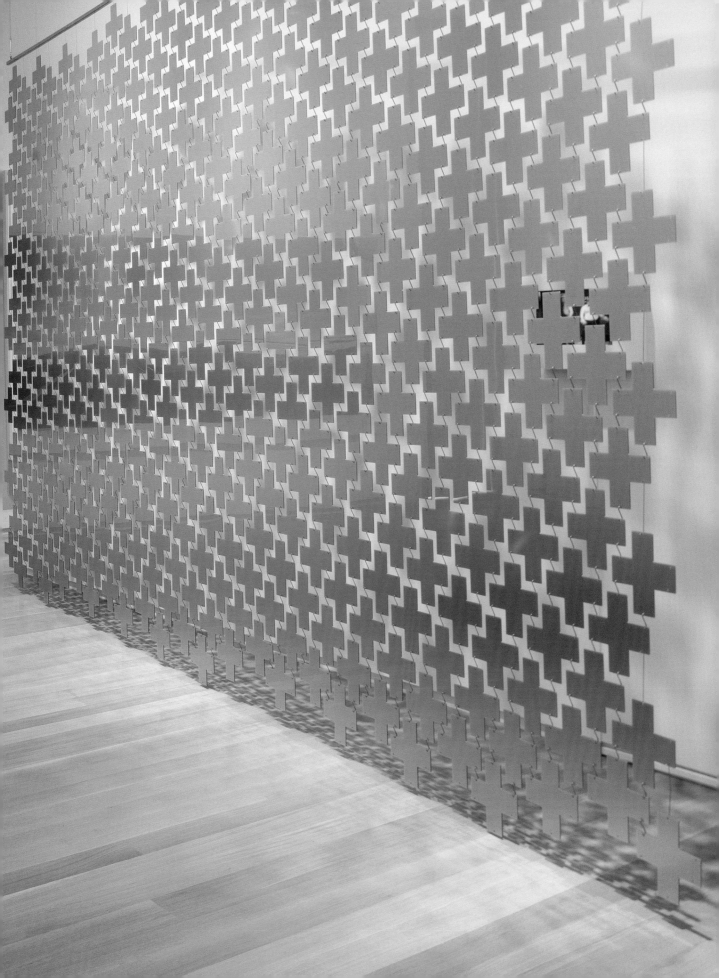

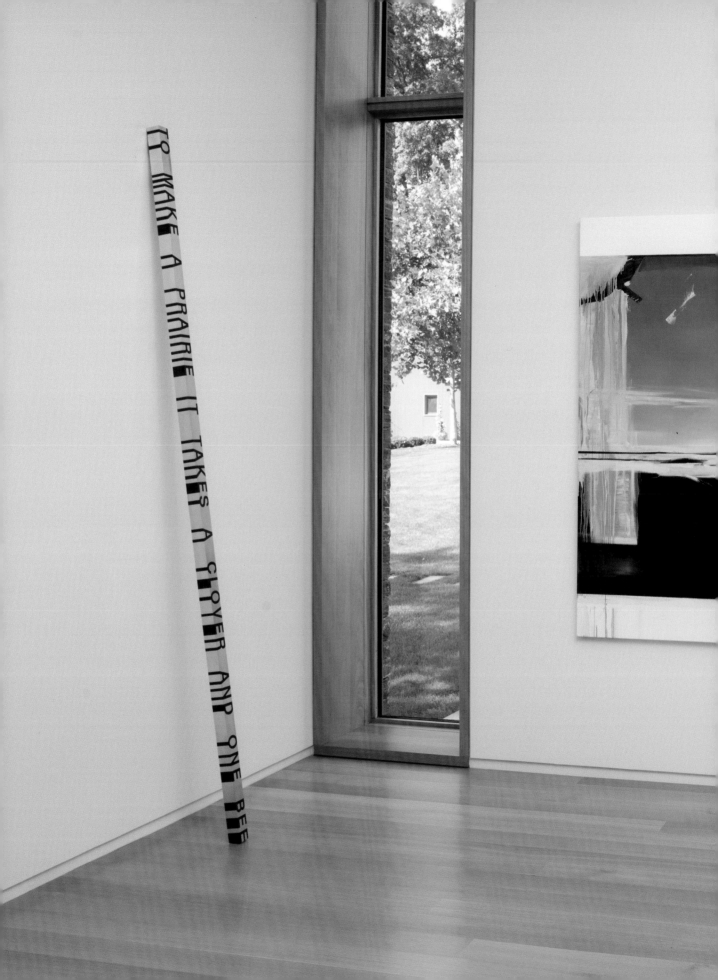

Lee Bul, *Vanish (Orange)*, 2001

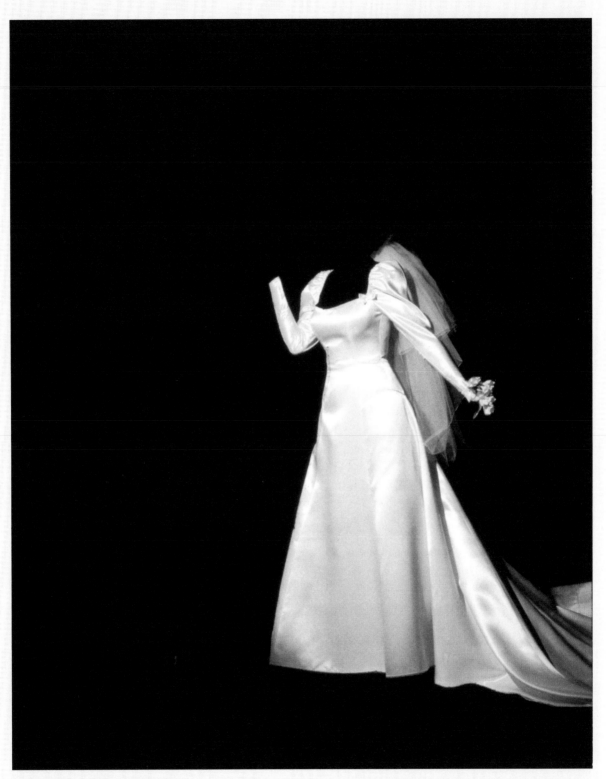

Sara Charlesworth, *Bride*, 1983–84

In her essay The Women, Joan Simon looks at Melva Bucksbaum's selection of works for *The Distaff Side*, sets out the contexts in which the curator's eye and collecting acumen developed, and explores the ongoing need both to honor and to critically assess the work of women who have shifted the paradigm of art making over the past forty years.

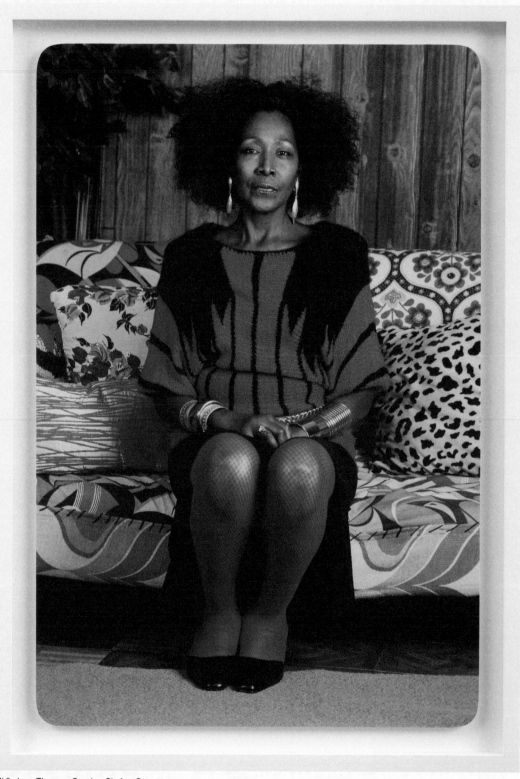

Mickalene Thomas, *Sandra: She's a Beauty*, 2009

The Granary—the exhibition and art storage facility that Melva Bucks-
baum and Ray Learsy opened in Sharon, Connecticut, in 2009—
houses collections that are hers, his, and theirs. This state-of-the-art,
museum-quality space, designed by Steven Learner, is close enough to their
home as well as to a building housing an art library (both also part of an over-
all design plan by Learner) that access to their art and to their research materi-
als may be impromptu and frequent, allowing them to look at and think about
the works that they have collected since the 1970s and to bring them out of the
lower-level storage racks and into the upper-level galleries for exhibition.

Since The Granary's opening, the installations filling the building have
been configured in different ways, sometimes as a single exhibition and other
times as multiple shows, all of which only begin to hint at the breadth of this
collection of collections. The first exhibition, on view from November 2009
to January 2011 and titled *Not on Your List*, was a focused survey curated by Ray
Learsy that "included a wide range of established and emerging artists," as The
Granary's director, Ryan Frank, notes. "The title refers to the unexpected and
atypical presentation of works on view—though several well-known artists were
included, the exhibition presented many lesser-known artists or lesser-known
works by well-known artists and demonstrated that this collection is of a wide
and varied scope—'not on your list,' as in not what the public thought was in
Ray and Melva's collections."[1] The second installation (April 2011–December
2012) was a constellation of several individual shows, including *Not on Your
List and Not Present* (an exhibition of nonfigurative, minimal works, many of
which used nontraditional materials) as well as *Cologne 1980s: A Tribute in Honor*

of *Eleonore and Michael Stoffel* and *Emergent New York*, all of which were curated by Ray Learsy; *Reflective Landscape*, curated by Ryan Frank; and *Art of the Protest*, curated by Frank and Caitlin Smith, The Granary's registrar and archivist.

Melva Bucksbaum is the curator of The Granary's third installation, the exhibition *The Distaff Side*, which opened in April 2013. It fills the two gallery floors as well as the walls lining a staircase between them and another wall leading to the storage area. Elements of the show are also on view in the library, including book works by Laurie Anderson (*Dream Book*, 2005; pp. 130–37), Louise Bourgeois (*Ode à l'oubli*, 2004; pp. 121–27), and Michele Oka Doner (*What Is White*, 2010; pp. 128–29). Also in the art library is a two-story-high installation of the eighteen C-prints constituting Laurie Simmons's *Instant Decorator* series (2001–4; p. 147). Two later photographs in the series introduce The Granary's founders into the work: *The Instant Decorator (Melva)* (2006; right) and *The Instant Decorator (Ray)* (2010; right).

As Melva Bucksbaum's title allusively signals, *The Distaff Side* is constituted of artworks by women from the couple's individual and joint collections, thus prompting the straightforward title of this essay, "The Women." This title is also a reference to Clare Boothe Luce's famous play, first produced in 1936. (Bucksbaum, Frank, and Smith also considered *The Women* as a possible title for the exhibition.) The Luce play has an all-female cast, and though males (the women's husbands, lovers, and others) are the subject of its many provocative, witty, and caustic conversations, no man ever appears on stage. In fact, the last sentence of the rights section in the opening pages of the published script for *The Women*, set in capital letters and boldface type, reads: "In all performances of this play, no changes may be made to the gender of the characters."[2]

Top: Laurie Simmons, *The Instant Decorator (Melva)*, 2006
Bottom: *The Instant Decorator (Ray)*, 2010

Although *The Distaff Side* is in some ways no different from other wide-ranging survey exhibitions in museums and galleries in its presentation of provocative, challenging, and formally innovative works in many mediums, and although the gender of its artists may not be immediately apparent to viewers, especially for the many for whom the meaning of its title is obscure, the show is distinguished by the fact that that it is composed entirely of art by women. (In the interests of accuracy, I should note that two works in the show are collaborations with male artists.)[3] Such statistics are important for many reasons: to contrast with those recording the relative numbers of male and female artists in contemporary art surveys of the past few decades; to critically assess the notable work by women that has shifted the paradigm of contemporary art making; and to serve as a benchmark as well as a reference, one hopes, for shows to follow elsewhere.

A group show in 2013 based on the premise of featuring artwork solely by women tells a very different story than the group shows of the late 1960s and early 1970s. This was when Melva Bucksbaum became active in the art world, as did this writer, and while this period may be distant history for some readers, it remains vivid and immediate in others' recollections, particularly my own. The "norm" was for group exhibitions to be predominantly, if not exclusively, dedicated to male artists (and white male ones at that). For example, in 1969 "women comprised 8 out of the 143 artists represented in the Whitney Museum Annual exhibit." In 1970, "88 percent of the reviews in *Artforum* discussed men's work, as did 92 percent of *Art in America* reviews."[4] This went largely unchallenged until feminists, activists, artists, and others affiliated with or sympathetic to the contemporary women's movement began to raise their voices. Women Artists in Revolution protested

the 1969 Whitney Annual. The 1970 Whitney Annual was also protested, this time by Women, Students, and Artists for Black Art Liberation, which decried the absence of artists of color as well as women, and by the Ad Hoc Women Artists' Committee, which picketed and sat in at the Whitney, calling for the annual to represent women at a full 50 percent.[5]

If the Whitney Museum of American Art was a continuing focus of protest, this was in part because of its mission to exhibit and collect works by living artists and the correspondingly higher expectations of this museum on the part of artists, especially because of the prominence and importance of its annual (later biennial) exhibition and the promise of recognition that inclusion in this show held for younger artists. By 1971 the protests had extended to many of New York's leading museums through Women in the Arts, which offered "an open letter to the major players of the New York art establishment—the Museum of Modern Art, the Brooklyn Museum, the Metropolitan, the Guggenheim, the Whitney, and the New York Cultural Center—demanding an exhibition of five hundred works by women artists."[6] In January 1971 *Art News* published a special issue devoted to women artists, which included Linda Nochlin's groundbreaking article "Why Have There Been No Great Women Artists?," which, as Jane F. Gerhard writes, "situated artistic genius as an outgrowth of social privilege, not mere 'talent.'" Still, Gerhard notes, "On a typical day in 1971 at the Los Angeles County Museum of Art, art made by women comprised a mere 1 percent of what was on display." And, she adds, in 1972, "100 percent of arts grants sponsored by the National Endowment for the Arts went to men."[7]

In the mid- to late 1970s women artists came to greater prominence, exploring new directions in photography (particularly staged performa-

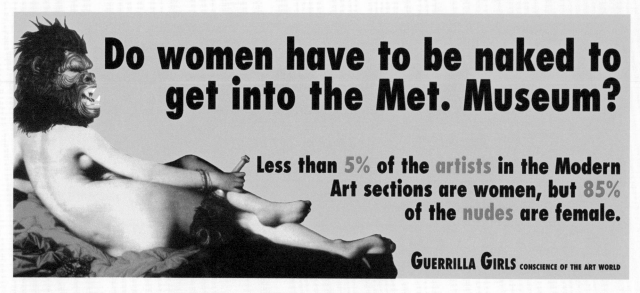

Guerrilla Girls, *Do Women Have to Be Naked to Get into the Met. Museum?*, 2005.
Poster. 12 × 26 in. (30.5 × 66 cm). Courtesy www.guerrillagirls.com

tive works and photo-text pieces), painting, architectural sculpture, and conceptual practices. The contributions of Trisha Brown, Joan Jonas, Adrian Piper, Yvonne Rainer, and others were crucial to the development of temporal art forms such as dance, performance, and video. Yet the important international survey shows of the 1980s were still overwhelmingly dominated by male artists. In 1982 Susan Rothenberg was the only female artist of the forty-six whose work was included in *Zeitgeist*, held at Berlin's Martin-Gropius-Bau, which heralded the new expressionist painting that was gaining critical attention in the United States and Europe. By mid-decade the dearth of women in a Museum of Modern Art show coinciding with the opening of its new building prompted the formation of the Guerrilla Girls. This collective of artists, who chose anonymity in print and in person, wearing gorilla masks for public appearances, became "the conscience of the art world" in their practice of "fighting discrimination with facts, humor, and

fake fur"—a role that the collective continues to play almost thirty years later. They report, as ever, with statistics, wit, and superb graphics, and their "creative complaining," as they call it, remains all too necessary.[8] The members assume the names of historic women artists, and two of them spoke about the MoMA exhibition in response to a question about the group's origins.

Käthe Kollwitz: In 1984, The Museum of Modern Art in New York opened an exhibition titled *An International Survey of Painting and Sculpture*. It was supposed to be an up-to-the-minute summary of the most significant contemporary art in the world. Out of 169 artists, only 13 were women. All the artists were white, either from Europe or the US. That was bad enough, but the curator, Kynaston McShine, said any artist who wasn't in the show should rethink "his" career. And that really annoyed a lot of artists because obviously the guy was completely prejudiced. Women demonstrated

in front of the museum with the usual placards and picket line. Some of us who attended were irritated that we didn't make any impression on passersby.

Meta Fuller: We began to ask ourselves some questions. Why did women and artists of color do better in the 1970's than in the 80's? Was there a backlash in the art world? Who was responsible? What could be done about it?[9]

These questions remain as relevant today as they were in 1985, when the group was founded, or in 1989, when the Guerrilla Girls designed a billboard for the Public Art Fund in New York. The poster's gorilla-masked odalisque was accompanied by the question "Do women have to be naked to get into the Met. Museum?" The answer: "Less than 5% of the artists in the Modern Art sections are women, but 85% of the nudes are female." When the group updated the poster in 2005 and 2012, the results, as they say, "were very 'revealing'": in 2005, the numbers were 3% and 83%, respectively (left), and in 2012, 4% and 76%.[10]

In a *Los Angeles Times* article of July 2013 surveying the record of Los Angeles museums in offering solo shows to women artists, Christopher Knight writes: "The scope of the problem becomes stark when you add together LACMA, MOCA and the Getty photo department. In the last five calendar years, four out of five museum solo shows have been by men." In his nuanced and forceful critique, Knight observes: "Institutional culture is difficult to change. And don't underestimate the power of the art market on the museum world, where a profit-motive does not apply (at least theoretically). The market has always favored the investment potential of art made by men, and despite a cataclysmic correction in the early 1990s, the art market is now in full crazy-mode. Prices

may be unrelated to quality, but the market erects an expanding platform of visibility that has an indisputable impact."[11]

While there have been important group shows dedicated to women artists—notably those referenced in Knight's article, which include *Women Artists: 1550–1950* (1976), "the first survey of its kind anywhere"; the Museum of Contemporary Art's *WACK! Art and the Feminist Revolution* (2007), "the first show to fully examine the international foundations and legacy of feminist painting, sculpture, photography, film, video, and performance art made between 1965 and 1980"; and the Los Angeles County Museum of Art's *In Wonderland: The Surrealist Adventures of Women Artists in the United States* (2012)—these critically important exhibitions have been few and far between, even as they began to correct the art historical record and to look at art by women in theoretical, sociocultural, and thematic contexts.[12]

If these exhibitions were rare occasions in the museum world, rarer still are shows of art by women that are, like *The Distaff Side*, drawn from a single collection. A recent example is *So Much I Want to Say: From Annemiek to Mother Courage*, which opened in April 2013 at the Sammlung Goetz at Haus der Kunst, Munich. The exhibition, drawn from the collection of Ingvild Goetz, presents film and video works from the early 1970s to the present featuring female protagonists. All but one of the eleven artists are women.[13] Examples from the 1990s include the traveling exhibition *Defining Eye: Women Photographers of the 20th Century* (1997), organized by the Saint Louis Art Museum from the collection of the psychotherapist Helen Kornblum, and *The Louise Noun Collection: Art by Women* (1990) at the University of Iowa Museum of Art and the Des Moines Art Center. The latter exhibition presented works acquired over many years by the Des Moines native, activist, writer, and late-

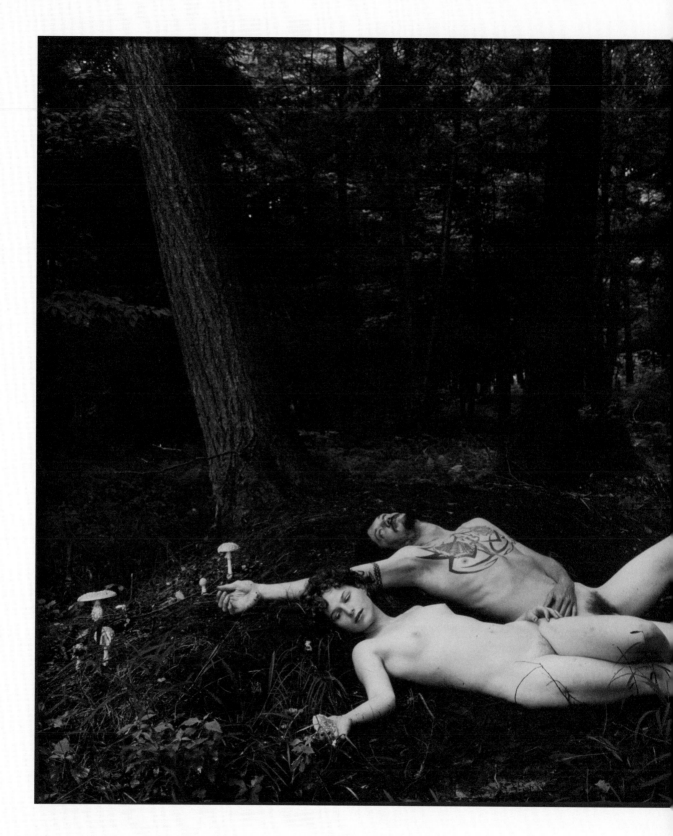

Justine Kurland, *The Pale Serpent*, 2003. C-print. 40 × 50 in.
(101.6 × 127 cm). Exhibited in *Reflective Landscape* at The Granary,
April 2011–December 2012, curated by Ryan Frank

in-life feminist Louise Rosenfield Noun, a colleague and friend of Bucksbaum's and an important influence on her ideas of connoisseurship. Noun pursued graduate studies in art history at Harvard, taking Paul Sachs's renowned "museum course" and earning a master's degree, but was discouraged from pursuing a professional career in the field because of her gender.[14]

Opportunities for women are much greater today, and Knight concludes his article by noting that of the Los Angeles institutions he discusses "only the Hammer [Museum] has a woman occupying the director's office. While there has been a sharp rise in the number of women in curatorial and other administrative positions in art museums, individuals always make the difference. Hammer Director Annie Philbin acts on her egalitarian commitments."[15]

Melva Bucksbaum is another of those individuals who has made and continues to make a difference—through her collecting, through loans of artworks to museums, through her role as a museum trustee, through her funding support of museum exhibitions and acquisitions, and in her debut as an exhibition curator. The word *curate*, ultimately derived from a Latin word meaning "care," has two different but related definitions: the noun form refers to a member of the clergy in charge of a parish, while the verb form refers to the act of overseeing a museum or other collection or of organizing an exhibition.[16]

I would like to suggest that both definitions pertain to Melva Bucksbaum's work on *The Distaff Side* as well as to her life's work as a leader, philanthropist, and artists' advocate. In each of her choices—whether that of an individual work of art, of how an artwork is installed in one of her homes, in honoring the innovative by funding a substantial artist's award (the Whitney Museum's Bucksbaum Award), or in funding numerous

↑ Meghan Boody, *PsycheStar*, 2011
↓ Amy Arbus, *Madonna, St. Mark's Place*, 1983, from the series *On the Street 1980–1990*

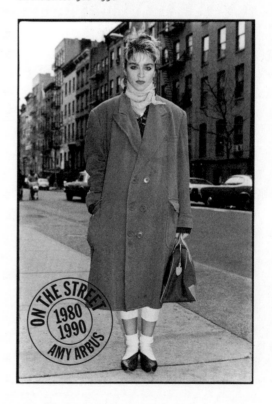

exhibitions and institutions—she has cared for artists and the institutions that honor, conserve, and study their works in addition to presenting them to many different publics.

It was apparent to Bucksbaum that the three collections from which she could select her exhibition included a substantial number of works by women artists in many different mediums and ranged chronologically from the early years of the twentieth century to within months of the exhibition's opening in 2013. More notable than the numbers (which are historically significant in themselves) was Bucksbaum's relation to the works and the artists in the collection. This is illustrated by the fact that she considered dedicating this catalogue "to the women who rock my world" and chose to reprint a favorite Maya Angelou poem, "Phenomenal Woman" (p. 234).[17]

Beyond the numbers, however, it was important to the curator that the works set out a compelling yet personal narrative of contemporary art history. Encompassing varied approaches and mediums, international in scope yet not forgoing artists known primarily to local audiences, the show is inclusive, expansive, and characterized by a sure eye and a sense of independence. Without being restricted to one thematic focus, it provokes thoughts about the diverse ambitions of the artists, the techniques used, the relations among the artworks, and the larger issues raised by these works both individually and in concert with one another.

The Distaff Side could be described as containing several smaller exhibitions, installation groupings that highlight certain key themes or types of imagery or subject matter while mixing various mediums and art historical periods and "categories." For example, one gallery is characterized by representations of women and diverse permutations of portraiture or self-portraiture. These

works include Mickalene Thomas's *Sandra: She's a Beauty* (2009; p. 92); Meghan Boody's *PsycheStar* (2001; left); Rineke Dijkstra's *Coney Island, NY, July 9, 1993* (1993; p. 20); Zanele Muholi's *Sunday Francis Mdlankomo, Vosloorus, Johannesburg* (2011; p. 55); Amy Arbus's *Madonna, St. Mark's Place* (1983; left); and an early work by Ana Mendieta, *Untitled (Glass on Body Imprints)* (1972; pp. 60–64).

Without a didactic panel explicitly stating the issues invoked, the installation presents explorations of many photographic mediums: traditional black-and-white photography (the gelatin silver prints of Arbus and Muholi), color printing (the C-prints of Thomas and Dijkstra), and new digital technologies (the light-jet print of Boody). Here are the implications of the continuing importance of street photography (Arbus) and of conceptual, performative works employing the artist's body as a medium to be manipulated (Mendieta). There are iconic images of women of many ages, whether the adolescent of Dijkstra's work, the emerging pop star of Arbus's view, or Thomas's "No. 1 muse": her mother, Sandra Bush, an elegant, self-possessed "former fashion model who works in the special services school district of Bergen County, N.J."[18] The artists themselves—born in Cuba, South Africa, Holland, and various parts of the United States—reflect the international scope of the collection as well as its chronological span, with works dated from 1972 to 2011 in this gallery alone.

Two other galleries also highlight the strengths and diversity of photography in the collections but include sculpture and a salon-style installation of drawings, watercolors, prints, and other editions. Bucksbaum isolated figurative works for the most part in one gallery and, in the center of the space, installed Kiki Smith's bronze *Autumn I* (2000; pp. 175, 177), which bestows different shades of meaning on the works surrounding it.

The bent arm of Smith's crouching female figure is echoed in Sharon Lockhart's untitled large-scale color photograph (2010; p. 177), which features a woman seated at a table and concentrating on a puzzle, and in Lisa Kereszi's *Gael Dressing, State Palace Theater, New Orleans, LA* (2000; pp. 162–63), whose subject is seemingly concentrating on her reflection in an unseen off-frame mirror as she adjusts her red lace bra, which stands out against her luminous white body within a darkened room. The large cast-bronze leaves at the base of Smith's figure are a microcosm of nature that resonates with Victoria Sambunaris's haunting macro-view in her color photograph from the *Border* series (2010; p. 175).

In contrast to Kiki Smith's sculpture of a body in repose, another Lockhart color photograph, *Goshogaoka Girls Basketball Team: Ayako Sano* (1997; p. 171), features the body in dynamic motion. The player, arms raised and palms facing out, has just gotten off a shot. In her installation Bucksbaum links this work to the sole outfacing hand seen through the upper frame of a window in Rachel Harrison's *Untitled (Perth Amboy)* (2001; p. 182) and also links the blue palette that fills the reflection in Harrison's window to the basketball player's bright blue jersey within the overall darkened field of the court. Two figurative sculptures by Judy Fox are set apart yet hover over this room in their own alcove: *Ayatollah* and *Rapunzel fragment* (2004 and 1999, respectively; pp. 194, 195).

In the second gallery, Marina Abramović's *Portrait with Firewood* (2009; p. 196), which shows the artist holding a bundle of branches, is juxtaposed with Jennifer Steinkamp's *Mike Kelley* (2007; pp. 197–99), a computer video installation that is a technological, transformative wonder presenting a tree in changing colors. As Steinkamp notes: "This piece was made for the Hammer Gala 2007 honoring Mike Kelley, who was one of my favorite teachers. This piece is part of a series . . . in which I honor past teachers with trees dedicated to them."[19] Both galleries on the upper floor, which serve, in a sense, as related installations constituting one show within the show, offer comparative visions of women alone or with others and in different emotional states, whether isolate, as in Cindy Sherman's untitled photograph of 1982 (p. 168) and Katy Grannan's *Kamika, Near Route 9, Poughkeepsie, NY* (2003; p. 164); tenderly coupled, as in Nan Goldin's *Valerie and Gotscho embracing, Paris* (1999; p. 181); or in intimate triplings, as in Louisa Marie Summer's *She Gets Away with Murder* (2010; right) and Catherine Opie's *Catherine, Melanie, and Sadie Rain, New York, New York* (1998; p. 172).

Yet Bucksbaum also departs in important ways from any strict one-to-one linkage of works, an example of which is her inclusion of many photographs and conceptual works in the room with the Steinkamp video installation (p. 158). Such pieces include Sophie Calle's *La cravate* (1992; pp. 166–67), which features a tie as a surrogate for a male figure, and Kim McCarty's large watercolor on paper, *Single Strand* (2012; p. 169). The expansive salon-style hang of drawings, prints, and watercolors in this room further defies individual pairings and also conveys the scope of the collection as well as an attempt to include as many works as possible in the show while maintaining the integrity of visual relationships and the pace of the exhibition *parcours*. Works on this "salon" wall include Jennifer Dalton's all-text pencil drawing *Cool Guys Like You* (2011; p. 189); Ellen Phelan's pastoral abstracted gouache and watercolor *Gate: Westport* (2002; p. 173); a variety of figurative works, such as Rosemarie Trockel's untitled "Pinocchio" watercolor (1986; p. 178) and Ellen Gallagher's multimedia work *Ruby Dee* (2005; p. 105); and abstract works on paper such as Elizabeth Murray's

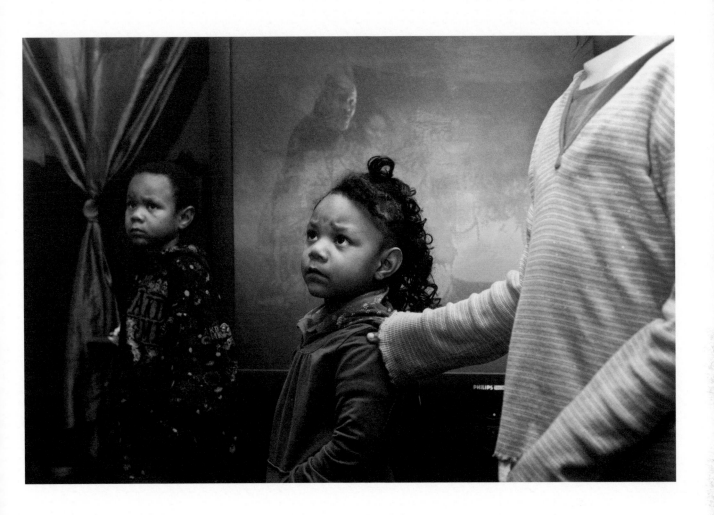

Louisa Marie Summer, *She Gets Away with Murder*, 2010

← Carla Arocha and Stéphane Schraenen,
Chris, Untitled (Crosses), 2006 (detail)
→ Ellen Gallagher, *Ruby Dee*, 2005

watercolor *Blue Shadow* (2001), Pat Steir's wood-block print *Chrysanthemum* (1982), and Charline von Heyl's untitled work combining photocopy, collage, and ink (2003).

In four of the five galleries, a sculpture (or, in one case, two sculptures) anchors a grouping of works. Just as Kiki Smith's bronze provides a lens through which to view the works surrounding it, so too do the sculptural works in the ground-floor galleries. Rachel Whiteread's *Daybed* (1999; p. 84), for example, placed centrally in the space, raises many questions about the use of geometric forms while also introducing notions of abstraction and reality, the domestic, the formal, and the utilitarian function of furnishings as well as the more theoretical problematic of replication. Carla Arocha and Stéphane Schraenen's *Chris, Untitled (Crosses)* (2006; p. 85, above), a stainless-steel screen made up of small crosses, conceals but also partially reveals the video monitor mounted on the wall behind it, which shows a *Saturday Night Live* sketch featuring Chris Farley. Such combinations are also at play in the repetition of lines and in the conceptual force of Jorinde Voigt's *Botanic Code—M. M. Gryshko National Botanical Garden, Kiev*

(August 2010) (2010; p. 16); in the language on the surface of Roni Horn's *Key and Cue, No. 1755* (1996; p. 86), a three-dimensional "line" with text resting against the wall; and in the line seen in the strip of road that diagonally crosses Carla Klein's untitled oil painting (2005; pp. 86–87). This, in turn, leads one back to the wide red, blue, and yellow "lines" edging each of the canvases of Shinique Smith's triptych *the step and the walk* (2010; p. 17). These borders are seen only from a sidelong view yet function with the viewers' movement to shift one's focus back and forth between the paintings' central bravura expressionist strokes and their surrounding linear edges, long bands that also evoke the title of Barnett Newman's famous series of paintings *Who's Afraid of Red, Yellow and Blue* (1966–70).

The largest gallery of The Granary, on the ground floor and illuminated by skylights, presents two groupings of works that are each keyed to a sculpture: Mika Rottenberg's video sculpture *Cheese* (2008; pp. 68–79) at one end and Jenny Holzer's white stone table *Turn Soft* (2011; pp. 42, 44–46) at the other. *Cheese* is first seen as a large-scale architectural structure within the ground-

floor gallery. It is a makeshift shed, seemingly built haphazardly of found wood elements. "Most of the wood used was the surplus from a sawmill that cuts down trees into two-by-fours," notes Rottenberg, "which links back to my interest in the process of creating units out of a natural resource. The structure invites the viewer into its recess and is the beginning of a narrative of labor and many sorts of nature's sources."[20] In the context of The Granary, the structure also alludes to the agricultural heritage of this particular Connecticut site.

When the piece was first exhibited in the 2008 Whitney Biennial, "the audience entered a makeshift barnyard," the artist Judith Hudson noted, "through a cattle-chute-like structure to watch the video." As Rottenberg explains in the same article, an interview with Hudson, "You enter into the installation and then start watching the film, and hopefully at some point, you become aware of the space that you're watching the film in and your own body in it. I want the structure to trigger your thinking about the labor behind the whole construction."[21]

The video (shown as multiple videos in six projections) is a fictionalized remaking of the nineteenth-century rags-to-riches tale of upstate New York's seven Sutherland sisters, who, "with the longest hair in the world,"[22] started out as barefoot, long-tressed farm girls chasing flocks of turkeys. They became concert singers and eventually performed with Barnum & Bailey's Circus, where, "dressed in white and hair hanging so long it touched the platform, they captivated large crowds."[23] Later they manufactured such commercially successful products as their Hair Fertilizer, which was created and sold to restore hair to bald men.[24]

Rottenberg's re-creation of the Sutherlands' story invokes the fairy tale, as she says, "at its essence"—most obviously the story of Rapunzel (also explored in Judy Fox's *Rapunzel fragment*), in which the symbolic and utilitarian aspects of hair are central—as well as the rustic settings of many of those narratives.[25] Bringing together the built and the filmed, the artist tells a story that is stunning in its imagery, sounds, and sensations while also directing the viewer's attention outward from the structure. The artist shot her videos in Florida, where she "rented a piece of land from this guy who owned a petting zoo. That's where I built the set—it was only me and another artist friend, Deville Cohen, that came to help me out. I wasn't really sure what it was going to be. I started with a circular fence that surrounds half an acre of land, and inside that circle is where I started to think about exactly what I wanted to do. I was starting from a sound or a sensation, and also wanting to make a sculptural set, using the soil to grow stuff as part of this sculpture."[26]

Rottenberg's women are clothed in long white shifts and, like the Sutherland sisters, use their long hair to productive purpose, surreally so in this case as they manipulate it to shepherd goats and "milk" both their tresses and the goats for materials for their cheese making. They are all the while seen in different, changing contexts of the set Rottenberg constructed, which is used as a dormitory (an orderly if crowded space within this shantytown, in contrast to the realities of housing for itinerant farm labor), and they are glimpsed chasing chickens and goats in exterior shots.

The artist explains: "I am interested in the limitations and expansiveness of one's own body. The subject-object relationship of hair and person. It really is a byproduct of a person, a surplus. . . . On a more psychological level, you can look at hair as the ultimate transitional object, something that functions as a link between you and the external world and helps you locate your subjectivity. Milk

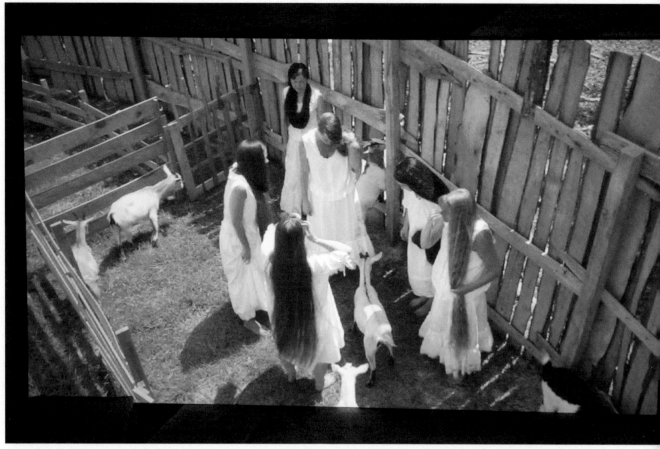

Mika Rottenberg, *Cheese*, 2008 (video still)

is also part of the body and can be made into objects, such as cheese."[27]

While the films themselves provide views of the barnyards, the small livestock, and the manufacture of cheese, the shed's oddly angled apertures offer visitors views of the various artworks installed around it. These include one of Rottenberg's own videos, projected at ankle height on a gallery wall. Also visible through the shed's openings are Louise Lawler's photograph *Discus and Venus* (1997/2002; p. 28), contrasting classical nude sculpted bodies male and female; Cindy Sherman's own shadowy figure in her untitled photograph (1982; p. 83); and Louise Nevelson's abstraction *December Wedding* (1984; pp. 80–81),

which is perhaps notable in this context for its natural materials—wood and palm bark—as well as the organic materials transformed to create its paper and cloth.

At the opposite end of this large gallery, the configuration of the Holzer table *Turn Soft*, its surface hand-carved with the phrase "Turn soft and lovely any time you have a chance"; Adriana Duque's photographs *Felipe* and *Daniel* (both 2010); and Abramović's video *The Kitchen V, Carrying the Milk* (2009) evokes an altar in which the Holzer table functions as the pulpit and its text as a contemporary form of biblical homily (pp. 46–47). Behind the Holzer, the Duque and Abramović works form a triptych of sorts, the

two portraits of young boys (who might be mistaken for girls given their costumes, rouged lips, and ambiguous hairstyles) flanking the central, large-scale video screen on which Abramović is tentatively, slowly balancing what might be an offering—so slowly, in fact, that the work might be viewed as a "still," either a photograph or a hyperreal painting. The central figure of Abramović dressed in black is formally framed, as are the heads set against black fields in the Duque photographs, recalling Dutch portrait paintings. In all, the installation is a study in black and white and grisaille—from the bright light seen behind the geometries of the window mullions high on the far wall of Abramović's kitchen to the starkly detailed white ruffs worn by the subjects of Duque's photographs to Holzer's white stone table—a palette that has particular importance for the curator, as she notes in the interview with Elisabeth Sussman in this volume.

The relationships between works set out by Bucksbaum can also be traced between works in distant galleries. Visitors may recall Abramović carrying milk in the ground-floor video when they encounter her carrying firewood in the black-and-white portrait in the upper gallery. The "concreteness" of Holzer's carved words in *Turn Soft* (left), not unlike the inscriptions on gravestones or memorial benches, may be compared to the words of her *Stripes* (2007; right, p. 36), which move fluidly on brightly colored arcs of LED lights in the opening gallery. Fully integrated with the architecture and installed high up so that each stripe appears to penetrate the wall and ceiling, Holzer's texts may be imagined to circle through the wall and back as they glide down and around the arcs. This bold stroke of color is a daring move by Bucksbaum in a room dominated by black and white.

Bucksbaum's opening gallery speaks to the many new forms, mediums, subjects, and voices

of the art of the past thirty years, whether Holzer's groundbreaking use of text; Sarah Charlesworth's conceptual works incorporating found photographs and other borrowings, represented here by *Bride* (1983–84; p. 90); Kara Walker's questioning of gender, race, and history in works such as *Restraint* (2009; p. 33); or Kathleen Gilje's appropriation of art historical sources to address contemporary concerns, as in her commissioned oil painting *Melva Bucksbaum as the Girl with the Pearl Earring* (2010; p. 138).

The subject of Melva Bucksbaum as the *Girl with the Pearl Earring* glances inquisitively over her left shoulder, thereby allowing the curator and girl with the earring to look back at the Holzer, the Charlesworth, and the large-scale performative sculpture by Jennifer Rubell installed in this signal gallery, *'Engagement (with Prince William sculpted by Daniel Druet)'* (2011; pp. 150–51). Rubell's work invites the visitor to break the usual rule of exhibition going by stepping up on the platform to engage with the wax museum–like replica of Britain's Prince William, looping an arm through his and slipping a finger into a replica of the famous engagement ring (here pinned to his sleeve) that he gave to his betrothed. This sculptural "performance," different from but related to the food-centered participatory events for which Rubell is known, draws from popular culture while also adding levity, indeed laughter, to a gallery that is generally sober. In the next first-floor gallery is Barbara Kruger's 2011 archival pigment print with its more stark, conceptual, and political declaration: "When was the last time you laughed?" (p. 23).

The first gallery also features a work that cannot be easily classified by medium, technique, or support. Traditional in form and made entirely by hand—in contrast to the works in the show involving technology, like Su-Mei Tse's kinetic

↑ Jenny Holzer, *Stripes*, 2007 (detail)
← Jenny Holzer, *Turn Soft*, 2011 (detail)

neon sculpture *Swing* (2007; pp. 38, 45), Michal Rovner's sculpture with video projection *Dahui* (2004), Steinkamp's computer video installation, or Holzer's LED stripes—it is not painting, drawing, or sculpture yet embodies concerns of each as well as text and historical references, notably the recuperation of "women's work" from the domestic sphere to contemporary art making. Elaine Reichek's conceptual work *Sampler (Kruger/Holzer)* (1998; right, p. 112), an embroidered piece on linen, is key to *The Distaff Side*.

The phrase "distaff side" came to refer to the female side of a family, a maternal line, or women's work because of women's traditional involvement in spinning and weaving. A distaff is a spinning tool used since ancient times. A woman held a long staff in her left hand so that she could draw and twist the material bound around it—flax or wool, for example—through the fingers of her right hand to spin yarn for weaving. By contrast, the phrase "spear side," referring to the implement held in the male's right hand, has come to refer to the male domain, though it is less common than "distaff side."[28]

Sampler (Kruger/Holzer) recuperates a form of decorative arts historically practiced by girls and young women that had been characterized as folk art or craft rather than fine art. From the beginning, the use of embroidery and other handcrafts was for Reichek, as she has said, "a political act."[29] Similar techniques have been used by many other women artists since the 1960s, particularly those who defined themselves as feminists. For example, Annette Messager used embroidery early in her career and continues to do so, as evidenced at The Granary by *Mes ouvrages de broderies* (1988; p. 165). Like its eighteenth-century precedents (the tradition goes back to the fifteen and sixteenth centuries), Reichek's sampler includes alphabets and proverbs. Such samplers were used to educate young women (in lettering, reading, drawing, and stitchery) while also serving as finished works to be displayed and to demonstrate the skill of their makers. Young girls of ten or eleven used coarser base cloths and simpler figures for letters and numbers, working their way up to a more refined textile base and more complex imagery. A finished work was thus evidence of both an educational process and accomplishment. Some were signed and dated.

Reichek's piece consists of two vertical embroidered panels. At the top of each is a "found" text from an eighteenth-century sampler, embroidered with the name of the maker and the date of the sampler. The saying at the top of the left panel reads "A fool and his money are soon parted. / Phebe Smith 1768." At the top of the right panel is "Do as you would be done by / Hannah Breed 1756." Their "doubles" at the bottom are from the twentieth century. The left panel bears the inscription "I shop therefore I am / Barbara Kruger 1987" while the right reads, "Abuse of power comes as no surprise / Jenny Holzer 1977." Just as the embroidered phrases by the eighteenth-century women are separated by a decade, so are those by the contemporary artists. Kruger's and Holzer's text-based works emboldened the language of conceptual art, embedding ethical, moral, and political messages in sharply honed, aphoristic phrases. Kruger emblazoned hers in signature bold red type on found black-and-white photographs (a "style" that has been widely copied in contemporary graphic design and advertising), with some works taking the form of posters or room-size installations. Holzer's phrases (including one of the best known of her *Truisms*, used here on Reichek's sampler) have appeared on supports as different as hats, breaking waves, and stone benches. Both artists use accessible, everyday matters (as subjects and material supports), embedding speech

in their works as straightforwardly as their eighteenth-century predecessors did.

In linking together across time four distinct voices by literally stitching together eighteenth- and twentieth-century texts, Reichek also uses the educational form of the sampler in newly instructive ways. It is, as the artist says, "a hybrid form" that in its very materiality embodies "aesthetic politics." As she has explained:

> When I was growing up and was a student, painting was the dominant art form, really the center of a cult, and the members of that cult were historically mostly male—there was very little room for women there. And I have to say I love painting, but I also feel, what's the big deal? I can make these same images using knitting, using embroidery—using media traditionally associated with women. But if I make them that way, of course their meaning changes, since the meaning of an artwork is always bound up with its media and processes and their history. Following through those changing meanings is one of the basic pursuits in my work.[30]

Reichek, who studied with Ad Reinhardt and was trained as a painter at Brooklyn College and Yale University (where she received her MFA), decided "very early," as she says, "to take a critical view of the kind of work, and the kind of role as an artist, that I was being trained to take on, and I decided to explore other media."[31] She began to make works using knitting, needle and thread, and hand-painted photographs, as well as making installations not limited to one medium or technique. Her earliest works were made at a time when reclaiming "women's work"—sewing, knitting, and textiles themselves—introduced a political content that at once revalued domestic

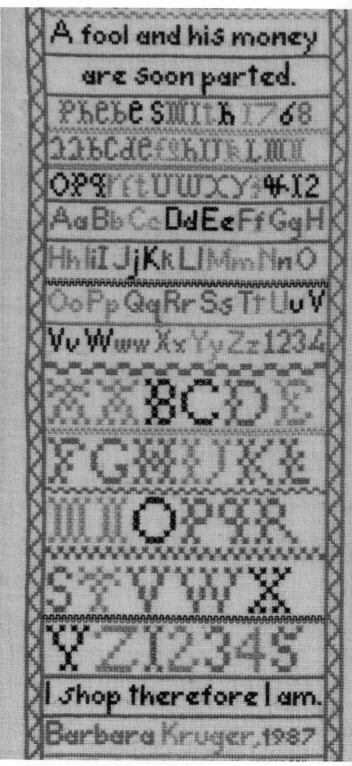

Elaine Reichek, *Sampler (Kruger/Holzer)*, 1998 (detail)

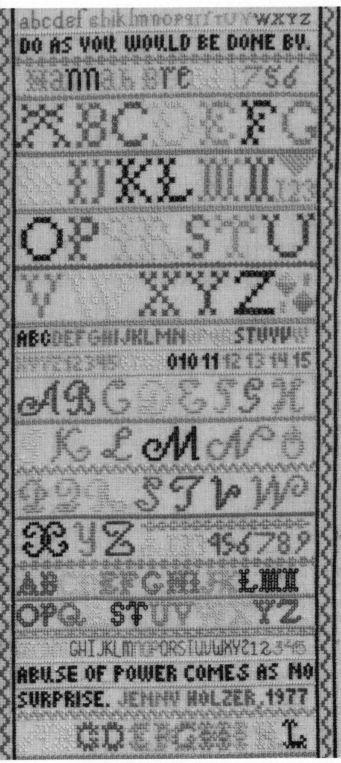

Elaine Reichek, *Sampler (Kruger/Holzer)*, 1998 (detail)

production and fundamentally questioned how art could be made, what materials could be used, and what those materials in themselves could say.

Kruger and Holzer used fabrics and other techniques of women's handwork early in their careers. As Ann Goldstein writes, "Kruger's artwork of the early 1970s included crocheted and sewn hangings adorned with paint, glitter, ribbons, etc., that asserted these 'decorative' techniques into the language of 'art.'"[32] Holzer has described the work she made as a painting student at Rhode Island School of Design: "I ripped my paintings and left long colored ropes at the beach for people to puzzle over." From these temporal installations, she went on to work with texts and diagrams and then, after moving to New York, to work on text alone, first printing her texts as anonymous posters wheat-pasted outdoors and later displaying them on what became her signature medium, LED signs. She has used and continues to use a host of other supports. "I like placing content wherever people look," Holzer told Kiki Smith in an interview, "and that can be at the bottom of a cup or on a shirt or hat or on the surface of a river or all over a building."[33] Most recently, she has returned to painting for her works involving redacted government documents.

In Reichek's *Sampler* are many of the concerns found elsewhere in *The Distaff Side*: a recuperation of historic forms or images, as seen in Lisa Ruyter's painting *Dorothea Lange "Destitute peapickers in California. Mother of seven children. Age thirty-two. Nipomo, California"* (2009; p. 4), Sherrie Levine's watercolor *After Egon Schiele* (1984), and Gilje's remake of the iconic seventeenth-century Johannes Vermeer portrait; a display of women's voices; a demonstration of how skills might be embodied; and a conversation across time periods.

Reichek's is an open-ended conversation as it poses new questions to new audiences, per-

haps those unfamiliar with the history of such embroidered samplers or the more recent use of embroidery, hybridizing handwork with conceptual art. The notion of the "remix" has become familiar from the world of popular music. Here, however, it is deliberately used to both political and aesthetic ends to create a sense of a recomplicated narrative, one that is inclusive and, in a sense, collaborative. It is not limited to a particular moment in time or to the romantic myth of the isolated artist. In rewriting art history, the restoration of names of makers to their works has been paramount, whether to "old mistresses" or to works often categorized as folk or outsider art.[34] "Anonymous was a woman" was a phrase frequently heard in early discussions of the historical absence of works by women in the canon. Reichek's naming of the samplers' creators gives agency to the makers as well as recognition of the forms made and is as important as her "sampling" of their words along with those of contemporary women artists.

In Melva Bucksbaum's selection of more than one hundred works for this show, which she organized in key groupings, the scope, quality, and importance of the collections from which the show is drawn are evident. The history of the formation of The Granary's collections is equally important. To put this history in context, especially in relation to *The Distaff Side*, some background is in order.

When Melva Bucksbaum and her first husband, Martin Bucksbaum, began collecting in the early 1970s, their primary goal was to collect art for their Des Moines home. They did not begin by collecting contemporary art or art by women. Among their first purchases were old masters, including *Triumph of Hope* (ca. 1625) by Peter Paul Rubens, and impressionist works, including examples by Edouard Vuillard and Claude Monet.

Their first purchases of modern and contemporary works were a Marc Chagall print and a watercolor by William T. Wiley. Melva Bucksbaum credits James Demetrion, former director of the Des Moines Art Center, as a key influence during her early years of acquiring art. Her friendship with Louise Noun, who was also associated with the museum, was important as well.[35]

After Martin Bucksbaum's death in 1995, Melva began to collect minimalist works by such artists as Dan Flavin (p. 144), Robert Mangold, Agnes Martin (p. 14), and Robert Ryman (p. 144). She began to collect contemporary art in earnest after her move to New York and after meeting Ray Learsy when both were serving on the board of the Whitney Museum. (They married in 2001.) Their individual and joint collections are wide-ranging, including historical as well as recent works. Following their interests in history and in works in many mediums, they have also formed other collections, including one of nineteenth-century sailors' "woolies," which is installed in the library of their Connecticut home. These examples of sailors' handwork, far less known than such shipboard pastimes as scrimshaw carving, relate in form and material less to the hunt than to the domestic sphere. These are portraits of the sailors' ships, stitched by hand in wool, an endeavor that occupied their time and their hands during long periods at sea. It is a form that was made obsolete by the ubiquity of photography by the end of the nineteenth century as well as by the faster ships that diminished the free time of sailors on board. Melva Bucksbaum has also collected modern and contemporary ceramics, on view in her Colorado and Connecticut homes, as well as extraordinary sets of tableware and glassware that are further examples of the arts of daily living. Such works are equally reflective of her collector's eye and connoisseurship and her mindful attention to the

craftsmanship, materiality, beauty, and "installation" of such objects, whether on a table, in a room, or in a museum-quality exhibition space.

That more than one hundred artworks by women are in *The Distaff Side* is impressive in itself. Just as impressive are the many other works by women in the Bucksbaum and Learsy collections that, for various reasons, are not included in this show. Some were included in previous installations at The Granary, such as paintings by Agnes Martin (*Untitled #10*, 1990, and *Untitled #2*, 1997; p. 14), an etching by Isabel Bishop (*Friends*, 1942, the only work by a woman in *Emergent New York*), and a wall relief by Annette Lemieux (*Comfort Painting*, 2001).

Art of the Protest included a work by the collaborative artist team Jacqueline Tarry and Bradley McCallum, *Negro Girl arrested, St. Louis, Illinois, August 12, 1963* (2007; p. 116). It remains unknown just how many of the intentionally anonymous artists who made posters for the printmaking collective Atelier Populaire ("people's studio") during the May 1968 uprisings in Paris—a group of posters featured in the *Protest* show—were women. The group was made up of art students from the École des Beaux-Arts as well as other artists, so it seems reasonable to assume that some were from the distaff side.[36] One of Rosemarie Trockel's conceptual wool "paintings" (Untitled, 1987; p. 117) and Rebecca Horn's sketch of an installation (*Margon-Rosa*, 1977) were included in *Cologne 1980s*, while *Reflective Landscape* included photographs by Sabine Hornig, Angela Strassheim, Ann Lislegaard, Carrie Levy, Justine Kurland (pp. 98–99), Noriko Furunishi, and Nan Goldin as well as a film still by Holly Zausner and a still from a video by Su-Mei Tse (pp. 118–19).[37] Other female artists who have been included in previous shows are also in some way a part of *The Distaff Side*, among them Laurie Simmons and Cindy

Sherman. Bucksbaum could not include Judith Shea's *Black Dress* (1983; right) or Annette Messager's *Victim of Torture* (2002–3) because of space limitations, though she did include a smaller piece by Messager, *Mes ouvrages de broderies*. Similarly, instead of showing Pat Steir's large painting *Hungry Ghost* (2000–2002), with its signature dense fluid veils of paint, Bucksbaum included a small woodblock print. As might be imagined, there are many more works by women to choose from, and following this, her debut exhibition, Bucksbaum has ideas for her next installation.

One of the most important open questions one is left with after viewing *The Distaff Side*—which reflects the discerning, informed, and always curious, exploratory "eye" of both Melva Bucksbaum and Ray Learsy—is how this exhibition relates to other exhibitions in galleries and museums. And there are, of course, related questions: What purposes does a show devoted to art by women serve today? How does such a show reflect the times in which we live and in which artists work—or not?

In her preview of the fall 2013–spring 2014 art season, Roberta Smith, co-chief art critic for the *New York Times*, presented a top-ten list under the subhead "We Can Always Hope." She describes it as "a list of events, not exhibitions, that I am looking forward to—but that in all likelihood will not be happening." Her list included: "Art galleries everywhere refraining from organizing group exhibitions that are all but devoid of female artists"; "More high-end collectors and art dealers not 'chasing the same artists,' in the words of Marc Glimcher of Pace Gallery, and instead developing individual visions that include artists other than those approved by market, theory or both"; and "Younger artists (and museum curators) fixating on the art of some decade other than the 1970s."[38]

Melva Bucksbaum, whose exhibition opened months before Smith's article was published, has

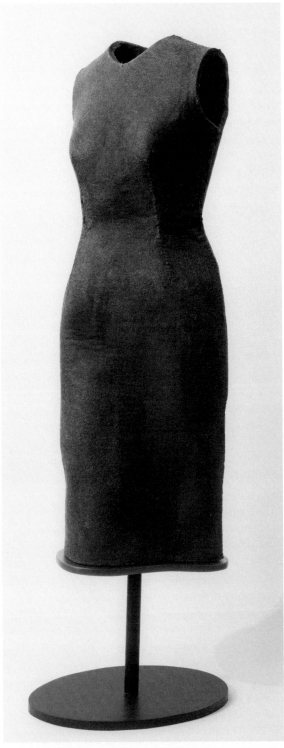

Judith Shea, *Black Dress*, 1983. Wood, felt, wax, india ink. 43 ¼ × 14 ½ × 12 ⅝ in. (109.9 × 36.8 × 32 cm)

succeeded on all three counts with *The Distaff Side*. Each of Smith's probable nonevents is a reality at The Granary. The exhibition is built from adventurous collections including artists from different generations and of many nationalities, those who are well known and those who are less so, those with international reputations and those known locally. These collections were created through the individual, independent visions of Melva Bucksbaum and Ray Learsy on their own and in conversation with each other. And while they include signal works of the 1970s, the collections delve decades back from that key era and many decades forward.

Through her curatorial eye and her perceptive and at times provocative installation groupings, Melva Bucksbaum critically explores the ongoing conversation between past and present, between artists, between artworks and those who tend them, and between exhibitions and their publics, notably placing the women at the forefront. A bold accomplishment in its own right, *The Distaff Side*—as well as the collections from which it is drawn—offers an example for galleries and museums to note and one that "we can only hope" (to borrow the words of Smith) to follow. ◉

Joan Simon is a writer, curator, and arts administrator who works independently for museums and publishers in the United States and Europe.

NOTES

1. Ryan Frank, e-mail correspondence with the author, October 9, 2013.
2. Clare Boothe Luce, *The Women*, rev. ed. (New York: Dramatists Play Service, 1995), 2. The 1939 movie based on Luce's play, with a screenplay by Anita Loos (and Jane Murfin, with uncredited writing by F. Scott Fitzgerald and Donald Ogden Stewart), was directed by George Cukor.

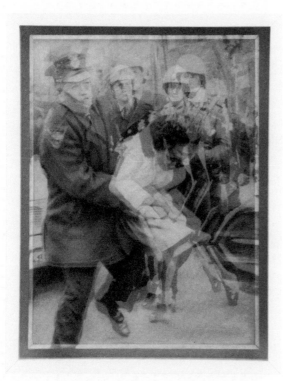

↑ Jacqueline Tarry and Bradley McCallum, *Negro Girl arrested,*
St. Louis, Illinois, August 12, 1963 (after uncredited photographer;
New York World-Telegraph & Sun Collection, Library of Congress),
2007. Oil on canvas and toner on silk. 14 ³/₈ × 16 in. (36.5 × 40.6 cm).
Exhibited in *Art of the Protest* at The Granary, April 2011–December
2012, curated by Ryan Frank and Caitlin Smith
→ Rosemarie Trockel, Untitled, 1987. Knitted wool. 50 ½ × 35 ½ in.
(128.3 × 90.2 cm). Exhibited at The Granary in *Not on Your List,*
November 2009–January 2011, and in *Cologne 1980s: A Tribute in*
Honor of Eleonore and Michael Stoffel, April 2011–December 2012,
both curated by Ray Learsy

3. These collaborative works are Carla Arocha and Stéphane
Schraenen's *Chris, Untitled (Crosses)* (2006; p. 85) and Inez van
Lamsweerde and Vinoodh Matadin's *Anastasia* (1994; p. 51).

4. Jane F. Gerhard, *The Dinner Party: Judy Chicago and the Power of*
Popular Feminism, 1970–2007 (Athens: University of Georgia
Press, 2013), 23.

5. As Gerhard writes of this protest by the Ad Hoc Women
Artists' Committee: "Their handout read 'THE WHITNEY
STAFF SUFFERS! GRAVELY! FROM ACUTE MYOPIA!
This show is more about the artists they couldn't see than about
the ones they have included.'" Ibid., 24.

6. Ibid. In 2010 Sarah Meller, an education assistant at the
Whitney, wrote, "The curators of this year's Biennial exhibi-
tion . . . did not choose the artists specifically on the basis of
gender or race, but 2010 is the first Biennial to include slightly
more female than male artists: twenty-nine women and twenty-
six men." Among the events in Meller's look at the history of
protests against the biennial, she notes the 1987 Guerrilla Girls
show, *The Guerrilla Girls Review the Whitney*, at the Clocktower,
which "protested the lack of representation of women art-
ists and artists of color in the Whitney's 1987 Biennial." Sarah
Meller, "The Biennial and Women Artists: A Look Back at Fem-
inist Protests at the Whitney," May 3, 2010, http://whitney.org
/Education/EducationBlog/BiennialAndWomenArtists.

7. Gerhard, *Dinner Party*, 24, 23.

8. Guerrilla Girls website, http://www.guerrillagirls.com.

9. "Guerrilla Girls Bare All" (interview), http://www.guerrilla
-girls.com/interview/. "When we tell the story, we usually add
the fact that at the 1984 demonstration in front of MoMA we
had an aha moment, and realized there had to be a more con-
temporary, media-savvy way to change people's minds about
the issue of discrimination in the art world, which led to the
idea to do street posters. It took us until the spring of 1985 to
call a meeting, name ourselves Guerrilla Girls, and pass the hat
around to pay for printing the first posters. In May of 1985 we
put them up on the streets of New York and all hell broke loose."
Käthe Kollwitz, e-mail correspondence with the author and
Flora Irving, October 16, 2013.

10. See Guerrilla Girls, "Posters/Actions," http://www.guer
rillagirls.com/posters/nakedthroughtheages.shtml.

11. Christopher Knight, "LACMA, MOCA Fall Behind in Giv-
ing Female Artists a Solo Platform," *Los Angeles Times*, July 11,
2013.

12. Ibid.

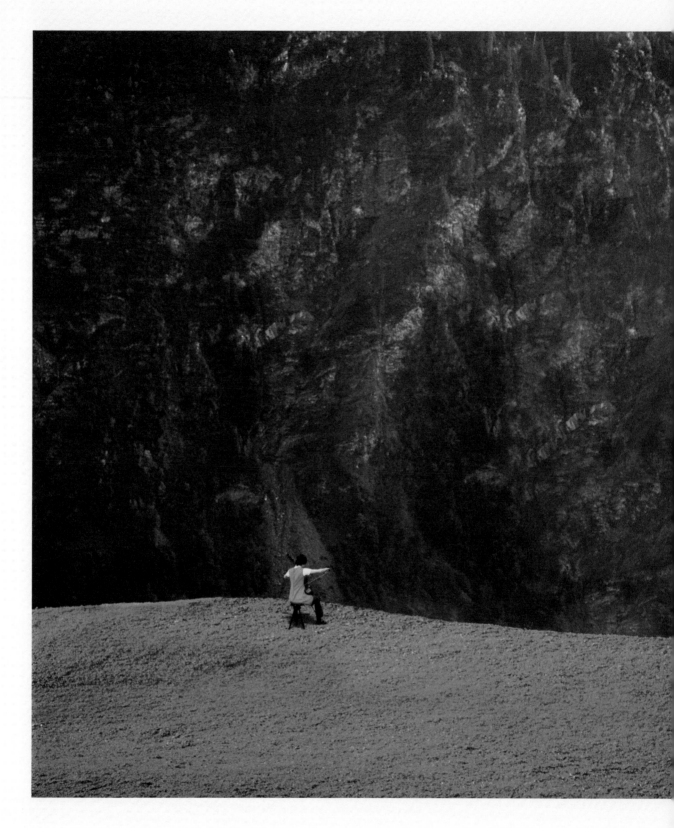

13. The Goetz show, international in scope and devoted to film and video works from the mid-1970s on, has as its stated goal to provide an overview of the development of feminist discourse since the 1970s.

14. Noun later wrote of the experience: "My ambition was to work in a museum print room but when I went back to Harvard to ask Professor [Paul] Sachs for help in finding a job, he just shook his head and commented, 'Why don't you just go home and get married.' He said it would be impossible to place me even as a volunteer. I was so humiliated by Sachs's attitude that it took years—in fact until the arrival of the current feminist movement—before I could even talk about it." Louise R. Noun, *Journey to Autonomy: A Memoir* (Ames: Iowa State University Press, 1990), 40. Noun's professional skills were recognized by Jim Demetrion during his tenure as director of the Des Moines Art Center. She helped to catalog the collection, organized an exhibition dedicated to Abestenia St. Leger Eberle, and wrote a history of the permanent collection. During my own time as interim director of and consultant for the Des Moines Art Center (1986–87), I learned much from Louise Noun, trustees Melva Bucksbaum and Jackie Blank, education director and assistant director Georgeann Kuhl, and former assistant director Peggy Patrick. It was also the opportunity to curate the first US Jenny Holzer museum show, *Jenny Holzer: Signs*, which subsequently traveled. Melva Bucksbaum, then president of the museum's board, photographed a Holzer work installed off-site at a local bar for the exhibition catalogue.

15. Knight, "LACMA, MOCA Fall Behind."

16. *Merriam-Webster's Collegiate Dictionary*, 11th ed., s.v. "curate."

17. Melva Bucksbaum, e-mail correspondence with the author, August 2013.

18. Carol Kino, "A Confidence Highlighted in Rhinestones," *New York Times*, April 7, 2009.

19. See the artist's website, http://jsteinkamp.com/html/body_kelley.htm.

20. Judith Hudson, "Mika Rottenberg" (interview), *Bomb*, no. 113 (Fall 2010), http://bombsite.com/issues/113/articles/3617.

21. Ibid.

Su-Mei Tse, *L'Echo*, 2003. Color photograph mounted on aluminum. 35 × 26 in. (88.9 × 66 cm). Exhibited in *Reflective Landscape*, April 2011–December 2012, curated by Ryan Frank

22. "Wealth of Hair Brings Riches to 'Seven Sutherland Sisters,'" Sideshow World, http://www.sideshowworld.com/13-TGOD/2010/Sutherland-Sisters-A1.html.

23. Ibid.

24. See "Mika Rottenberg," Frieze Foundation, http://www.friezefoundation.org/cartier/category/year_2006/.

25. Hudson, "Mika Rottenberg."

26. Ibid.

27. Ibid.

28. Although it is possible that the title *The Distaff Side* has been used for other contemporary art exhibitions, The Granary staff has not yet discovered one. (Any information that others might have would be welcome.) It was, however, used as the title of a 2006 exhibition about women printers: *The Distaff Side: Women as Printers from the Fifteenth Century to the Present Day* (St. Bride Foundation Library and Archive, London; Paul W. Nash, curator). The Distaff Side was also the name of a group of women involved in the book arts, including designers, bookbinders, and typographers. Among the publications from their Distaff Side imprint are *Bookmaking on the Distaff Side* (1937), *A Typographic Discourse for the Distaff Side of Printing, a Book by Ladies* (1937), and *Bertha S. Goudy: First Lady of Printing; Remembrances of the Distaff Side of the Village Press* (1958).

29. Elaine Reichek, "Feminist Artist Statement," Elizabeth A. Sackler Center for Feminist Art: Feminist Art Base; http://www.brooklynmuseum.org/eascfa/feminist_art_base/gallery/elaine_reichek.php.

30. Reichek, "Feminist Artist Statement."

31. Ibid.

32. Ann Goldstein, "Bring in the World," in *Barbara Kruger: Thinking of You* (Los Angeles: Museum of Contemporary Art; Cambridge, MA: MIT Press, 1999), 29.

33. Holzer, in Kiki Smith, "Jenny Holzer," *Interview*, April 2012, http://www.interviewmagazine.com/art/jenny-holzer/#_.

34. Many names have been restored to anonymous makers and to those in collaborative partnerships, whether in art history, architecture and design history, film history, or other fields. For example, Alice Guy Blaché's pioneering work as a director and head of production at Gaumont from 1895 to 1907 was long subsumed under the corporate name but is now becoming known. (The acquisition of Alice Guy Blaché's papers by the Museum of Modern Art—funded by Melva Bucksbaum and her daughter, Mary—has benefited many scholars and filmmakers.) Contemporary women jewelers have made a big impact in what was formerly a male-dominated profession. As Suzy Menkes writes: "Women now rule the world of fine jewelry. And it shows. There can never have been so many big bijoux in famous and storied houses, where females are the creative force in what used to be a mainly male profession." Suzy Menkes, Jewelry Designs by Women's Hands," *New York Times*, September 2, 2013. By comparison, recent articles have discussed how few women are working as automotive designers (Caitlin Kelly, "A Woman's Touch, Still a Rarity in Car Design," *New York Times*, October 29, 2013) or as orchestra conductors (Ellen McSweeney, "Alone at the Top: What Conductor Susanna Malkki's Success Means—and What It Doesn't," *New Music Box*, October 30, 2013, http://www.newmusicbox.org/articles/alone-at-the-top-what-conductor-susanna-malkkis-success-means-and-what-it-doesnt/).

35. See the interview with Elisabeth Sussman in this volume.

36. Jon Henley, "Photographer Philippe Vermès's Best Shot" (interview), *Guardian*, April 27, 2011.

37. Many of the artists mentioned here have works in *The Distaff Side* and have also been represented by different works in previous Granary exhibitions.

38. Roberta Smith, "Spanning Styles and the Globe: A Broad Selection of Noteworthy Art Exhibitions," *New York Times*, September 4, 2013.

Louise Bourgeois, *Ode à l'oubli*, 2004 (detail)

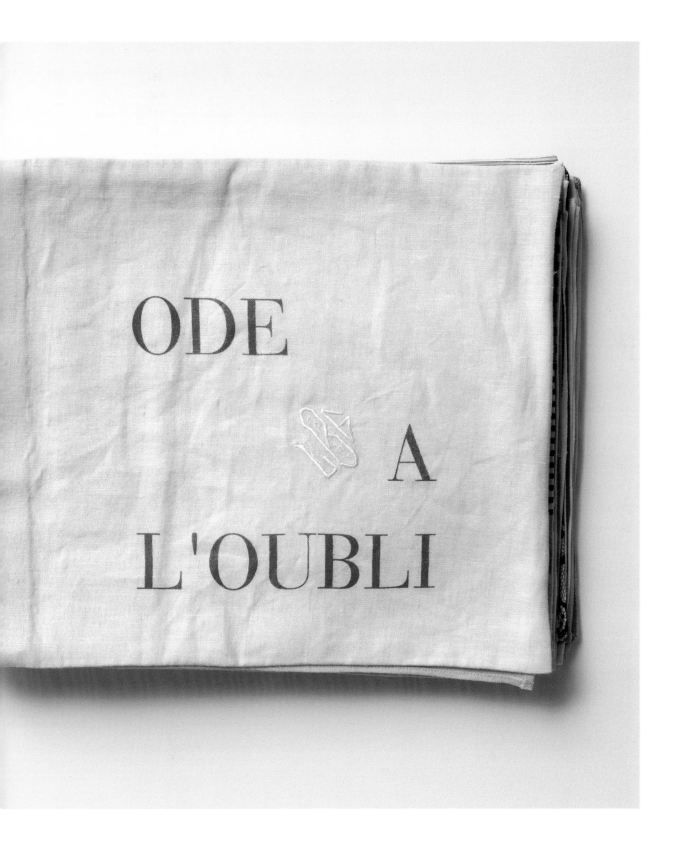

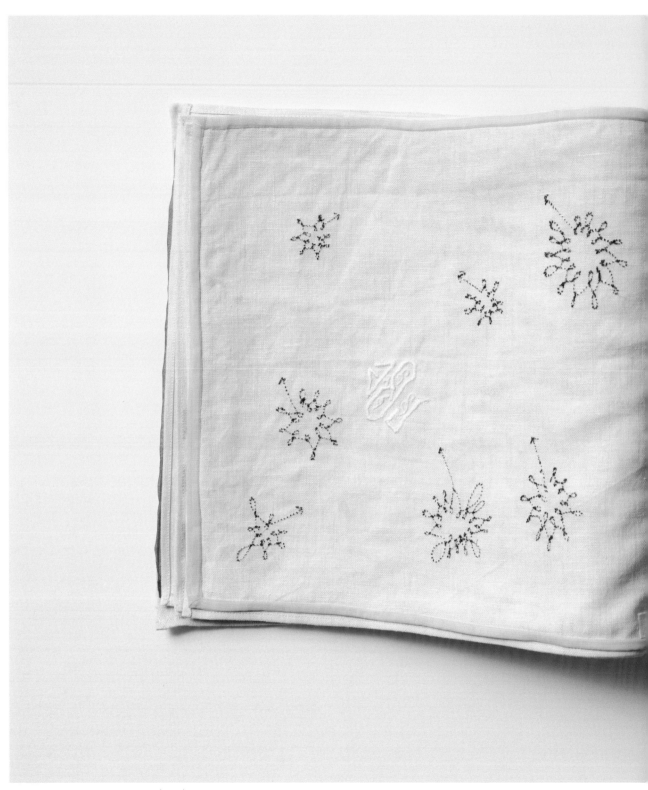

Louise Bourgeois, *Ode à l'oubli*, 2004 (detail)

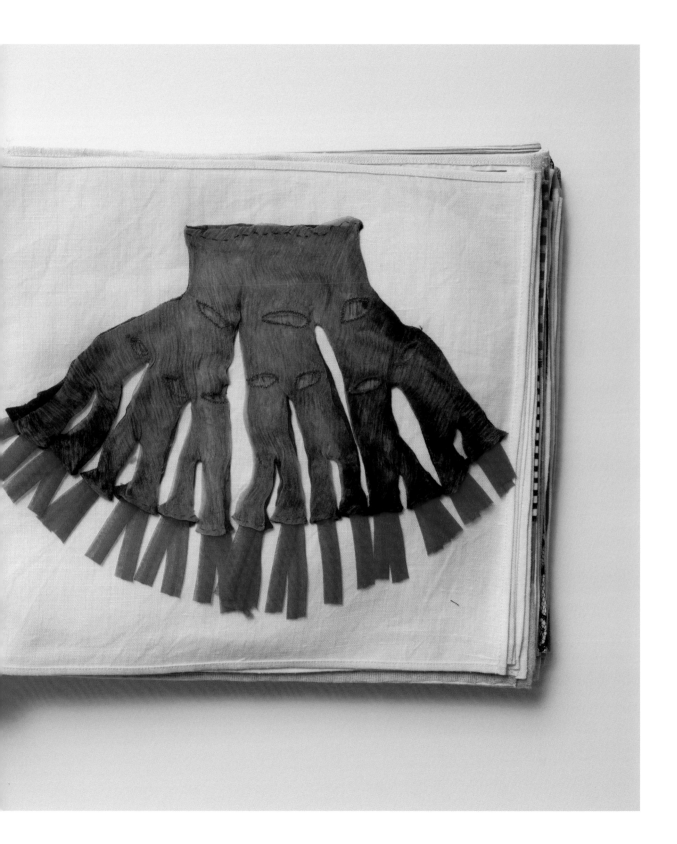

Louise Bourgeois, *Ode à l'oubli*, 2004 (detail)

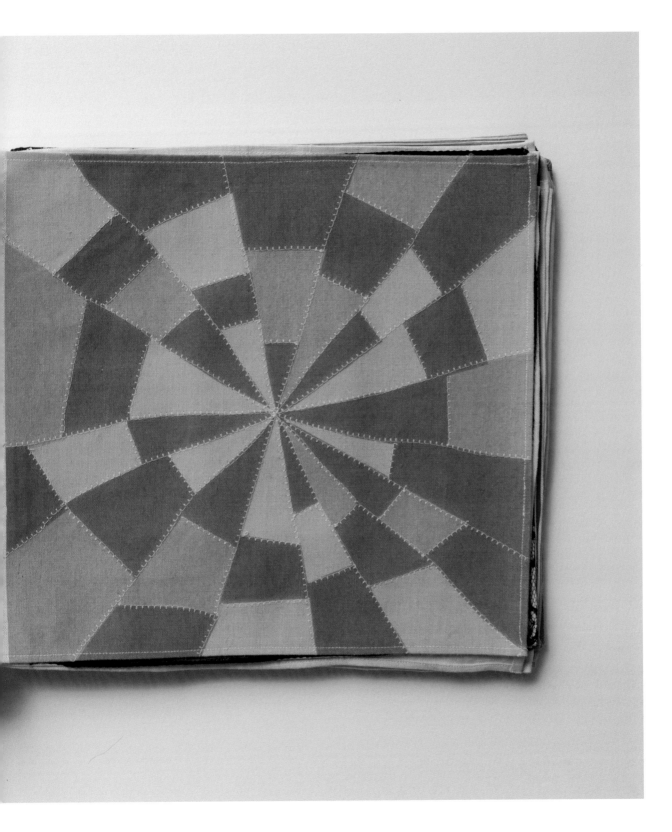

Louise Bourgeois, *Ode à l'oubli*, 2004 (detail)

Michele Oka Doner, *What Is White*, 2010 (details)

129

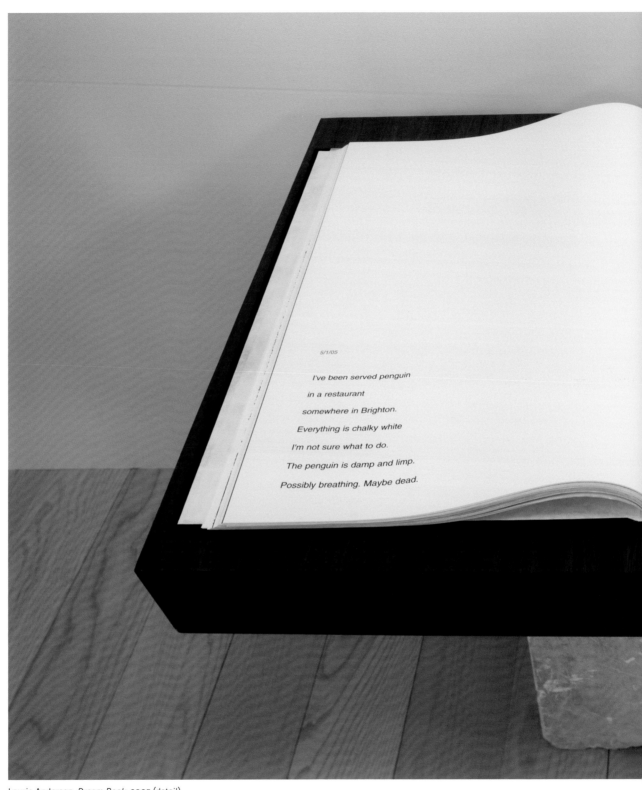

The text within the image reads:

5/1/05

I've been served penguin

in a restaurant

somewhere in Brighton.

Everything is chalky white

I'm not sure what to do.

The penguin is damp and limp.

Possibly breathing. Maybe dead.

Laurie Anderson, *Dream Book*, 2005 (detail)

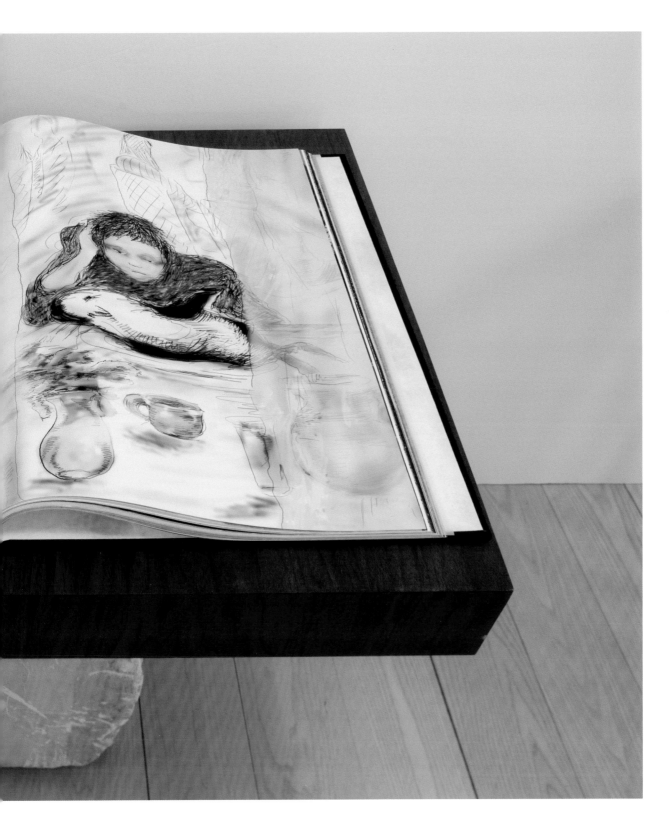

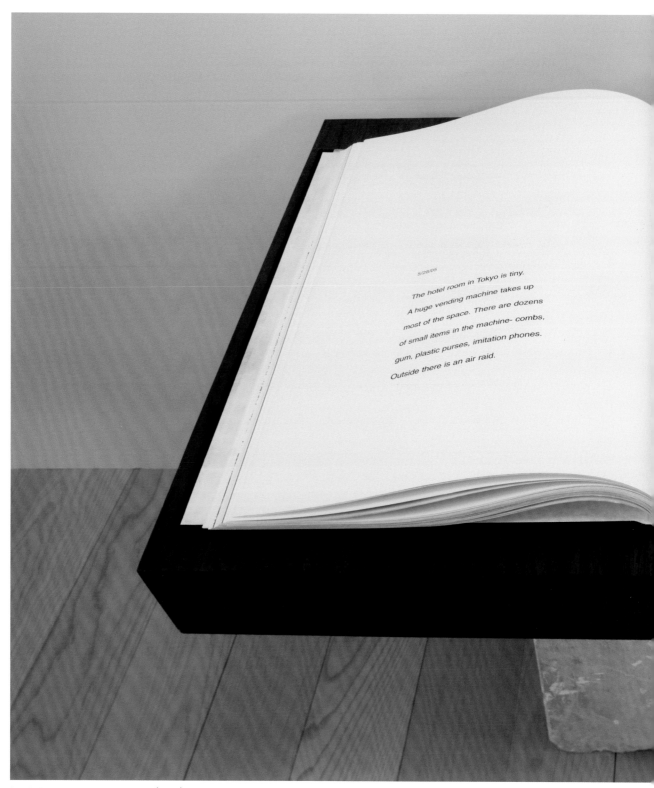

5/28/05

The hotel room in Tokyo is tiny.
A huge vending machine takes up
most of the space. There are dozens
of small items in the machine- combs,
gum, plastic purses, imitation phones.
Outside there is an air raid.

Laurie Anderson, *Dream Book*, 2005 (detail)

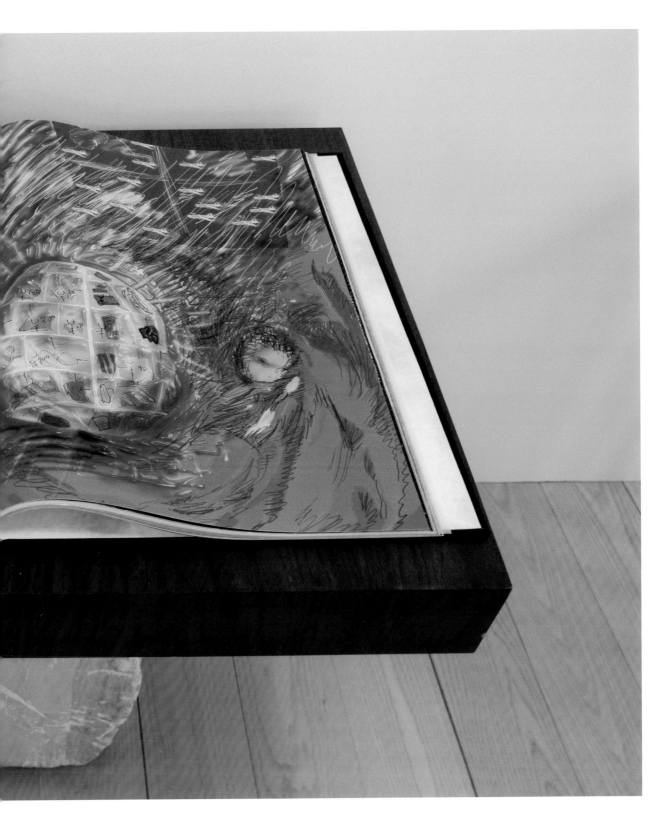

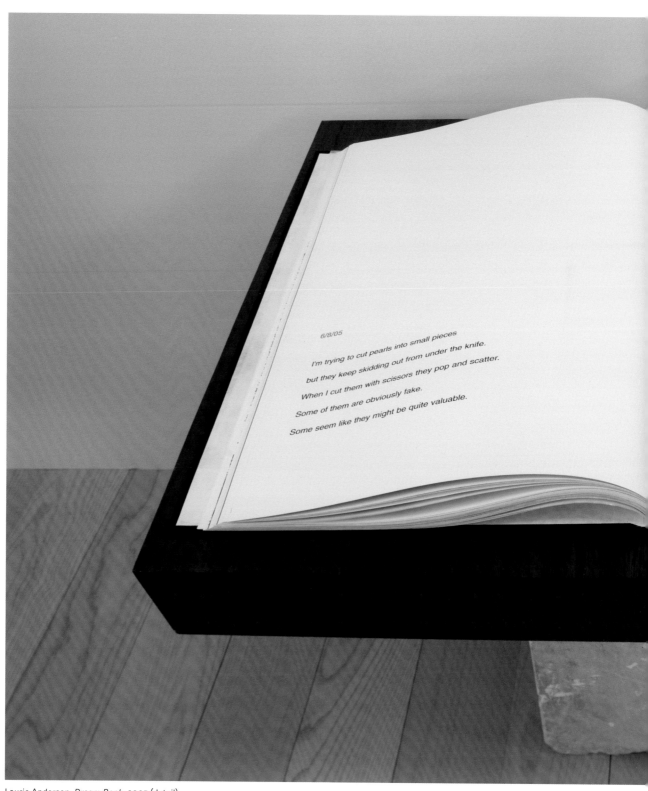

6/8/05

I'm trying to cut pearls into small pieces
but they keep skidding out from under the knife.
When I cut them with scissors they pop and scatter.
Some of them are obviously fake.
Some seem like they might be quite valuable.

Laurie Anderson, *Dream Book*, 2005 (detail)

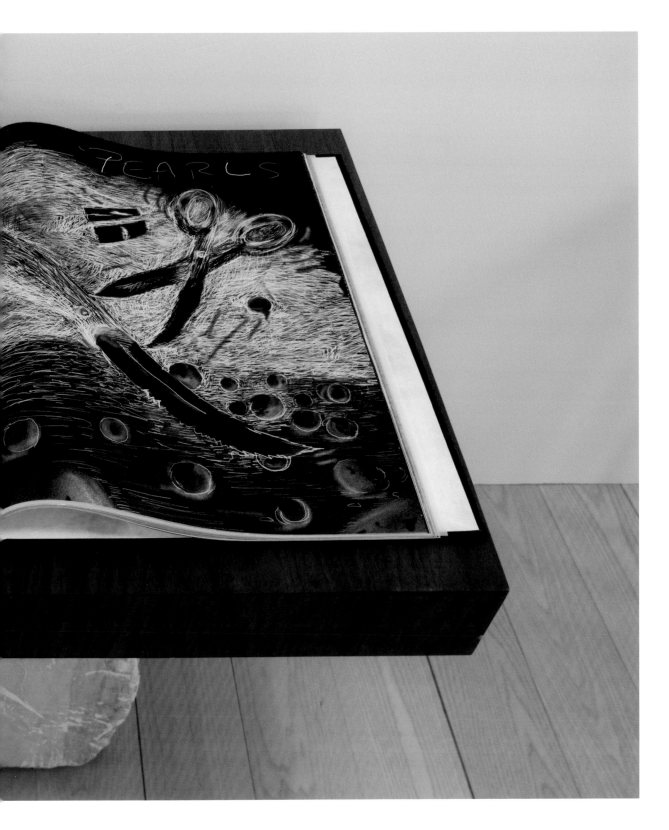

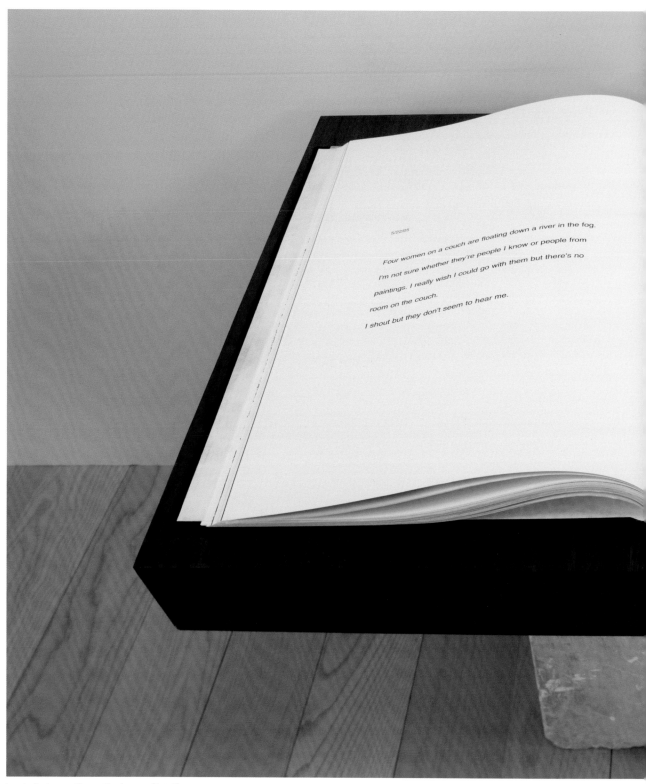

5/22/05

Four women on a couch are floating down a river in the fog.
I'm not sure whether they're people I know or people from
paintings. I really wish I could go with them but there's no
room on the couch.
I shout but they don't seem to hear me.

Laurie Anderson, *Dream Book*, 2005 (detail)

In Elisabeth Sussman's Conversation with Melva Bucksbaum of July 29, 2013, the collector discusses a lifelong engagement with the arts, from her childhood visits to the National Gallery to curating her first exhibition, *The Distaff Side*.

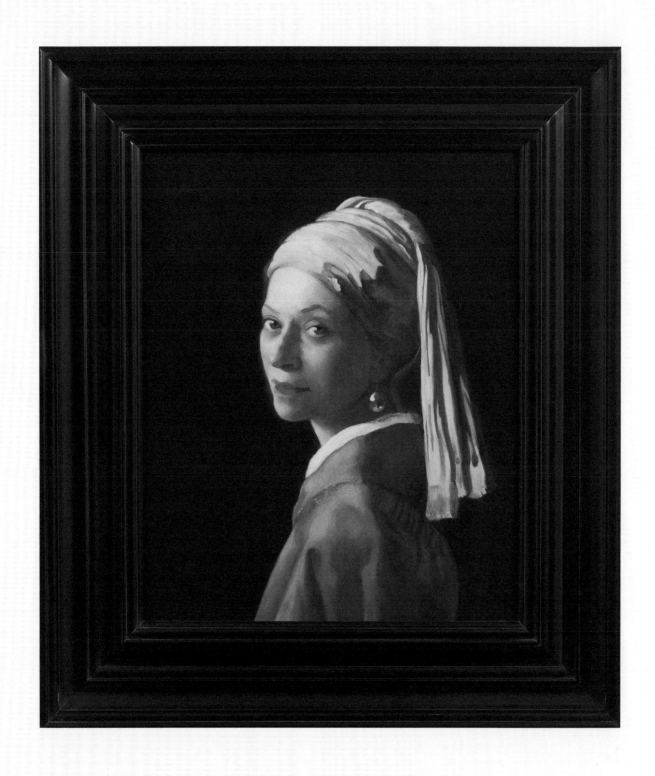

Kathleen Gilje, *Melva Bucksbaum as the Girl with the Pearl Earring*, 2010

E lisabeth Sussman: *The exhibition* The Distaff Side *is an event in your long history of involvement with art. Could you talk a bit about Washington, DC, where you grew up? I assume that as a young person you were interested in art because you have said that you went to museums all the time on your own.*

Melva Bucksbaum: I did, and in those days when you were eight years old you could take the bus downtown and go anyplace, and no one ever bothered you. Your parents weren't worried about you, and you just put a nickel on the bus, wandered around the monuments and the museums, put another nickel on the bus, and you came back home again.

ES: *But not everyone went to museums!*

MB: No, but I did. And I always had collections—whether it was storybook dolls or glass animals or whatever it was—I was always collecting something. Later in life I began collecting the real stuff.

ES: *Is there anything about that period in Washington that made a particular impression on you?*

MB: Yes, it was when the National Gallery was being built. It was such a beautiful building, and it was almost an escape mechanism for me to go downtown and go into this beautiful building and just look at the art and the fountains and the fantasy of it all. I didn't grow up in a wealthy home, so this was a magical place for me. We always called it the Mellon.

ES: *The National Gallery of Art was dedicated on March 17, 1941.[1] It had the grand Mellon collection. There were old masters. There was really not much interest in contemporary art at all at that time, as I understand it.*

MB: It was not contemporary until much later.

ES: *The greatest things have been bought for the National Gallery, so you were seeing wonderful things.*

MB: Exquisite. The impressionists. It went through the history of art, and it was wonderful. Raphael's *Saint George and the Dragon* [ca. 1504–6] was always a favorite of mine, plus Manet's *Masked Ball at the Opera* [1873].

ES: *You talked about going to the Phillips Collection and seeing the great Renoir. At the Phillips Collection your interest in impressionism must have developed more, and you would have seen more modern art.*

MB: The Phillips was, of course, a very different place. And it wasn't as easy for me to get to as the National Gallery was, but I managed to get there. Whenever I'm in Washington, I like to go back to the Phillips Collection and visit Renoir's *Luncheon of the Boating Party* [1880–81; right]. It's one of my favorite paintings. The piece is so engaging and immersive—every time I stand in front of it I feel as though I'm a guest at the party.

ES: *At that time the Phillips Collection must have had things like Mark Tobey and some abstract painting as well.*

MB: They did, and it was in the old house. They hadn't put the addition on yet, so it was in the Phillips's house.

ES: *Do you remember as a younger person going to New York and seeing modern art there?*

MB: No, not at all.

ES: *Washington was really where you saw things. We can talk about Des Moines next, but was there anything important in terms of art between the time you lived in Washington and the time you lived in Des Moines that we should speak about?*

MB: There was a period of time in my twenties when I thought I wanted to be an artist. I was taking art lessons until I realized that my hand didn't do what the head wanted it to do [*laughs*]. I really

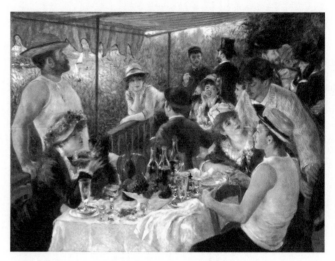

Pierre-Auguste Renoir, *Luncheon of the Boating Party* [*Le Déjeuner des canotiers*], 1880–81. Oil on canvas. 51¼ × 69⅛ in. (130.2 × 175.6 cm). The Phillips Collection, Washington, D.C.

wanted to be able to draw and to paint, but it was always too tight, I could never loosen up. Even when I moved to Iowa in 1967, I took painting lessons and art lessons. When I would compare my work to that of other people in my class who were so much better than I was, I could see how mine was so tight and stiff and theirs was loose, lyrical, and beautiful. I said to myself, "Okay, give this up [*laughs*]. It's a lost cause."

ES: *But you kept at it a little bit?*
MB: I did, I did. Members of my family still have some of my paintings that are really—you know, they're student paintings, but they're not bad. What I really liked best of all were the pen-and-ink drawings. Maybe because they were so tight I could do them in small pieces, and that's what I liked doing best.

ES: *Let's talk about Des Moines. You moved there because you married Martin Bucksbaum.*
MB: Right.

ES: *I've been to Des Moines, but I bet a lot of people haven't. The town itself made a big impression on me. It was so green and beautiful.*
MB: When were you there?

ES: *When I was working on Eva Hesse, so the nineties.*
MB: It's changed a lot since then because there was a Des Moines Vision Plan, which I worked on with Skidmore, Owings and Merrill, and Mario Gandelsonas and Diana Agrest—their firm is called Agrest and Gandelsonas Architects. Because of the plan, all of downtown Des Moines has changed dramatically for the better, and it's really quite spectacular. When I first moved to Des Moines, I said, "Well, I'll go to the art center one day and see what they have." My jaw just dropped. The collection was so exquisitely beautiful: every

piece there, almost every piece, was a masterpiece that had been chosen by the DMAC's directors. It was always their goal to pick the best piece by any particular artist they were going to collect.

Of course, the DMAC architecture is also a collection. First there was the Eliel Saarinen building, which nestles right on the top of this little knoll on Grand Avenue in Greenwood Park. At the time I moved to Des Moines, they were just beginning to build the I. M. Pei building behind the Saarinen. Later the Richard Meier building was added.[2] The Des Moines Art Center now has three great buildings, from the forties, the sixties, and the eighties. Not bad for a little town.

ES: *It's like three connected masterpieces.*
MB: Yes, they blend very well into the landscape. It was always interesting to me when architecture students came from other towns and other places to see the buildings—they were always all over the Saarinen building. They were checking out *everything* in the Saarinen building.

ES: *I don't know anything about the directors before James [Jim] Demetrion. Did you know them before?*
MB: No. Jim came about the time that I came, and he was my mentor in art.

ES: *You were saying that Jim would collect only the best work by an artist. But he had very catholic taste; he didn't always toe the party line.*
MB: The Francis Bacon "Pope" painting in the Des Moines Art Center's collection [*Study after Velásquez's Portrait of Pope Innocent X* (1953)] is the best of that series. Other museums often wanted it for their exhibitions, and it seemed as if was always out on loan. The Giacometti sculpture *Man Pointing* [1947] is an incredible piece of art. When Jim bought those works, he was raked over the coals by the press. They would say, "He spent *that*

amount of money on *this*?" And of course these were masterpieces when he bought them, and they are masterpieces now.

ES: *But tough, I mean, to convince the community that these pieces were worth the expense. That must have been amazing.*
MB: He bought a Dubuffet, *The Villager with Close-Cropped Hair* [1947], and a Philip Guston, *Friend— To M.F.* [1978]. Jim was amazing. He knew how to do it, and he's a very humble man. What I mean is that, as important as he is and was in the art world, he doesn't think of himself that way. He knows what he's done and what he's accomplished, but he's not full of himself, and through his vision people started collecting in Des Moines. There were a few collectors—Dorothy Schramm, who lived in Burlington, Iowa, had a great modernist collection, plus Watson Powell, head of American Republic Insurance Company, whose Skidmore, Owings and Merrill building was filled with seventies contemporary art.

Jim Demetrion started putting together selling shows, which you couldn't do today, shows at the museum where you could buy the pieces of art from the exhibition. We all bought something from these shows, which helped us begin collecting. This person started collecting, and then that person started collecting. John Pappajohn did, my husband and I did, and the shows just started many people collecting good contemporary art. Mary and John Pappajohn are the city's major collectors and philanthropists. Their amazing Pappajohn Sculpture Park opened in September 2009. Plus there was Louise Noun, whose insightful collection of art by women was donated to the DMAC on her death.

ES: *So that was the moment when you saw yourself as someone who bought art, although maybe you hadn't thought of yourself as a collector.*

MB: We just bought art to hang on walls. My husband, Martin, was not very adventurous in contemporary art, to say the least. He was most conservative, and he depended on me to choose the art, along with Richard Feigen, the art dealer. We bought Dubuffets and some impressionist works, plus James Rosenquist and a Lichtenstein sculpture, which was a step into the contemporary world.

ES: *How did your interest change? Did James Demetrion keep up with what was going on? Would he show work by living artists?*
MB: He did at the Art Center. And when he left Des Moines in 1984, after serving as the Art Center's director for fourteen years, to become the director of the Hirshhorn, he continued to show work by living artists. My own interest in collecting the work of living artists shifted in the mid-1990s, after Martin died, to collecting minimal art.

ES: *Did you support Demetrion's program when he was the Des Moines Art Center's director? What did you do to help him or to help the Art Center at that point?*
MB: We had a group called the Members Council that did all the entertaining, fund-raising, and ancillary support for the Art Center. I was president of the Members Council for a while and then joined the board of trustees and became president of the board. This was volunteer work but hands-on. We put a lot of time into making the Art Center work, and it was the place to be.

ES: *Let's fold Aspen into that, because you said you went there in 1968.*
MB: I moved to Des Moines at the end of 1967, and in the summer of 1968 my sister-in-law and brother-in-law, Kay and Matthew Bucksbaum, invited us to come out to Aspen, where they had rented a place for years and where they've since

built houses. We started visiting in the summer and then started going there in the winter, so I've been going to Aspen for more than forty years. There wasn't such a big art community at the beginning, even though the Aspen Art Museum and the Anderson Ranch were very popular and both attracted artists over the years. There weren't many collectors then, and there was one gallery, the Joanne Lyon Gallery. Over time it became more and more of an art community. Now I think half the members of the Whitney National Committee have houses in Aspen and keep part of their art collections there.

ES: *That wasn't the case when you first went there?*
MB: That's happened in the last twenty years, but I've been going there for so long, and I gradually watched it change. I never wanted to hang contemporary art in Aspen since I wanted to show Native American craft. I had a huge collection of cornhusk bags that the Nez Percé Plateau Indians made and a collection of Plains Indian parfleche carriers. Because some of my smaller contemporary art pieces fit in well with the cornhusk bags, I mixed them together. That started changing little by little, and then when Harley Baldwin opened the Baldwin Gallery, it was easy to buy good contemporary art in Aspen, so I began introducing contemporary art into the Aspen house.

ES: *And other people moved in who must have had wonderful art too?*
MB: They started moving in, and it became a large art community. And suddenly it seemed as though some of the top collectors in the country had purchased homes in Aspen. The Aspen Art Museum's annual ArtCrush benefit brings in the crème de la crème of the art world. And now the museum is constructing a new building, designed by Shigeru Ban. And let's not forget the Aspen Institute,

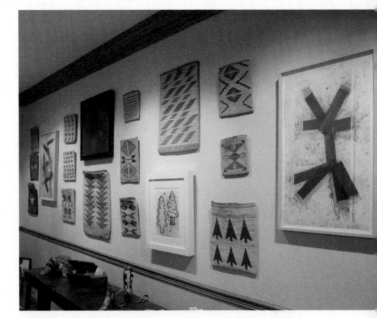

Installation of Nez Percé cornhusk bags alongside works by Joel Shapiro and other contemporary artists in Melva Bucksbaum's home in Aspen, Colorado

which has a pivotal collection of Herbert Bayer's works and a summer residency program.

ES: *Did you socialize with artists?*
MB: Yes, we had dinners for artists all the time. They'd be at the Anderson Ranch, and we'd go there to see the work they were producing. They were creating excellent work, and occasionally we would buy. Several years ago at the ranch they honored George Condo, and he did a series of charcoal drawings on panel. My daughter, Mary, and I bought the entire set, and now they are here at The Granary. Artists were always visiting Des Moines and Aspen. After Jim Demetrion left the Des Moines Art Center and Julia Brown Turrell [who was married to the artist James Turrell at the time] became director, we had visiting artists who were the Turrells' friends.

ES: *I met you in the early nineties, just before your husband, Martin, died and when you were on the National Committee of the Whitney. During that period were you dividing your time between Des Moines and New York?*
MB: Martin and I had kept an apartment in New York for years. But after he died, I wasn't spending much time in Des Moines. I was spending more time in New York and in Aspen. He died in '95, and I bought a new apartment in New York at the end of '95 or the beginning of '96 and I bought the Aspen house then also. My daughter, Mary, and I shared a house, but later I sold my interest to her and bought another house in '97. At that time I became a resident of Colorado, and I'm still a Colorado resident.

ES: *Did these moves to new places initiate new stages of collecting? It sounds like it did, with your interest in minimalism.*
MB: It did. As I said before, after Martin died, I began collecting minimalist work, which I really, really loved. And then I met Ray [*laughs*].

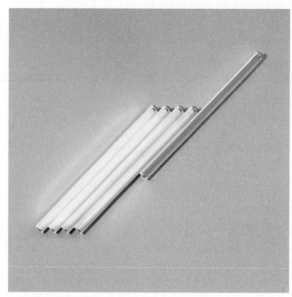

Dan Flavin, *Untitled (for Fredericka and Ian) 1*, 1987. Pink and red fluorescent light. Overall: 79 ¾ × 13 ½ × 3 ⅝ in. (202.6 × 34.3 × 9.2 cm); length (diagonal): 72 in. (182.9 cm). Whitney Museum of American Art, New York; gift of Melva Bucksbaum

Robert Ryman, *Area*, 1994. Oil and Enamelac on boxboard. 25 × 25 in. (63.5 × 63.5 cm)

ES: *Right, right.*

MB: And I had to do a whole one-eighty.

ES: *Let's talk about that interest in minimalism, because you didn't give it up.*

MB: No, no.

ES: *That was the first real personal love. You had collected significant work with your husband, Martin, but it sounds like your interest in and collecting of minimalism was all yours.*

MB: It wasn't very extensive—Robert Ryman [left], a couple of Agnes Martins [p. 14], Robert Mangold, and Dan Flavin [left]. I thought of the Jeff Koons mirror piece of a basket of flowers that I had hanging in my hall in New York as minimal, although others wouldn't usually think of his work in that way. I wasn't a major collector. I was filling up wall space, but I wanted good art to fill up the wall space.

ES: *Did you discover work on your own in galleries, or did you work with advisers?*

MB: There were certain people I trusted in the art world, like Douglas Baxter—when he was at Paula Cooper and then when he moved to Pace—and a few other people. I went and talked to them. But I looked at the art and decided myself what I wanted to buy. David Ross was also a help when he was director of the Whitney.

ES: *So then, as you say, along came Ray [both laugh]. . . . How would you describe the differences between you and Ray as collectors?*

MB: I was collecting art to hang on my walls, but Ray is really a collector's collector. He buys because he does his legwork. As he likes to say, he uses up a lot of shoe leather going to the galleries all the time, looking and searching. And he has a great eye. When I first went to his loft, I was like,

"Wow!" It took a year after we started going together for me to shift from historic minimalism of the sixties into contemporary art of the nineties.

ES: *Really?*

MB: Yes. I worked at learning about contemporary art with Ray that first year and then slowly and gradually came into it and could recognize many artists I hadn't known before. Ray helped me to understand contemporary art.

ES: *And did you give up collecting minimal work, or is that something that you still think about?*

MB: I still have a few pieces, but no, I never carried that collecting further. It was a brief interlude.

ES: *Work from your collection, Ray's collection, and your shared collection is included in* The Distaff Side, *which opened in April 2013. I looked up the word* distaff *in a big dictionary that I have, and it is a wonderful word. According to my dictionary, it refers to a staff used to hold wool or flax used in spinning, but it's come to mean "woman's work or domain." It's a very old term. I'm curious about how this word came to you.*

MB: Well, for a long time I had wanted to do a show of all art by women from our collection. At one point I noticed that several museums, galleries, and auction houses were having exhibitions of artwork by women at the same time, and I thought, "We've got this in the works, and we just have to find a different name for it, something edgy." There is a Scottish author I like, Alexander McCall Smith, and he said one day on Facebook, "Let's bring up old words we haven't used in a long time." The word *distaff* was used quite a bit when I was growing up to refer to the distaff side of a workplace, distaff in the military—the female part. I said, "I'm going to call it 'distaff.'" Ray said, "How about 'The Distaff Side'?" That's how we came up with the name.

ES: *As far as I know, it's never been used to describe any exhibition of contemporary art by women, so it's going to stand alone, I think, just from the title.*

MB: [*Laughs.*] I hope so!

ES: *You were telling me before that many people don't even understand it when they see the title* The Distaff Side. *They have to ask you what it means.*

MB: Many people who came to the opening in April said, "Oh, I had to look up that word to see what it meant." Ray and I were recently at a Shabbat dinner in Aspen, and part of the Bible reading at dinner was about women and the distaff, and Ray and I just looked at each other with our mouths dropping open. [*Elisabeth laughs.*] Because it was her spinning and her fingers twirling the distaff, so we found that very interesting.

ES: *But it's fallen out of most people's vocabulary.*

MB: Yes.

ES: *It stood for a lot of things when you were growing up, none of them necessarily involved with what we might call craft or art.*

MB: No, it always had to do with the women's side of a family, the women's side of an office, what the women did. It never had to do with art and craft. I just liked it because it was a word that many people weren't going to know—well, actually, I didn't think that many people wouldn't know what it meant. I thought people would know what it was and I was surprised that they didn't.

ES: *I'm sort of surprised too, because it's a word I've heard but without knowing precisely what it meant. I knew the meaning as you knew it, you know, that it stood for women, but I didn't know what a distaff was. And what do you make of that, now that you know what a distaff is?*

MB: I have no idea what to make of it. Well, it ties in with Elaine Reichek's work, of course. I thought

that was interesting, and I wanted to keep my reference to the way I had always thought of it fresh in my head.

ES: *As a collector you never set out just to collect the work of women. Is this true?*

MB: Yes. But I was influenced by my old friend from Des Moines who's now gone, Louise Noun, who put together a wonderful collection of art by women. It was so smart, so daring and adventurous of Louise to do that. She had Eva Hesse, Natalia Goncharova, and on and on and on. It was never in my mind just to collect art by women. I always looked at the art for its own merit, but when I realized how much art by women we had in the collection, I wanted to do a show.

ES: *When I met you in the early nineties, I thought that you would like Elaine Reichek's work, and I remember having no hesitancy in telling you about it. There must have been something about your thinking at that time that made it clear that you'd be interested in such work.*

MB: I remember very clearly the day that you took me to see Elaine. She put everything out on the floor, and I was absolutely intrigued by her work. I was in the midst of furnishing the Aspen house at the time, and I wanted that work for that house. Most of it is still there, but we'll be bringing it back eventually. I fell so in love with what she had done, with all that intensive detailed work that she did by hand so carefully and meticulously, with the intellectual process behind her choice of subjects, and with the fact that it involved the "women's work" of embroidery. I was hooked.

ES: *I'd like to know more about how you went about curating* The Distaff Side *because the separate collections that you and Ray have are much, much larger than what is represented in the exhibition. How did you go about creating this exhibition once you had decided that you wanted to do it?*

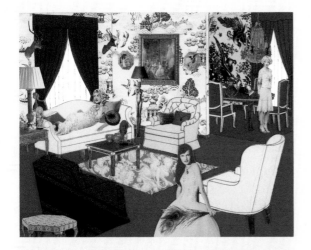

Three prints from Laurie Simmons's series *The Instant Decorator* (2001–4): (from top) *The Instant Decorator (Red, White and Blue Room)* (2002); *The Instant Decorator (Sun Room)* (2001); and *The Instant Decorator (Coral Room with Fireplace)* (2002)

MB: Ryan Frank and I started over a year ago. We sat down and went through the database. We checked off every work of art in the database by a woman. And then we went back, and I said, "Well, these are the must-haves, and these are maybes, and these are significant pieces that we have shown before, so we won't do that again." So that's how we did it. And then we started pulling the pieces out of storage and putting them up against the wall and seeing what fit and what didn't, and then we'd hang, and I'd say: "Yes, that piece goes there. No, that piece doesn't go there." A lot of help came from Tom Zoufaly.

ES: *What does he do?*

MB: Tom does the installation, and he has a great eye for hanging art. He's installed artwork for me and for Ray for many years, and we knew early on that we wanted him involved in The Granary. We tried to tie pieces together. There happen to be two pieces now in the main room that quietly make a connection: one is the Vanessa Beecroft photograph of sailors aboard a ship [*The Silent Service: Intrepid, New York* (2000; pp. 56–57)], and the other one is a photograph by Vera Lutter [*San Marco, Venice XIX: December 1, 2005* (2005; pp. 52–53)]. Those two are hanging together, but what most people might not realize is that Venice was the largest shipbuilding city in the world at one time. At the Arsenale, they could build a ship in one day. Those two photographs represent the Old World navy and New World navy.

ES: [*Laughs.*] *And so that bit of knowledge came to you, but people won't necessarily get that.*

MB: No, no, they won't necessarily get it. Unless we explain it to them. And then there's the connection between the Ena Swansea [*Identity* (2006; pp. 58–59)] and the Rosa Loy [*Das Essen* (2008; p. 31)]. In the Rosa Loy piece the redhead at the top

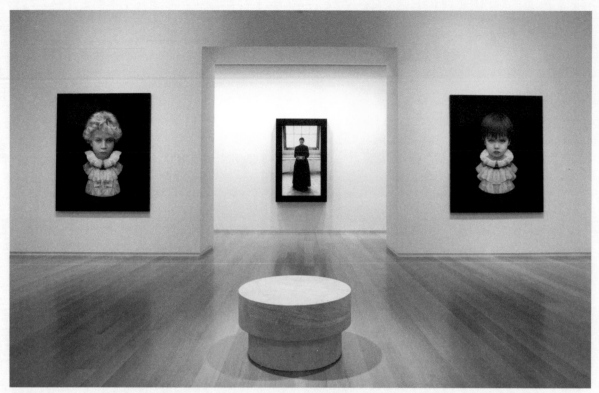

Installation view of *The Distaff Side* with (from left) Adriana Duque's *Daniel* (2010); Jenny Holzer's *Turn Soft* (2011); Marina Abramović's *The Kitchen V, Carrying the Milk* (2009); and Adriana Duque's *Felipe* (2010)

left is Ena Swansea, and she's looking at her piece that's hanging to the right.

ES: *Oh, that's great. If those things hadn't looked right together, you wouldn't have hung them together, but these things happen when you curate, and that's what makes it a wonderful activity, I think. So is this the first exhibition that you've worked on for The Granary?*

MB: Yes, it is. Ray's done the others; this is my only one and my first experience curating.

ES: *So your hanging experience comes from hanging art in your own places, where you live with it.*

MB: Yes, and having a sense of what works and what doesn't. In this exhibition there are, for me, two aha moments. One of them is in the large ground-floor gallery [above]. The two Adriana Duque photographs are placed on either side of an opening to another gallery, and centered in front of them is a Jenny Holzer table [*Turn Soft* (2011)]. On the same axis as the Holzer, visible through the opening and framed by the Duque pieces, is the Marina Abramović [*The Kitchen V, Carrying the Milk* (2009)]. And to me those four pieces are like, pow! I just love the way it works. Adriana is a photographer from Colombia, and these two works are part of a series that she did in 2010. They are titled *Daniel* and *Felipe*, and they're boys with very pale faces and white ruffs around their necks. That part of the installation is such a beautiful moment to me. Maybe it's because I like black and white so much and this is all black and white. Plus, the thrill for me is to have an almost unknown artist with two stars like Marina and Jenny.

Mika Rottenberg, *Cheese*, 2008 (interior view)

ES: *When something does that to you, and it engraves itself on your memory like that, chances are that everybody coming to the exhibition feels the same way.*

MB: I had collectors calling me asking who those two photographs were by because they weren't familiar with the artist.

ES: *Can you tell me about your affinity for black and white?*

MB: It just always seems to be that way when I'm choosing things. I don't live with color very well, even though we have a purple living room here in Sharon [*laughs*]. And I don't like beige very much, so my tendency is to go to black and white, and that's why this particular area of the exhibition appeals to me so much. It's crisp and neat and tidy.

ES: *You see so many exhibitions in museums and galleries. You must have strong opinions on how things look or how*

you like them to look. All that experience of looking must have come into play when you hung your own exhibition.

MB: It did. As we selected the works of art and started putting them on the floor, it was really a pick-and-choose process because I'm a novice, a complete novice. But I knew what I wanted this show to look like. I knew I wanted the Mika Rottenberg [*Cheese* (2008; pp. 68–79)] in the main gallery.

ES: *It was in the 2008 Whitney Biennial.*

MB: Yes. It's just wonderful. People just love it, so I knew I wanted that. That was going to be a knockout piece. The reaction would be: "Wow! Look at that, and it's in a private collection up here in Connecticut." Many of our friends here don't see much installation art like Mika's, so it will be very interesting for them to see this large

installation. I remember when Mika was here she wanted to move one area, and I said: "Mika, if you do that, you will take up a whole wall of exhibition space. I can't allow that, no." [*Elisabeth laughs.*] And so I wouldn't let her install it exactly the way she wanted it, and she was okay. I said, "I can't take that much wall space away from other artists."

ES: *Did you do a plan on paper before you actually put the work in the space?*
MB: No! [*Laughs.*]

ES: *Aha! You just brought it all out . . .*
MB: . . . and started putting it around. We knew what we wanted to go up on the second floor, we kind of knew what we wanted to be on the first floor, and there's one gallery space—the back gallery—which Ray has always hung salon style, floor to ceiling, and I knew I wanted it to be more minimal. I wanted the Shinique Smith [*the step and the walk* (2010; p. 17)]; I wanted the Carla Arocha [*Chris, Untitled (Crosses)* (2006; p. 85)] and the Jorinde Voigt [*Botanic Code—M. M. Gryshko National Botanical Garden, Kiev (August 2010)* (2010; p. 16)]. When the pieces were in place, this room was another aha moment for me.

ES: *And you knew that from the beginning?*
MB: I knew I wanted the Shinique Smith pieces. When I bought them, I fell in love with them.

ES: *They're beautiful.*
MB: A gallery had sent me a JPEG. I went to see them and thought, "Okay, that's it." The Carla Klein [*Untitled* (2005; pp. 86–87)] is also in that gallery, and there is Katy Schimert [*Female Torso* (2001; p. 82)], Roni Horn [*Key and Cue, No. 1755* (1996; p. 86)], and Rachel Whiteread's *Daybed* (1999; pp. 84). Just seven artists are exhibited there; it provides a calming tone for the visitor.

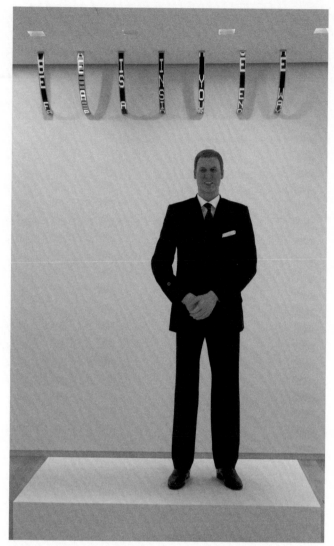

Installation view of *The Distaff Side* with Jenny Holzer's *Stripes* (2007) and Jennifer Rubell's '*Engagement (with Prince William sculpted by Daniel Druet)*' (2011)

ES: *So you had that in your mind's eye?*
MB: Yes.

ES: *Were there any changes that you hadn't anticipated?*
MB: Yes. There was one Annette Messager work that I wanted to hang, and we just couldn't find a place for it. Then Caitlin found another work in the collection by Messager, *Mes ouvrages de broderies* [1988; p. 165], and we hung that instead.

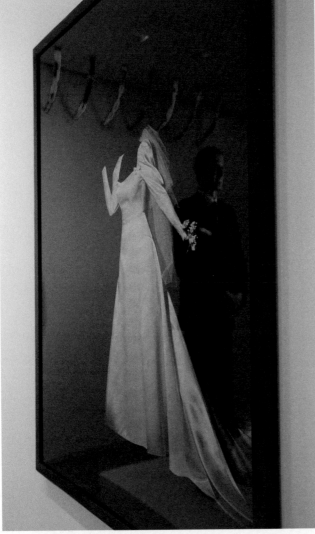

Installation view of Sarah Charlesworth's *Bride* (1983–84) reflecting Jenny Holzer's *Stripes* (2007) and Jennifer Rubell's '*Engagement (with Prince William sculpted by Daniel Druet)*' (2011)

ES: *Were you able to use most of the things that you had checked and whittled down with Ryan? Most of them ended up in the exhibition?*

MB: We were, although some pieces didn't make it in. We found out that one work that I particularly liked was by a man. [*Laughs.*] Of course it was removed. Since our exhibitions stay up for a long time, I may do some tweaking. There are many works not shown that deserve to be.

ES: *I see.*

MB: We bought one piece very late, as the exhibition was going up, an E. V. Day cast-aluminum piece [*Water Lily III* (2012)]. We also support local artists, and we wanted to include their work in the show as well.

ES: *So you pretty much got into the exhibition everything you planned to?*

MB: Almost. We had larger pieces by some very important artists. We used a small piece by Pat Steir [*Chrysanthemum* (1982)] because some of her larger pieces had already been in a couple of the shows that Ray had done. In the entryway is a Sarah Charlesworth [*Bride* (1983–84; p. 90)], and when she walked in the day of the opening, she just gasped that her piece was right there in the entryway and had a big smile across her face. That's how I will always remember Sarah. Her recent passing is a tragic loss to her family, friends, and the art world.

ES: *You knew Sarah, and you know many of the artists that you've mentioned. Maybe there are some that you don't know. I'm sure there are people you haven't had the chance to meet, like Shinique Smith. Have you met her?*

MB: Yes, I have met Shinique. But I don't know Paulina Ołowska, Adriana Duque, or Ruby Neri.

ES: *I bring that up only a propos of your anecdote about Sarah Charlesworth coming in. It's nice to know that she was someone you knew more than casually, and that's true of so many people in the exhibition. I think that the entryway exemplifies the diversity of your collection. Almost everything is made by living contemporary artists, but outside of that you don't seem to have any barriers—there's sculpture, photography, needlework. You just seem to follow where artists are going in the field and to embrace variety. Can you tell me about that?*

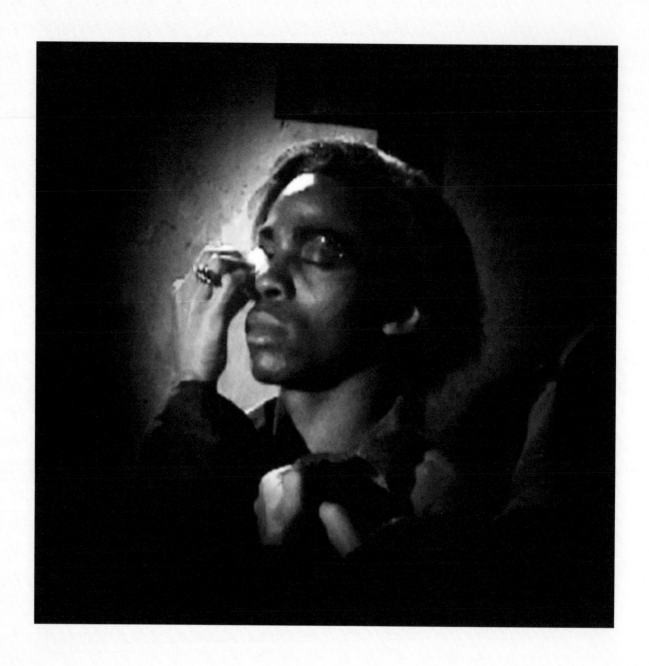

Irît Batsry, *Care*, from the series *Set*, 2007

MB: Well, that's the treasure of having our own space. We can do what we want in it, and if no one likes it, that's just too bad! [*Laughs.*] It's what we want. And actually we built The Granary to get the collection out of storage and to see what we had. We never realized that The Granary would become so popular.

ES: *In the entry space are works by Mona Hatoum [Projection (abaca) (2006; p. 34) and Projection (2006; p. 35)], Elaine Reichek [Sampler (Kruger/ Holzer) (1998; p. 22)], Sarah Charlesworth, Jenny Holzer [Stripes (2007; p. 36)], Kara Walker [Restraint (2009; p. 33)], and Jennifer Rubell ['Engagement (with Prince William sculpted by Daniel Druet)' (2011; p. 150)]. Can you tell me more about these works?*

MB: We bought the Mona Hatoum works at the Brodsky Center for Innovative Editions several years ago at a benefit honoring Marian Goodman. We bought all these beautiful pieces that night, including the two Mona Hatoums, which I've always found just absolutely gorgeous and which also fit in with the black-and-white theme of the entryway. It was Ryan who wanted to put up the Kathleen Gilje painting of me as the girl with the pearl earring [*Melva Bucksbaum as the Girl with the Pearl Earring* (2010; p. 138)], which I hadn't wanted because I thought it was too self-serving. Then we chose the Kara Walker, the Sarah Charlesworth, and the Jennifer Rubell, which is just a stitch [*laughs*]. The Jenny Holzer hangs above the Jennifer Rubell. And the Elaine Reichek sampler was really Ryan's idea. It's the linchpin for the show because it has in it everything that's in the show. Barbara Kruger's and Jenny Holzer's texts are used in Elaine's piece.

ES: *I can see in the entry room how your interests come together: the black and white, the combination of different mediums, the theme of the show that is embodied in Elaine's work. It sounds like all these components are part of the underlying structure of the exhibition.*

MB: I think so. We tried placing several works on the right wall where Sarah Charlesworth's piece is now, and none were right. Then there was Sarah's piece, and I thought, "Okay, that's the one!"

ES: *When you got into curating this show, did you get into themes at all, about the meanings of the work or the kinds of work or anything like that that's worth discussing?*

MB: I think we did. "The distaff side" is represented by the women of the Mika Rottenberg piece washing their hair, making cheese, and caring for the animals as well as in the botanical pieces of Jorinde Voigt. Gardening is usually considered women's work even though many men are master gardeners. I think those themes were always back there someplace. And there are many pieces upstairs that connect in one way or another, like the works by Rachel Harrison [*Untitled (Perth Amboy)* (2001; p. 182)], Sharon Lockhart [*Untitled* (2010; p. 177)], Malerie Marder [*One* (2006; pp. 184–85)], Lisa Kereszi [*Gael Dressing, State Palace Theater, New Orleans, LA* (2000; pp. 162–63)], and Victoria Sambunaris [*Untitled (VS-10-05)* (2010; p. 175)]. Those pieces have a figural aspect—namely the hand in the Rachel Harrison, Sharon Lockhart's basketball player, and the man in Irit Batsry's work [*Care* (2007; left)]—and that ties the room together. Also the Nan Goldin photograph [*Valerie and Gotscho embracing, Paris* (1999; p. 181)] and the Judy Fox pieces in a little alcove by themselves— Judy Fox's *Ayatollah* [2004; p. 195] is standing, and her *Rapunzel fragment* [1999; p. 194] is hanging above and a little bit to the right.

ES: *What about chronological periods? I mean there's great range, you have some Käthe Kollwitz from the twenties and thirties here . . .*

MB: Right.

ES: *But then some of it was done this year. How do you feel about chronology?*

MB: You know, Elisabeth, because of my personality and who I am—I'm so eclectic—I didn't worry about chronology. I just wanted the show to work. The pieces by Amy Arbus [*Madonna, St. Mark's Place* (1983; p. 100)] and Ana Mendieta [*Untitled (Glass on Body Imprints)* (1972; pp. 60–64)] are really wonderful. Ana Mendieta did those when she lived in Iowa, when she was at the University of Iowa, so I particularly wanted those. Anna Gaskell is from Des Moines, and I wanted the Käthe Kollwitz pieces (right).

ES: *So the exhibition works both thematically and chronologically because you've got a very clear sense of how one thing relates to another through your personal history and your own perception of the work. It sounds as if it's very clear to you.*

MB: It is to me. It may not be to anyone else, but that doesn't worry me. I'm not worried if a critic comes to look at it or not. It works for me, and that's what was important. We have a grouping of Evelyn Lauder's photographs installed on the stairway as a memorial to our friend Evelyn.

ES: *Those look great. She was very proud of that work.*

MB: Yes, we have the whole portfolio.

ES: *I remember Evelyn saying, "This is a little offbeat for me." So I think usually in curating if the person who puts the show together knows what he or she is doing then someone is going to get it. I think you must be very interested in curating because you seem to know how it works. So now that you've started, do you know whether curating interests you?*

MB: Oh, of course it interests me. Having The Granary has made me look at the collection in a new light. And having this collection to work with makes it very easy to curate. I now tell Ray, "I'd really like to curate an exhibition on the second

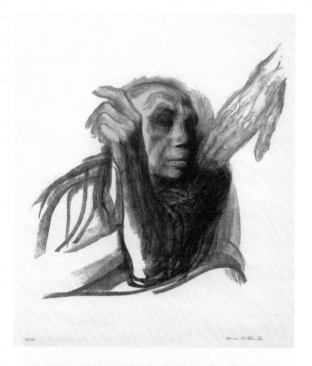

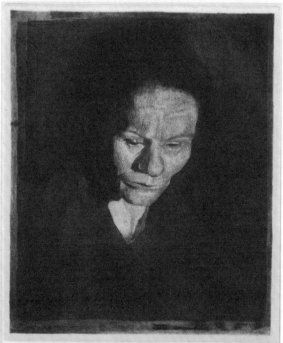

Top: Käthe Kollwitz, *Call of Death*, ca. 1937
Bottom: Käthe Kollwitz, Untitled, 1921

floor next time, and I know exactly what I want in there."

ES: *Now that you've curated this whole building, does it make you want to go to Chelsea or somewhere immediately—to fill a hole in the collection?*
MB: Yes, a few things.

ES: *So it sort of leads you down a road . . .*
MB: I won't name them, but there are a couple of artists whose work I wish I had in the collection.

ES: *And you found out about them while you were planning this exhibition?*
MB: Yes. We didn't have work by a particular artist, and when we tried to find it, it wasn't available. Eventually I'll get something by her.

ES: *How do you feel about collecting and displaying a mixture of photography, needlework, and sculpture?*
MB: It's all art to us. When Ray and I go to galleries—though I must admit that he has done more of the legwork than I have these past few years—we'll walk around individually, and then we'll come back and ask each other, "What did you like?" We almost always like the same thing.

ES: *Interesting.*
MB: We will almost always pick out the same things. And the medium doesn't make any difference. It's a piece of art whether it's sculpture, needlework, photography, painting—the medium doesn't make any difference as long as we consider it a compelling piece of artwork. But we tend not to get into craftwork, except for a small collection of pottery we have in Sharon and in Aspen.

ES: *I know that you didn't want to include Kathleen Gilje's portrait of you,* Melva Bucksbaum as the Girl with the Pearl Earring, *that that was Ryan's idea, and that you*

certainly didn't want to put yourself forward in that way. But it's very beautiful, and there it is!
MB: Yes. And we like it. It hangs in our living room when it's not at The Granary. It's a small painting, almost identical in size to the real one. When I found out that Kathleen would do commissioned work, I said, "Oh, I want to be *The Girl with the Pearl Earring*."

ES: *That fits with your personality, I think.*
MB: Kathleen has a show at the Bruce Museum in Greenwich, Connecticut, and they asked to borrow it. We told Kathleen that we wanted it for *The Distaff Side*, and she said okay, so we lent the Bruce Museum another piece and kept this one here.

ES: *You built The Granary so that you would have a place to both store and show your collection, and you open it frequently to the public. What are the rules for opening it that you set up for yourself?*
MB: When the town of Sharon let us build this building—I didn't think they would ever let us build it—they stipulated that it couldn't be open to the public on a daily basis. We said that it wouldn't be because we didn't want that responsibility either. So we have a big opening when we change the show, which isn't that often because it's a big deal for us to deinstall and then rehang the whole space; we're not a museum. We do a show about every year and a half to two years, and we have a large opening for our friends. We're often contacted by museum groups and individuals who would like to visit, and if it's convenient for Ryan and Caitlin and for us, then we allow that to happen because we certainly want people to see the collection, and we're thrilled that the public has taken such an interest in us. Especially high schools, colleges, and local artist residencies and organizations.

Exterior view of The Granary showing granite cladding

ES: *Tell me what you were thinking about when you designed the space.*

MB: When I first looked at the property, there was a barn where the pool house and library combine is now, and I thought: "Oh! We'll just tear down that barn and dig a basement, just concrete and waterproof it and we can have storage there. We can rebuild the barn out of this old wood and have a nice place to hang some art." And then . . . [*laughter*] the insurance company wasn't so happy about us storing all this art in a wooden barn.

One day we went to meet with the architect Steven Learner, who was actually redesigning the house for us, and he said, "What would you think if we did a new building?" And here we had this gorgeous front yard, and he was going to take up the whole front yard with this building, and I said, "The town will never allow that." I thought Ray would say absolutely not, but I was wrong. Ray was intrigued by the idea. Then we started working on plans, and when the town gave us permission to get building permits, Steven and I went to galleries, we looked at lighting, we looked at floors, we looked at ceilings, we looked at everything . . . walls, spaces, and materials. Ray and I both explained to him what we wanted in terms of more intimate spaces and larger spaces, and we came up with this design. Steven was the only architect I interviewed because I knew immediately that we were going to hit it off, and I was thrilled. His firm took great efforts to perfect every detail of the building and to make it fit with the landscape. It took the architects months to find the stone that's on the outside, and I said, "What is the big deal about this stone?" But then when I saw it, this charcoal-black stone, I realized, oh, that was the big deal!

ES: *So you brought it in under the budget you then had?*
MB: No! Are you kidding? [*Laughs.*] It was not under budget. But we got the building we wanted,

and we have the space we wanted. Tom Zoufaly was responsible for a great part of the design in the basement storage space. A company called Montel came down from Quebec and installed all those storage racks, which makes our collection easily accessible.

ES: *Are there some works that are still in Aspen and New York? Do you still have storage outside The Granary?*
MB: Yes.

ES: *But most everything is at The Granary now?*
MB: Yes.

ES: *How did you find Steven Learner?*
MB: Beth DeWoody, a friend and fellow Whitney trustee, recommended Steven. The house, which was built in 1890, was in pretty bad shape, and we didn't even realize what bad shape it was in. I wanted to bring it up to code and make some changes. Steven came to meet with us, and I liked him immediately. We decided we'd get the house done first and then talk about The Granary.

ES: *He had never built a museum before?*
MB: He had built a building for Sydie Lansing in Greenwich. Ray and I went to see that building and knew Steven would be able to design a great building for us. I'm thrilled with it. He may not ever have designed a museum building before, but he really showed his expertise and talent in doing this one.

ES: *I want to talk about your process of collecting. Do you and Ray go to galleries and exhibitions on a regular basis?*
MB: Absolutely.

ES: *Not only in New York but everywhere you travel?*
MB: When we are in Paris, we go out in the Marais and hit all the galleries and also to the Centre Pompidou, the Jeu de Paume, and the Palais de Tokyo. We're out looking at art all the time in Paris. The same is true wherever we are. We have a friend, Martine Schneider, who has a gallery in Luxembourg, and it is always a learning curve to visit her space because she has wonderful shows. We prefer looking at art in galleries and museums; we rarely go to artists' studios.

ES: *But suppose you decide you like somebody's work, would you go to the studio then?*
MB: Yes, and we have done that, though not on a regular basis.

ES: *You do feel comfortable talking to artists, and you're not afraid to say that you don't understand something. Artists are often turning a corner before the rest of us are.*
MB: I am comfortable with having an artist explain to me what he or she does and what a work means. And I'm comfortable with artists no matter how famous or not famous they are [*laughs*].

ES: *While I don't want to talk about specific works, I am curious about your interest in a variety of mediums, so I will ask you about a specific piece, Jennifer Steinkamp's computer video installation* Mike Kelley *[2007; pp. 158, 197–99].*
MB: I saw that at the Frieze Art Fair in London. I said to June and Paul Schorr, "I'm not buying anything today; I'm just looking." And of course, as soon as I saw that Jennifer Steinkamp, I was like, "Uh-oh! That's mine." [*Both laugh.*] And when they told me it was a unique piece dedicated to Mike Kelley, I said, "Okay, I want that." And it's taken us all these years to be able to install it. Each of our video pieces in this exhibition was such a challenge. Installing the Mika Rottenberg, Michal Rovner, and Jennifer Steinkamp pieces wasn't easy; we had a really rough time.

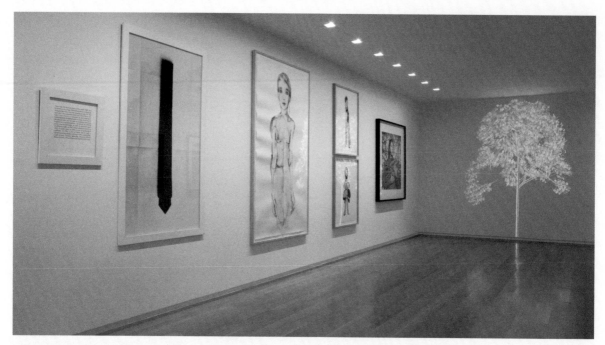

Installation view of *The Distaff Side* with (from left) Sophie Calle's *La cravate* (1992); Kim McCarty's *Single Strand* (2012); Nicola Tyson's *Man and Woman* (1997); Marina Abramović's *Portrait with Firewood* (2009); and Jennifer Steinkamp's *Mike Kelley* (2007)

ES: *And you're open to the next thing? If something turns up in some East Village art gallery, you'll go see it even if it's something that you've never seen before and that doesn't correspond to what you've collected prior?*

MB: Adam Weinberg said something about us that I liked. He said that we collect with our eyes and not with our ears.

ES: *In other parts of your life you meet people who don't have anything to do with contemporary art.*

MB: Most of our friends up here in Sharon are not into contemporary art. When they come to our home for dinner, we'll go over to The Granary, and they love seeing the art; they love being exposed to it.

ES: *You mentioned that students also come to see the art.*

MB: Yes, we had a group of high school students come during the last show. One kid came in kind of cocky, and he's looking around, and he says,

"Oh, I know what that is," and he looks at the Richard Prince, and he says, "That's a car hood." And then he looks at another piece, and he says, "Oh, I know what that is—that's mud." And then all of the sudden he got it; he understood it. And it was like, yes! That's what it's all about.

ES: *Do you and Ray agree on what to purchase?*

MB: Yes, most of the time.

ES: *And you occasionally make your own decisions, like with the purchase you described of the Jennifer Steinkamp work.*

MB: Yes, we make our own decisions, or we'll run it by each other; it's usually by consensus. But there are times when I just say, "Ray, I bought this today" [*laughs*], and he'll say, "Oh, okay." So we buy things both individually sometimes and with each other's approval at other times. If there was something that one of us really hated, then we

might not go through with it. Although I recently saw a piece in our storage that I hadn't seen before.

ES: *Another event in your long-term support of contemporary art is your endowment of an award for an artist in each Whitney Biennial, the Bucksbaum Award. It's a very significant award, and you put no strings on it at all. It's often a life-changing event for those who receive the award. The Granary, the Bucksbaum Award, your ongoing collecting, and your curating now for the first time—it all adds up to quite an extraordinary contribution to living artists. Everything I've described is with living artists. And that doesn't include your support of the Des Moines Art Center, the Whitney Museum, the Aspen Art Museum, and other institutions such as the Tate, the Museum of Modern Art, a chair in the Graduate School of Design at Harvard University called the Martin Bucksbaum Professorship in Practice of Urban Planning and Design, the Martin Bucksbaum Distinguished Lecture Series at Drake University in Des Moines, the Aspen Institute—all that is significant too. I assume that all this must be a source of family pride.*

MB: It is a great time for family pride because the Aspen Music Festival School and the Aspen Country Day School, which share a campus, are now open with seed money that my brother-in-law and sister-in-law gave. The music festival occupies the campus June through August, and the school occupies the campus September to June. Also, my daughter and her husband have donated Scanlan Hall on campus. We are supportive of the communities in which we live. I feel that you just have to give back something.

When Max Anderson first came to the Whitney and was meeting with the trustees, I had breakfast with him one morning, and he told me about an award he would like to initiate. I had always admired the Pritzker Architecture Prize, and for years I had been thinking about something like that for an artist. He said, "I wish there were an award like that in the art world," and as soon as he

said that, I said, "Max, I think I can help you!" And I called my attorney, and I said, "Can I do this?" And he said yes, and I thought it would be two years down the line, but within a couple of months we had it all set up. I made sure that nothing was written in stone, that any director who wanted to change it slightly could. But I always had to erase it from everyone's mind that the award is for an emerging artist. It isn't; it is for someone who has made a signification contribution to contemporary art and who will hopefully influence future artists. The idea that it was for an emerging artist was always in the jury's mind, and I had to hammer that out of their heads to get it right. But I've been very pleased with the award and all the recipients.

ES: *It has always been for a living artist, though, right?*

MB: Yes, always for a living artist. One of the sweetest moments related to the award was when Raymond Pettibon said to me one day, "Melva, I will never let you down." And that coming from Raymond Pettibon—I almost started to cry.

But there was something, Elisabeth, that happened about four years ago in New York related to the awards. There was a show at David Zwirner of Raymond Pettibon and then there was a show a couple of weeks later of Mark Bradford at Sikkema Jenkins. So the first show of Raymond Pettibon at David Zwirner had this big piece of art, *extremely* controversial, responding to Thomas L. Friedman, who writes for the *New York Times* and happens to be my nephew. And I thought, "Oh, my God." This was not a very kind piece. Two weeks later, a Mark Bradford show opened that featured a big piece called *The World Is Flat*, and I said, "Mark, what made you call that *The World Is Flat*?" He said, "Well, you know, it's dedicated to this writer for the *New York Times*, Thomas L. Friedman." I said, "Yeah, I know him; he's my nephew!" In two weeks, two Bucksbaum Award winners had

had pieces about Tom Friedman, which I felt was really quite unique and almost spooky.

ES: *That is quite something. And neither of them complimentary it sounds like?*
MB: Oh, the Bradford was. The Pettibon wasn't.

ES: *Interesting. You've done so much—between the Bucksbaum Award, The Granary, the exhibition, and all your philanthropy—and while family pride is part of it, I think that you do it because you really think art and artists are important.*
MB: Even though the Bucksbaum Award has my name on it, it was never about me—it's about the artists. I just want to recognize artists and hope the award might make a difference in their careers.

ES: *We've strayed far away from The Granary exhibition. The fact that this is the first time you ever curated an exhibition is pretty amazing.*
MB: And it was great fun. One nice thing was that Ray had been spending so much time with me after my 2012 surgery, and he needed to go to Europe, and I wanted to give him a break after being a 24–7 devoted spouse. I said, "Why don't you go while we are busy installing the show?" Nice planning, no?

ES: *Oh! Isn't that great? So he wasn't peering over your shoulder then?*
MB: No. And when he came back, I was in California visiting my sister, and I said, "I'm going to give you permission to go and see the show." And he said, "Oh, you mean I can go see the girlie show?" [*Both laugh.*] And I said, "Yes! You can go see the girlie show." Well, he called me back, and he said, "Oh, my God, it's so wonderful." ◉

Elisabeth Sussman is curator and the Sondra Gilman Curator of Photography at the Whitney Museum of American Art, New York.

NOTES

1. "About the Gallery," National Gallery of Art, http://www.nga.gov/content/ngaweb/about.html.
2. Eliel Saarinen's original stone building for the Des Moines Art Center (1948) was followed by I. M. Pei's bushhammered concrete addition (1968), the second of the three buildings. The third is Richard Meier's clad porcelain and granite addition (1985). "Architecture Overview," Des Moines Art Center, http://www.desmoinesartcenter.org/about/architecture.aspx.

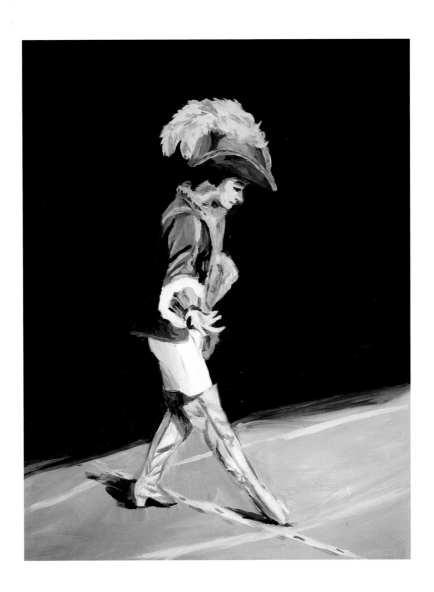

Karen Kilimnik, *Prince Siegfried Arriving Home in Vienna 1800's from Versailles 1500's*, 2000

Lisa Kereszi, *Gael Dressing, State Palace Theater, New Orleans, LA*, 2000

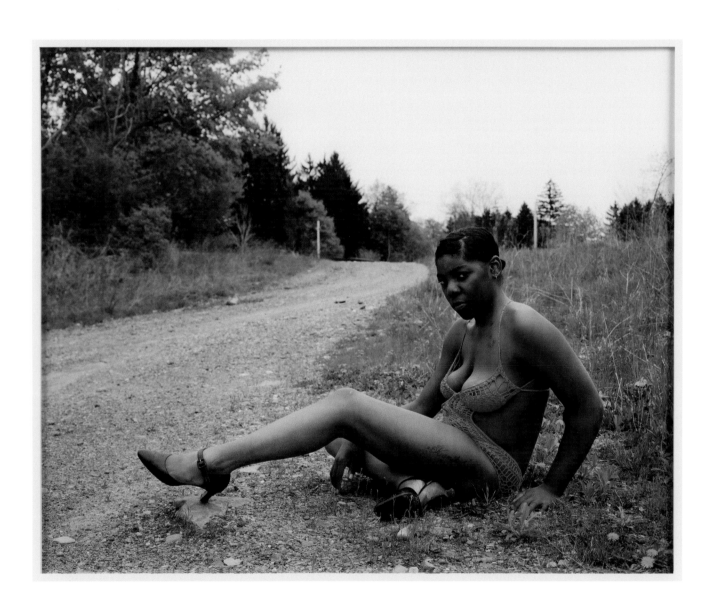

Katy Grannan, *Kamika, Near Route 9, Poughkeepsie, NY*, 2003

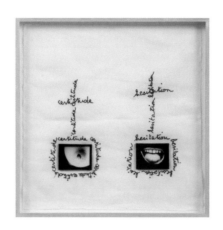

Annette Messager, *Mes ouvrages de broderies*,
1988 (details)

I saw him for the first time in December 1985, at a lecture he was giving. I found him attractive but one thing bothered me: he was wearing an ugly tie. The next day I anonymously sent him a thin brown tie. Later, I saw him in a restaurant; he was wearing it. Unfortunately, it clashed with his shirt. It was then I decided to take on the task of dressing him from head to toe: I would send him one article of clothing every year at Christmas. In 1986, he received a pair of silk grey socks; in 1987, a black alpaca sweater; in 1988, a white shirt; in 1989, a pair of gold-plated cufflinks; in 1990, a pair of boxer shorts with a Christmas tree pattern; nothing in 1991; and in 1992, a pair of grey trousers. Someday, when he is fully dressed by me, I would like to be introduced to him.

Sophie Calle, *La cravate*, 1992

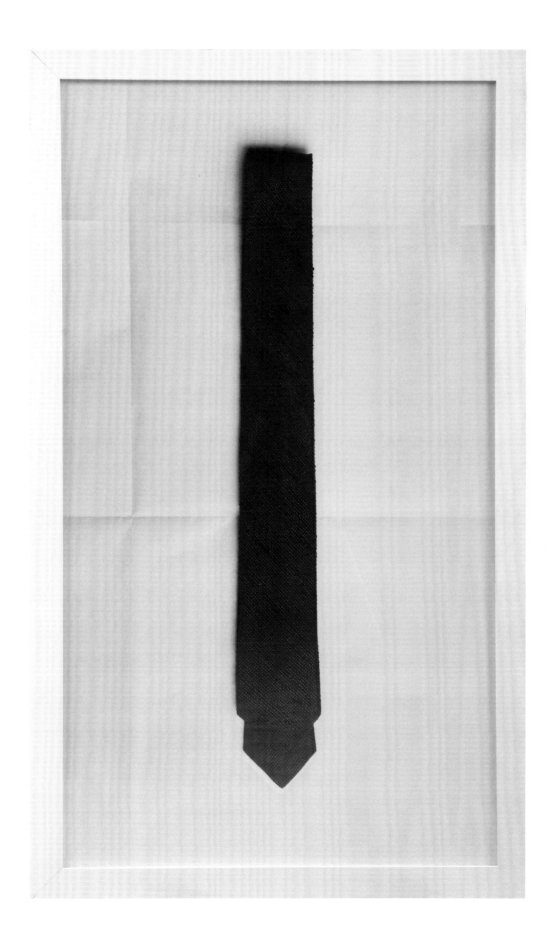

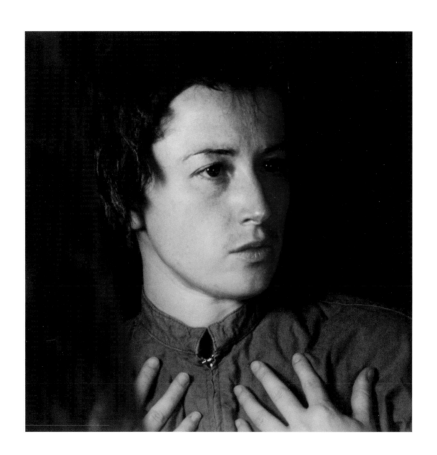

Cindy Sherman, Untitled, 1982

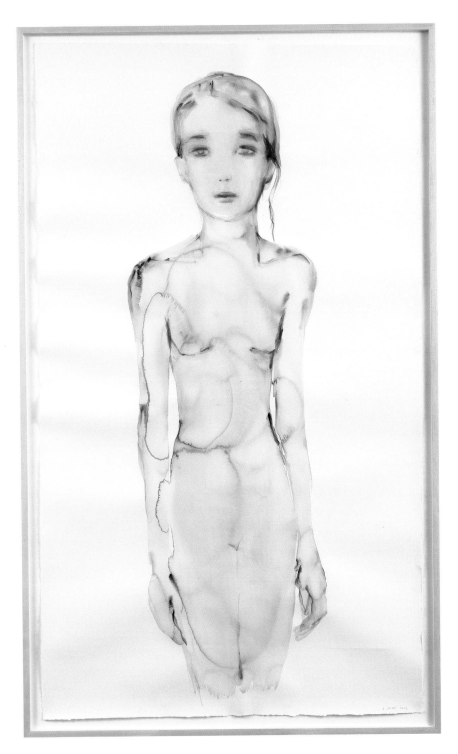

Kim McCarty, *Single Strand*, 2012

Sharon Lockhart, *Goshogaoka Girls Basketball Team: Ayako Sano*, 1997

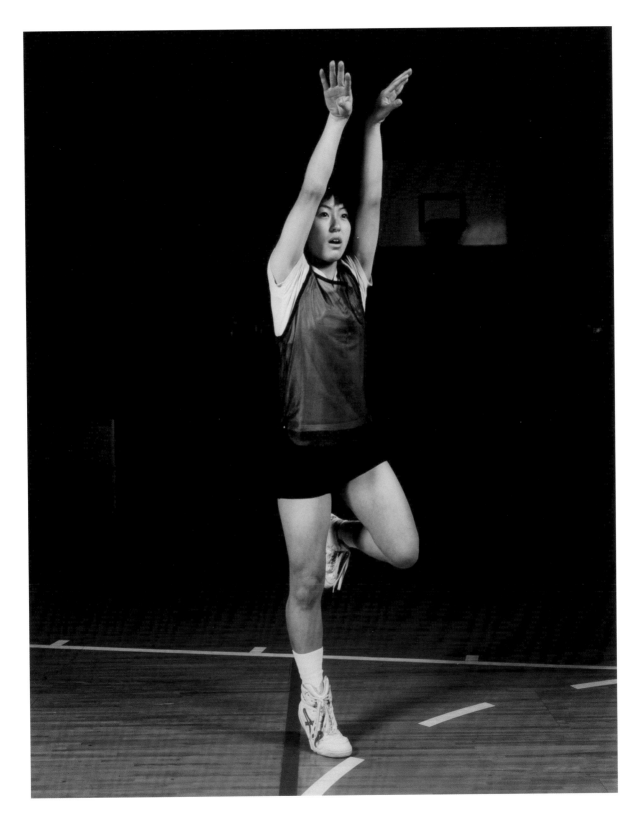

Catherine Opie, *Catherine, Melanie, and Sadie Rain, New York, New York*, 1998

Ellen Phelan, *Gate: Westport*, 2002

↑ Katy Schimert, Untitled, 1999
→ Installation view of *The Distaff Side* with Kiki Smith's *Autumn I* (2000) in the foreground
and Victoria Sambunaris's *Untitled (VS-10-05)* (2010) on the wall

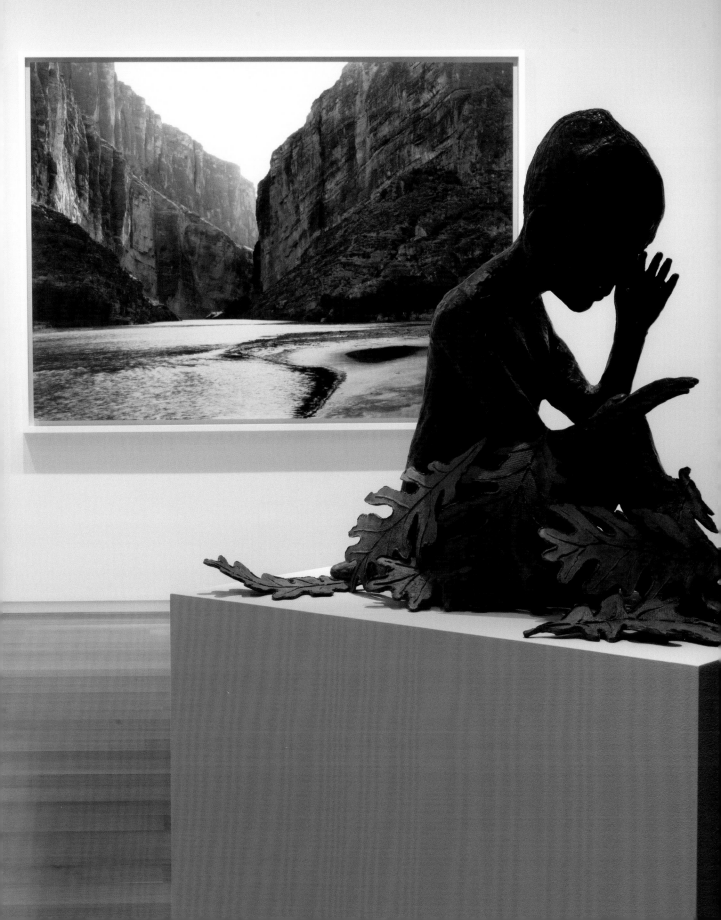

↑ Paloma Varga Weisz, *Tumor Man*, 2005
→ Installation view of *The Distaff Side* with Kiki Smith's *Autumn I* (2000) in the foreground
and Sharon Lockhart's Untitled (2010) on the wall

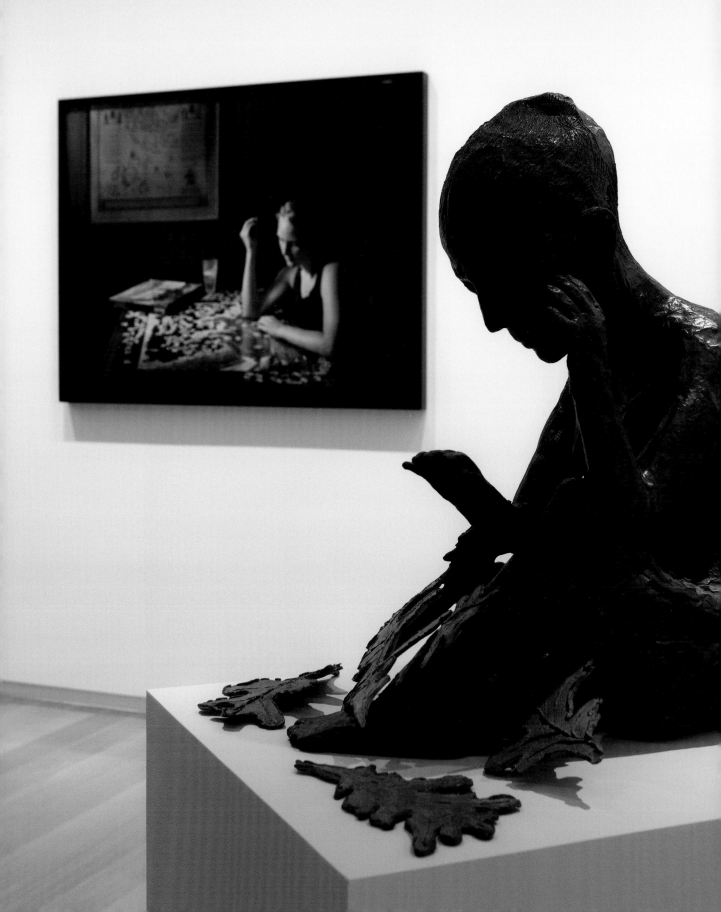

Rosemarie Trockel, Untitled, 1986

Natalie Frank, *Portrait 1*, 2011

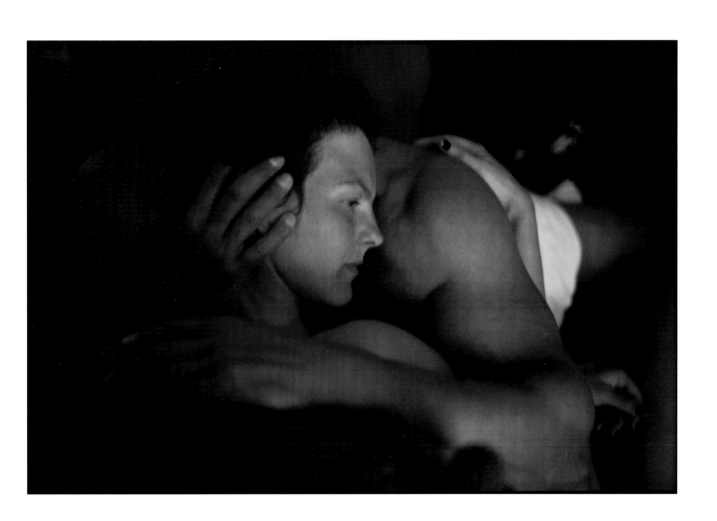

Nan Goldin, *Valerie and Gotscho embracing, Paris*, 1999

Rachel Harrison, *Untitled (Perth Amboy)*, 2001

Justine Kurland, *Ghost Ship*, 2001

Malerie Marder, *One*, 2006

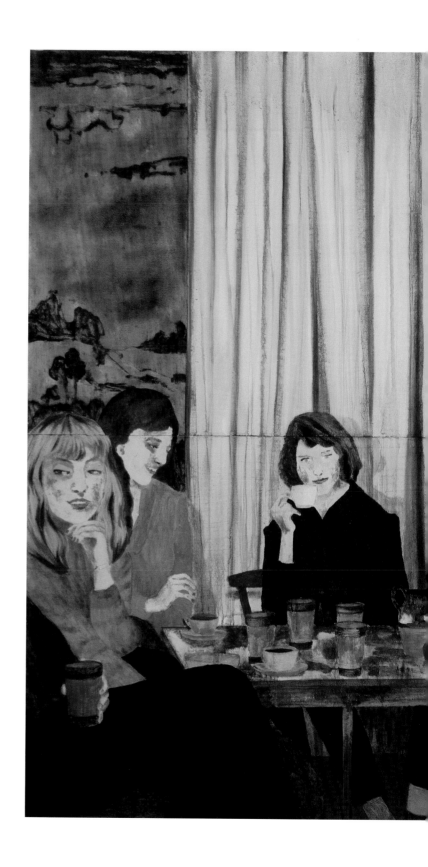

Mamma Andersson, *About a Girl*, 2005

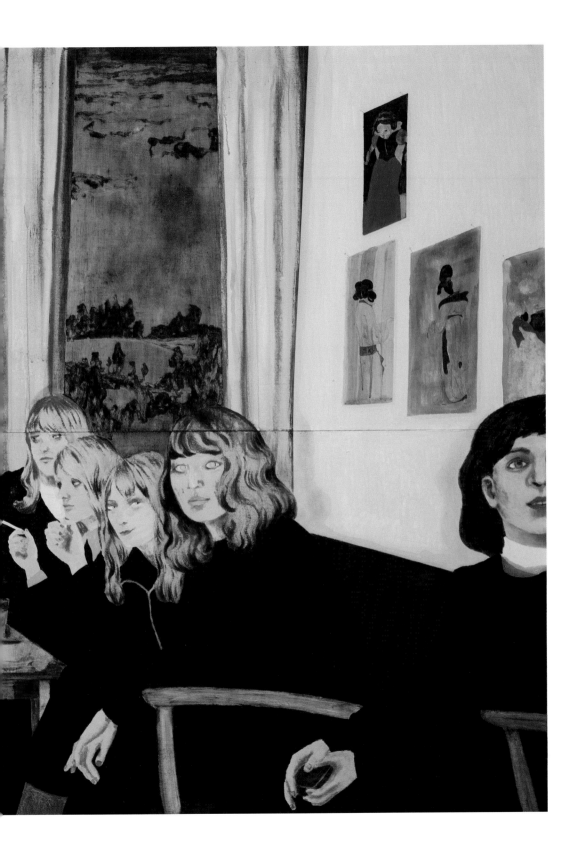

Nicola Tyson, *Man and Woman*, 1997

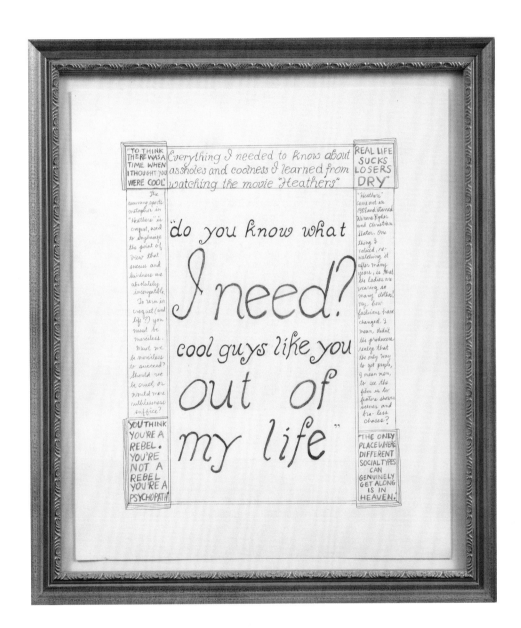

Jennifer Dalton, *Cool Guys Like You*, 2011

Anna Gaskell, *Sunday Drive*, 2000

Amy Cutler, *Garnering*, 2006

↑ Judy Fox, *Rapunzel fragment*, 1999
→ Installation view of *The Distaff Side* with Judy Fox's *Ayatollah* (2004) and *Rapunzel fragment* (1999) mounted on the wall

Pages 196–97: Installation view of *The Distaff Side* with (from left) Marina Abramović's *Portrait with Firewood* (2009) and Jennifer Steinkamp's *Mike Kelley* (2007)
Pages 198–99: Jennifer Steinkamp, *Mike Kelley*, 2007

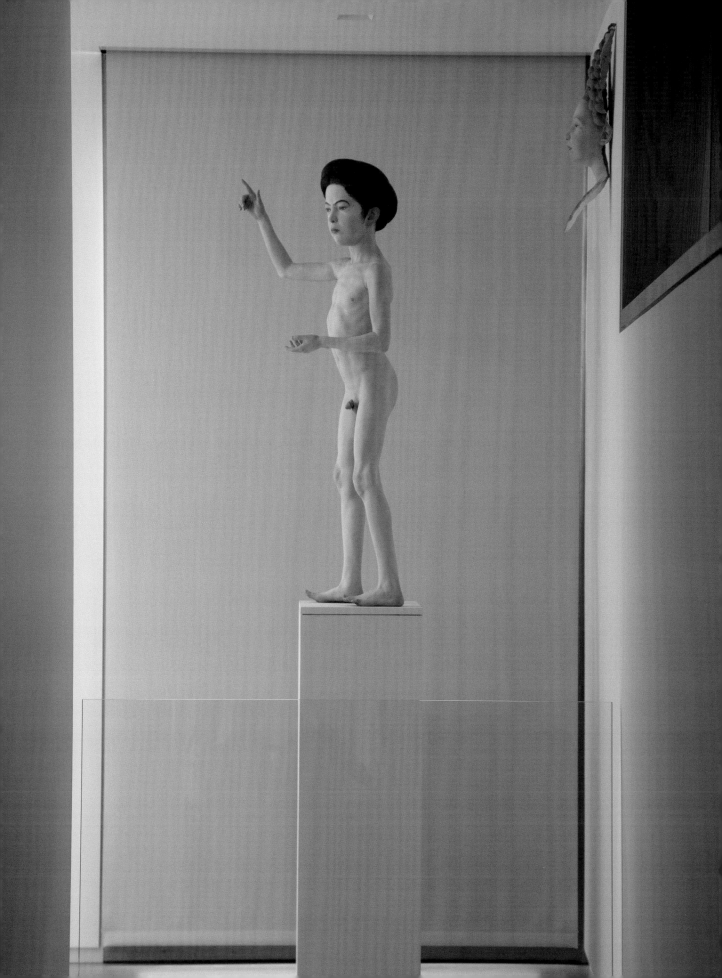

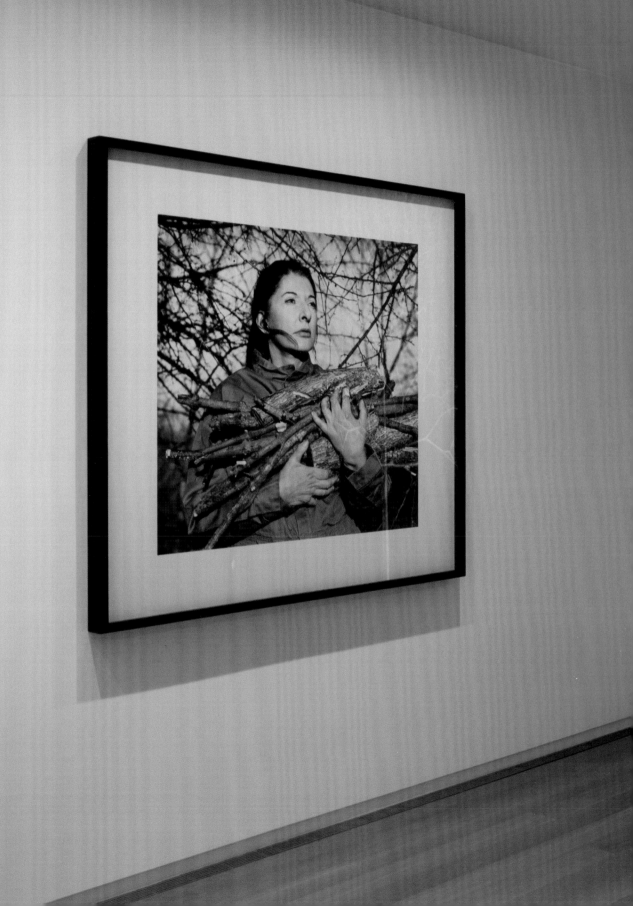

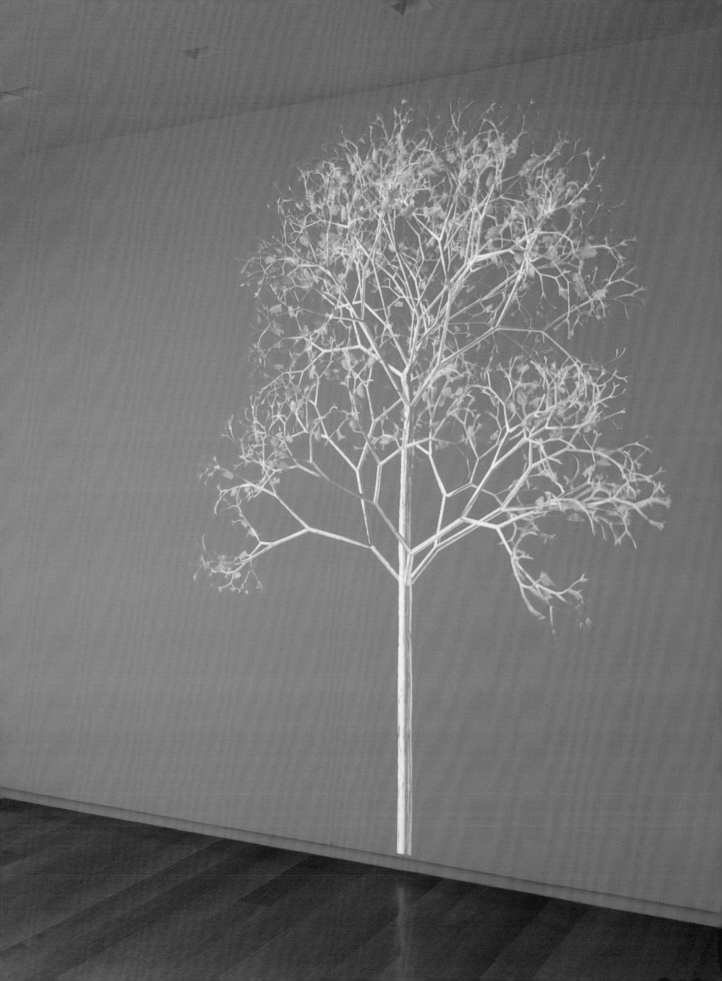

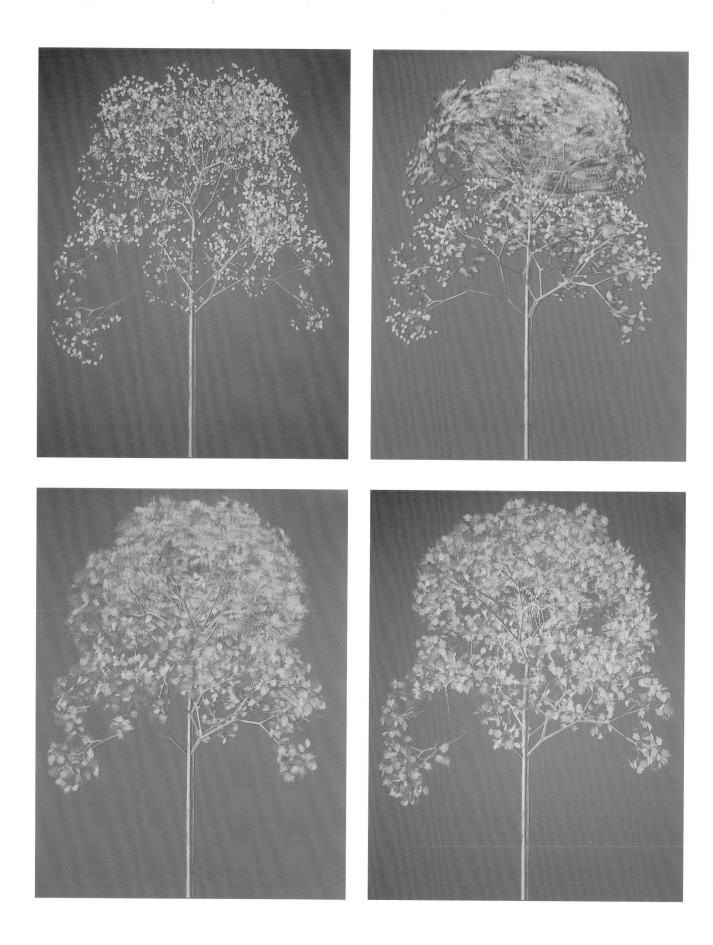

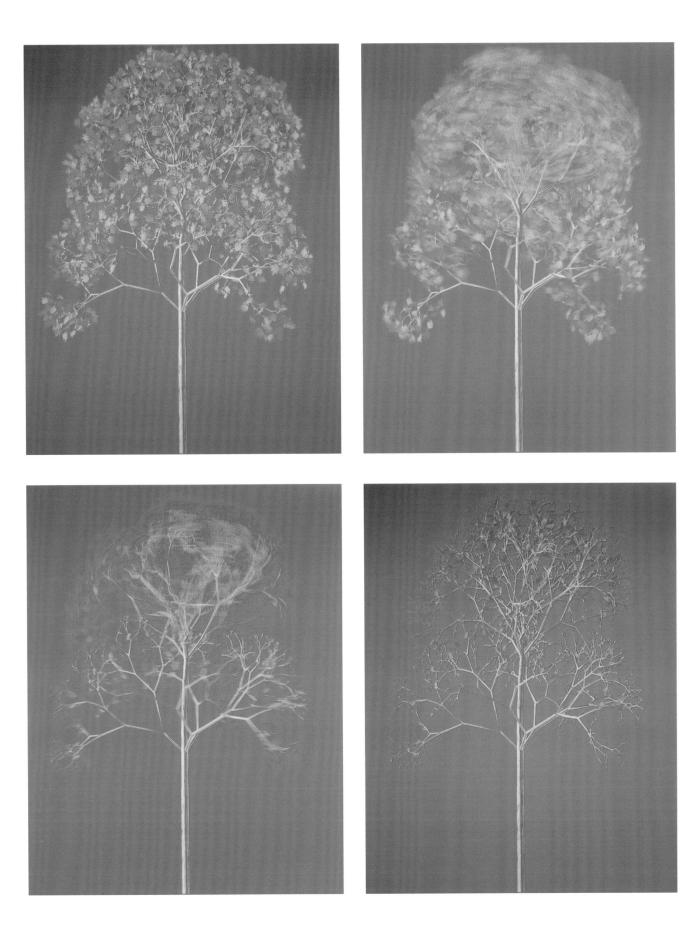

The Granary's art library

The Granary, Sharon, Connecticut

In On the Architecture of
The Granary, Steven Learner
describes the conception of
an exhibition and storage space
to complement and enrich lives
dedicated to contemporary art.

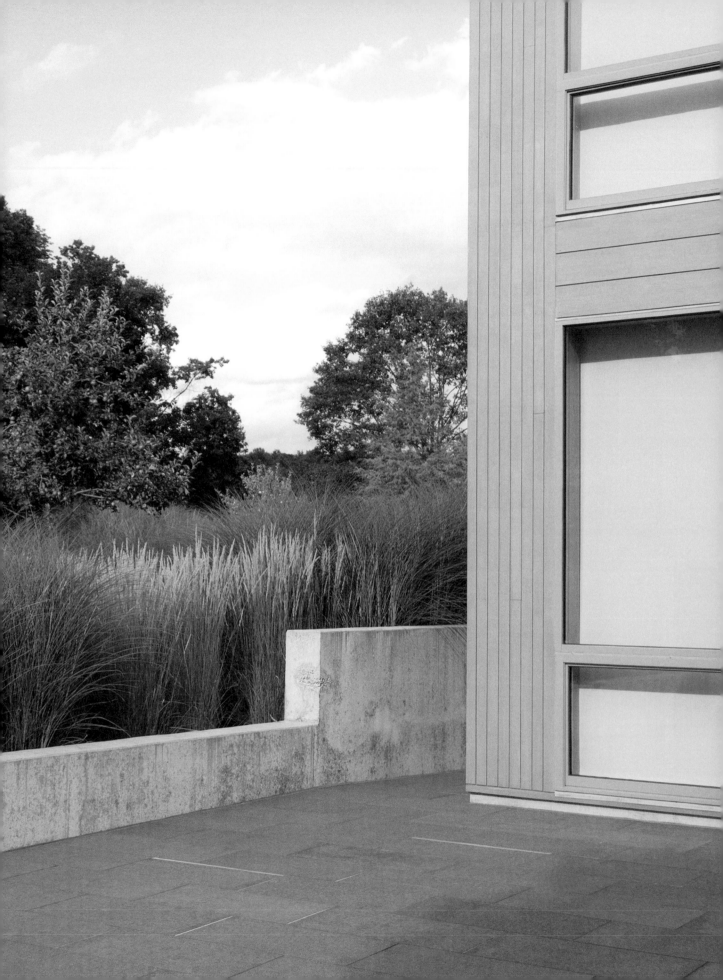

Architects often have to choose between a great project and great clients. Working with Melva Bucksbaum and Ray Learsy on The Granary meant getting both. The program began as the design of a private gallery building. As I spent time getting to know Melva and Ray, it became clear that they wanted physical spaces in which they could explore and enjoy their collection, as well as a holistic design of the entire property to complement and enrich their lives, which have been dedicated to contemporary art and their extended family.

After years of keeping artworks in various storage facilities, Melva and Ray wanted to gather their entire collection under one roof. This would give them immediate access to the artworks and make it easier to curate exhibitions from the collection. The Granary was designed to support the specific nature of their collection, accommodating works of various scales, mediums, and styles with spaces that range from the skylighted sixteen-foot-high main galleries to more intimate rooms in which works are often hung salon style.

Architecturally the building consists of three elements. The main gallery building is a double-height space clad with granite blocks the scale of oversize bricks and topped with sawtooth skylights reminiscent of the dormers on the adjacent house. An L-shaped smaller volume houses domestic-scaled galleries and is wrapped in cedar siding, a typical residential material that will soften in color over time. The building opens out onto a large terrace with an expansive

Exterior view of The Granary showing cedar siding and terrace

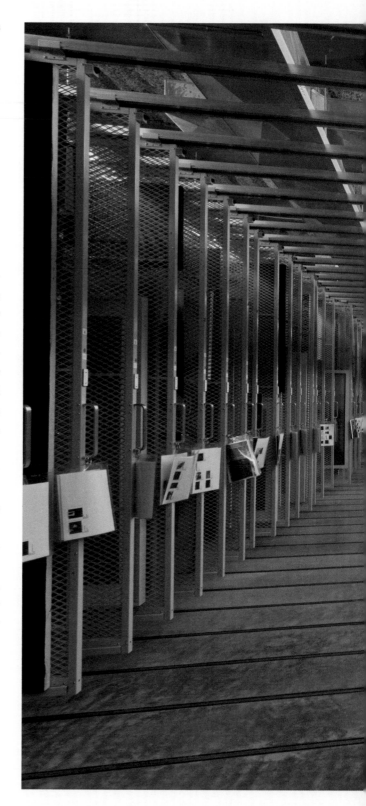

The Granary's storage facilities

Pages 208–9: The Granary,
Sharon, Connecticut

view of the property and of mountains in the distance. Supporting the galleries is an extensive below-grade storage space with a comprehensively cataloged racking system that allows for spontaneous viewing and trial runs of curatorial directions under consideration. Though The Granary is a decidedly modern building, it embraces local building materials, forms, and techniques to complement the other buildings in the area and to reflect the history of the site.

In addition to designing The Granary, my studio reconfigured the grounds; added a new, barn-like art library; and renovated the existing late nineteenth-century house. Designed to work together, the three buildings allow Melva and Ray to engage with their art on a daily basis.

As Melva and Ray described how they had met new artists and how each work had come into their collection and their lives, I was reminded of how intimate the process of collecting art can be. The exhibitions that they mount at The Granary are as personal as dinner parties, with the works on display like a gathering of friends old and new. I am so happy to have played a part in realizing this vision. ◉

Steven Learner is an architect and collector and is the founder and creative director of the Collective Design Fair.

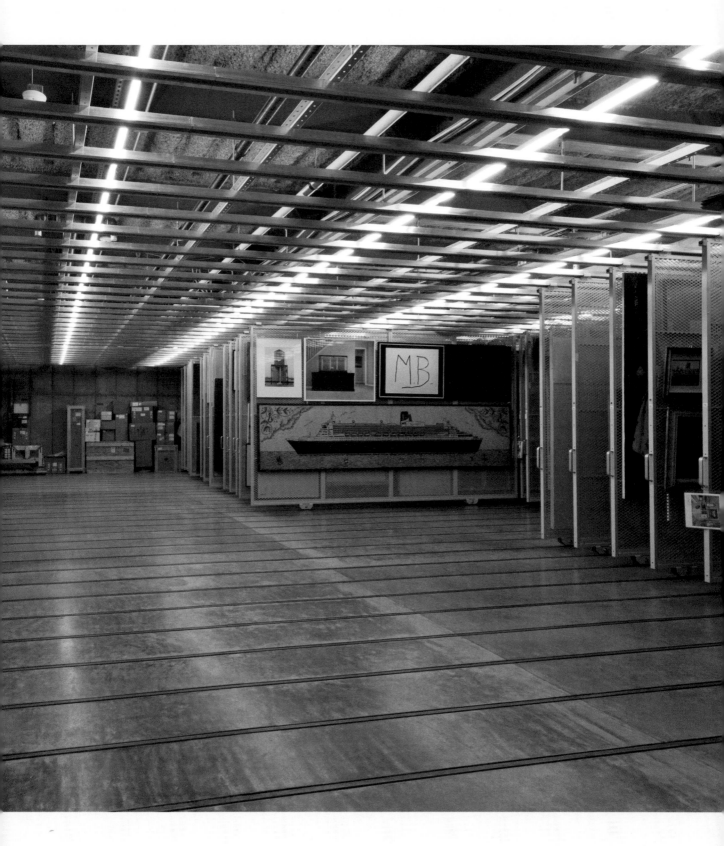

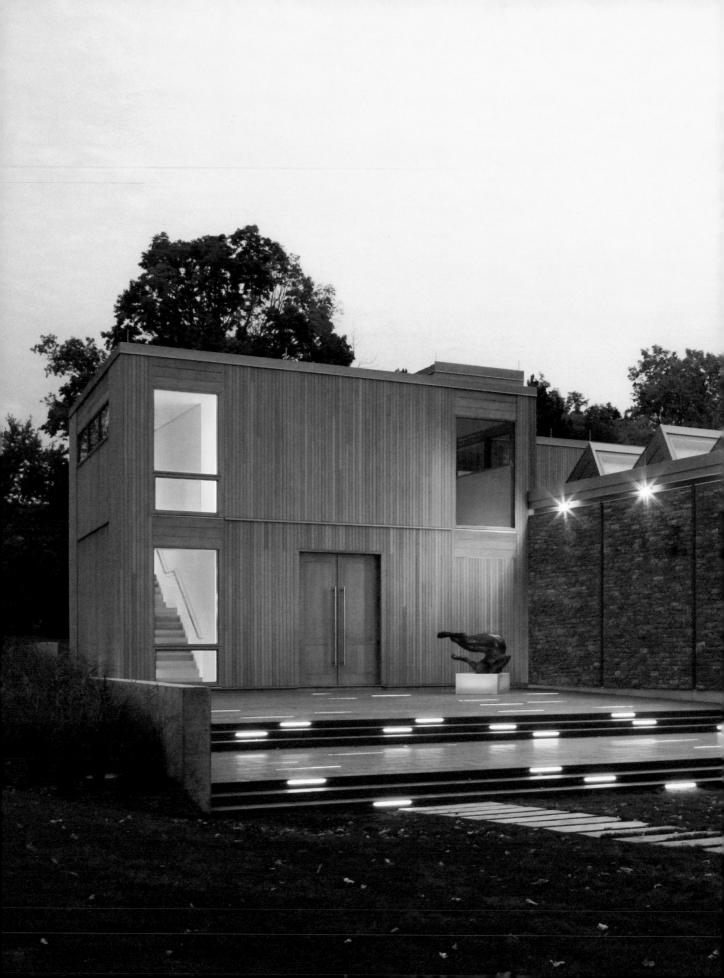

Works in the Exhibition

Marina Abramović (Serbian, b. 1946)
The Kitchen V, Carrying the Milk, from the
series *The Kitchen, Homage to Saint Therese*,
2009. Video installation (color, sound)
12:43 minutes

Marina Abramović (Serbian, b. 1946)
Portrait with Firewood, 2009
Black-and-white pigment print on cotton paper
40 × 40 in. (101.6 × 101.6 cm)

Laurie Anderson (American, b. 1947)
Dream Book, 2005
Book (cloth cover, Sunset Eclipse Duo paper,
50 double-sided pages), stone pedestal, wood
plinth, 25¼ × 34½ × 30 in. (64.1 × 87.6 × 76.2 cm)

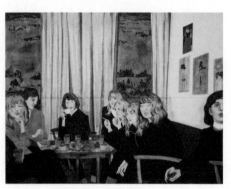

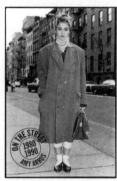

Mamma Andersson (Swedish, b. 1962)
About a Girl, 2005
Oil and acrylic on panel
48 × 63 in. (121.9 × 160 cm)

Shari Applebaum (American, b. 1957)
Dune, Namibia Sossusviei, 2011
Color photograph on Hahnemühle paper
56 × 44½ in. (142.2 × 113 cm)

Amy Arbus (American, b. 1954)
Madonna, St. Mark's Place, 1983, from the
series *On The Street 1980–1990*. Gelatin silver
print, 20 × 16 in. (50.8 × 40.6 cm)

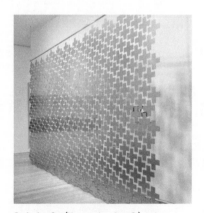

Carla Arocha (Venezuelan, b. 1961) and
Stéphane Schraenen (Belgian, b. 1971)
Chris, Untitled (Crosses), 2006
Madreperla acrylic, stainless steel, video
equipment. 126 × 197 in. (320 × 500.4 cm)

Tauba Auerbach (American, b. 1981)
[2,3], 2011
Paper, ink, binder's board, glue, fabric, silk
screen. 6 parts, dimensions variable

Kristin Baker (American, b. 1975)
Oversteer, 2003
Acrylic on Mylar
48 × 60 in. (121.9 × 152.4 cm)

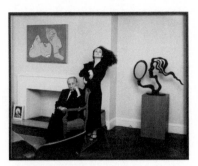

Tina Barney (American, b. 1945)
Mr. & Mrs. Leo Castelli, 1998
Chromogenic print
48 × 60 in. (121.9 × 152.4 cm)

Jennifer Bartlett (American, b. 1941)
The Last Thing He Saw, 2002
Oil on canvas
84 × 96 in. (213.4 × 243.8 cm)

Irît Batsry (Israeli, b. 1957)
Care, from the series *Set*, 2007
Lambda print on Fujiflex, front-mounted onto
Plexiglas. 38 ¾ × 40 in. (98.4 × 101.6 cm)

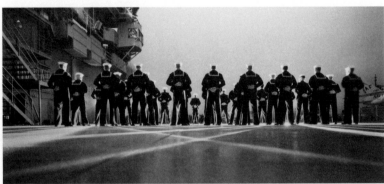

Vanessa Beecroft (Italian, b. 1969)
The Silent Service: Intrepid, New York, 2000
Vibracolor print
40 ½ × 87 ¾ in. (102.9 × 222.9 cm)

Lynda Benglis (American, b. 1941)
Three Leaf Clover, 2002
Color photograph with gold leaf
19 ¾ × 16 in. (50.2 × 40.6 cm)

Irene Blagden (American, b. 1942)
Marie Thérèse's Cat, n.d.
Acrylic on canvas
6 ½ × 4 ½ in. (16.5 × 11.4 cm)

Lee Bontecou (American, b. 1931)
An Untitled Print, 1981–82
Lithograph
93 × 42 in. (236.2 × 106.7 cm)

Meghan Boody (American, b. 1964)
PsycheStar, 2001
Light-jet print in custom acrylic frame
16 × 14 in. (40.6 × 35.6 cm)

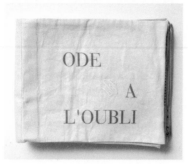

Louise Bourgeois (American, b. France, 1911–2010)
Ode à l'oubli, 2004. Book (fabric, color lithographs, 36 pages)
10 ¾ × 13 ¼ × 2 in. (27.3 × 33.7 × 5.1 cm)

Delia Brown (American, b. 1969)
Pianissimo, 2007
Oil on wood panel
17 × 17 in. (43.2 × 43.2 cm)

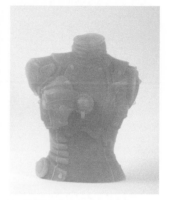

Lee Bul (South Korean, b. 1964)
Vanish (Orange), 2001
Cast silicone mixed with pigment
20 × 16 ¼ × 11 in. (50.8 × 41.3 × 27.9 cm)

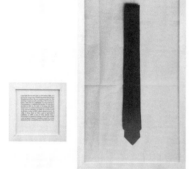

Sophie Calle (French, b. 1953)
La cravate, 1992. Black-and-white photographs (diptych). 15 × 15 in., 62 ¼ × 34 ½ in. (38.1 × 38.1 cm, 158.1 × 87.6 cm)

Vija Celmins (American, b. Latvia 1938)
Land Sea #2, 1969
Acrylic and graphite on paper
13 ½ × 18 ½ in. (34.3 × 47 cm)

Tina Chandler (American)
Highfield Solo, 2008
Pastel on paper
19 × 13 ½ in. (41.9 × 33.7 cm)

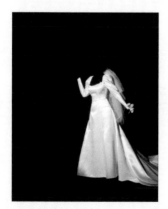

Sarah Charlesworth (American, 1947–2013)
Bride, 1983–84
Cibachrome with lacquered wood frame
39 × 29 in. (99.1 × 73.7 cm)

Jessica Craig-Martin (American, b. 1963)
If You Knew Suzy, Evening Honoring Bill Blass, the Waldorf-Astoria, New York, 1999
C-print. 19 ½ × 23 ¾ in. (49.5 × 60.3 cm)

Amy Cutler (American, b. 1974)
Garnering, 2006
Gouache on paper
22 ½ × 30 in. (57.2 × 76.2 cm)

Jennifer Dalton (American, b. 1967)
Cool Guys Like You, 2011
Pencil on paper
17 × 14 in. (43.2 × 35.6 cm)

Moyra Davey (Canadian, b. 1958)
Copperhead #36, 1990
C-print
24 × 18 in. (61 × 45.7 cm)

E. V. Day (American, b. 1967)
Water Lily III, from the *Pollinator Series*, 2012
Polished aluminum
28 × 28 × 12 in. (71.1 × 71.1 × 30.5 cm)

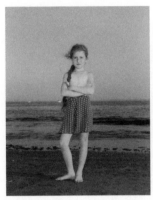

Rineke Dijkstra (Dutch, b. 1959)
Coney Island, NY, July 9, 1993, 1993
C-print
14 × 11 in. (35.6 × 27.9 cm)

Michele Oka Doner (American, b. 1945)
What Is White, 2010
Book (archival wax cover, abaca and cotton leaves, 38 pages)
18 ¾ × 15 ¼ × 1 in. (47.6 × 38.7 × 2.5 cm)

Marlene Dumas (South African, b. 1953)
Untitled, 1989
Ink and watercolor on paper
12 ½ × 17 ½ in. (31.8 × 44.5 cm)

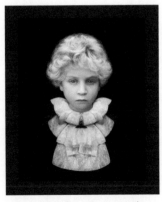

Adriana Duque (Colombian, b. 1968)
Daniel, from the series *Infantes*, 2010
Digital photograph
67 ½ × 56 ½ in. (171.5 × 143.5 cm)

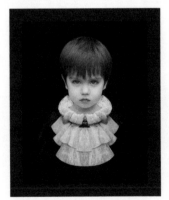

Adriana Duque (Colombian, b. 1968)
Felipe, from the series *Infantes*, 2010
Digital photograph
67 ½ × 56 ½ in. (171.5 × 143.5 cm)

Judy Fox (American, b. 1957)
Rapunzel fragment, 1999
Hydro-Stone, casein
21 ½ × 11 ½ × 6 ¼ in. (54.6 × 29.2 × 15.9 cm)

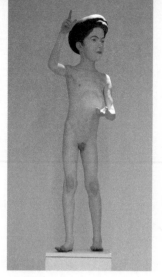

Judy Fox (American, b. 1957)
Ayatollah, 2004
Aqua-Resin, casein
50 × 20 × 17 in. (127 × 50.8 × 43.2 cm)

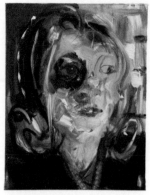

Natalie Frank (American, b. 1980)
Portrait 1, 2011
Oil on canvas
26 × 20 in. (66 × 50.8 cm)

Ellen Gallagher (American, b. 1965)
Ruby Dee, 2005
Two-plate photogravure with aquatint and
unique hand-shaped Plasticine elements on
laminated paper. 6 × 4 in. (15.2 × 10.2 cm)

Anna Gaskell (American, b. 1969)
Sunday Drive, 2000
9 C-prints mounted on metal
Dimensions variable

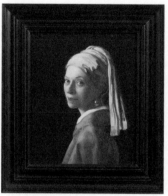

Kathleen Gilje (American, b. 1945)
*Melva Bucksbaum as the Girl with the Pearl
Earring*, 2010
Oil on linen
23 × 19 in. (58.4 × 48.3 cm)

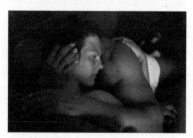

Nan Goldin (American, b. 1953)
Valerie and Gotscho embracing, Paris, 1999
Cibachrome print
30 × 40 in. (76.2 × 101.6 cm)

April Gornik (American, b. 1953)
Bay at Sunset, 2001
Oil on canvas
23 × 29 ½ in. (58.4 × 74.9 cm)

April Gornik (American, b. 1953)
Inlet, 2003
Lithograph
10 × 14 in. (25.4 × 35.6 cm)

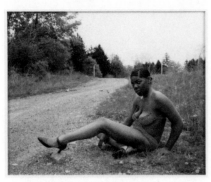

Katy Grannan (American, b. 1969)
Kamika, Near Route 9, Poughkeepsie, NY, 2003
C-print
48 × 60 in. (121.9 × 152.4 cm)

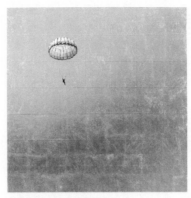

Isca Greenfield-Sanders (American, b. 1978)
Gold Parachute, 2008
Mixed media and oil on canvas
49 × 49 in. (124.5 × 124.5 cm)

Rachel Harrison (American, b. 1966)
Untitled (Perth Amboy), 2001
Chromogenic print
19 ¼ × 13 ¼ in. (48.9 × 33.7 cm)

Rachel Harrison (American, b. 1966)
Untitled, 2008
Pigmented inkjet print
16 × 12 in. (46.8 × 30.4 cm)

Mona Hatoum (Palestinian, b. 1952)
Projection, 2006
Cotton and abaca
35 × 55 in. (88.9 × 139.7 cm)

Mona Hatoum (Palestinian, b. 1952)
Projection (abaca), 2006
Abaca
30 × 50 ½ in. (76.2 × 128.3 cm)

Charline von Heyl (German, b. 1960)
Untitled, 2003
Photocopy, collage, ink on paper
24 × 19 in. (61 × 48.3 cm)

Jenny Holzer (American, b. 1950)
Stripes, 2007
Electronic LED signs with color diodes. 7 parts,
23 × 1 ⅞ × ½ in. (58.6 × 4.8 × 1.3 cm) each
See complete text, pages 228–33

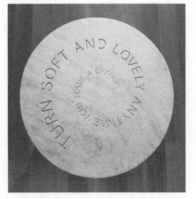

Jenny Holzer (American, b. 1950)
Turn Soft, 2011
Indiana buff limestone
16 ¼ × 30 × 30 in. (41.3 × 76.2 × 76.2 cm)

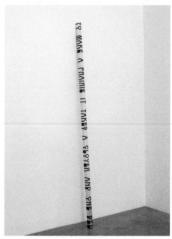

Roni Horn (American, b. 1955)
Key and Cue, No. 1755, 1996
Aluminum and plastic
102 ¾ × 2 × 2 in. (261 × 5.1 × 5.1 cm)

Lisa Kereszi (American, b. 1973)
Gael Dressing, State Palace Theater, New Orleans, LA, 2000. Chromogenic print
40 × 50 in. (101.6 × 127 cm)

Karen Kilimnik (American, b. 1955)
Prince Siegfried Arriving Home in Vienna 1800's from Versailles 1500's, 2000
Water-soluble oil color on canvas
14 × 11 in. (35.6 × 27.9 cm)

Carla Klein (Dutch, b. 1970)
Untitled, 2005
Oil on canvas
71 × 138 in. (180.3 × 350.5 cm)

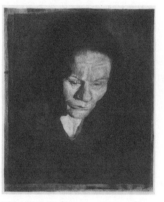

Käthe Kollwitz (German, 1867–1945)
Untitled, 1921
Etching
15 ¼ × 12 ¾ in. (38.7 × 32.4 cm)

Käthe Kollwitz (German, 1867–1945)
Self-Portrait in Profile, 1927
Lithograph on thin cream wove paper
18 × 15 ½ in. (45.7 × 39.4 cm)

Käthe Kollwitz (German, 1867–1945)
Call of Death, ca. 1937
Lithograph on cream wove paper
19 ¾ × 17 in. (50.2 × 43.2 cm)

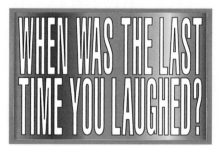

Barbara Kruger (American, b. 1945)
"Untitled" (When was the last time you laughed?), 2011. Archival pigment print
32 × 50 in. (81.3 × 127 cm)

Justine Kurland (American, b. 1969)
Ghost Ship, 2001
C-print mounted on Sintra
30 × 40 in. (76.2 × 101.6 cm)

Inez van Lamsweerde (American, b. Nether-
lands, 1963) and **Vinoodh Matadin** (American,
b. Netherlands, 1961)
Anastasia, 1994
C-print. 53 × 47 ½ in. (134.6 × 120.7 cm)

Evelyn H. Lauder (American, b. Austria,
1936–2011)
Aww, Gee, 2005, from *Ten Beauties Photog-
raphy Portfolio*. Color photograph
9 × 13 ½ in. (22.9 × 34.3 cm)

Evelyn H. Lauder (American, b. Austria,
1936–2011)
Carmen Miranda, 2005, from *Ten Beauties
Photography Portfolio*. Color photograph
9 × 13 ½ in. (22.9 × 34.3 cm)

Evelyn H. Lauder (American, b. Austria,
1936–2011)
Eyeshadow Please, 2005, from *Ten Beauties
Photography Portfolio*. Color photograph
13 ½ × 9 in. (22.9 × 34.3 cm)

Evelyn H. Lauder (American, b. Austria,
1936–2011)
This Party's Over, 2005, from *Ten Beauties
Photography Portfolio*. Color photograph
13 ½ × 9 in. (22.9 × 34.3 cm)

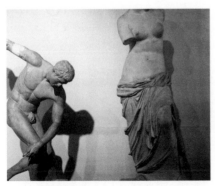

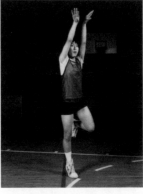

Louise Lawler (American, b. 1947)
Discus and Venus, 1997/2002
Cibachrome mounted on aluminum
47 × 57 in. (119.4 × 144.8 cm)

Sherrie Levine (American, b. 1947)
After Egon Schiele, 1984
Watercolor and pencil on paper
7 ¼ × 10 ¾ in. (18.4 × 27.3 cm)

Sharon Lockhart (American, b. 1964)
*Goshogaoka Girls Basketball Team: Ayako
Sano*, 1997. Framed chromogenic print
45 × 38 in. (114.3 × 96.5 cm)

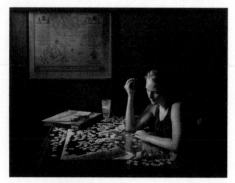

Sharon Lockhart (American, b. 1964)
Untitled, 2010
Chromogenic print
38 × 50 in. (96.5 × 127 cm)

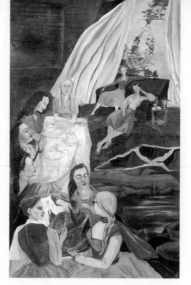

Rosa Loy (German, b. 1958)
Das Essen, 2008
Casein on linen
98 ½ × 59 in. (250.2 × 149.9 cm)

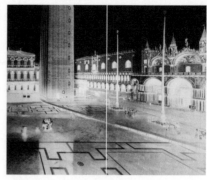

Vera Lutter (German, b. 1960)
San Marco, Venice XIX: December 1, 2005, 2005
Gelatin silver print
91 ½ × 112 in. (232.4 × 284.5 cm)

Mary Lydecker (American, b. 1982)
Canadian Rockies (Hartford, CT), 2009
Collage. 5 × 5 ½ in. (12.7 × 14 cm)

Malerie Marder (American, b. 1971)
One, 2006
C-print. 48 × 67 ½ in. (121.9 × 171.5 cm)

Rachel Mason (American, b. 1978)
Model Anthem, 2003
Video (color, sound), plaque. 12 minutes

Kim McCarty (American, b. 1956)
Double Leaves, 2011
Watercolor on paper
30 × 22 in. (76.2 × 55.9 cm)

Kim McCarty (American, b. 1956)
Single Strand, 2012
Watercolor on paper
77 ½ × 45 in. (196.9 × 114.3 cm)

Julie Mehretu (American, b. Ethiopia 1970)
Untitled, 2004
Graphite on paper
25 ¾ × 40 in. (65.4 × 101.6 cm)

Ana Mendieta (American, b. Cuba, 1948–1985)
Untitled (Glass on Body Imprints), 1972
Suite of 6 color photographs
19 × 12 ½ in. (48.3 × 31.8 cm) each

Annette Messager (French, b. 1943)
Mes ouvrages de broderies, 1988
Mixed media
3 parts, 17 ¼ × 17 ¼ in. (43.8 × 43.8 cm) each

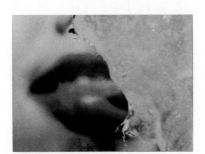

Marilyn Minter (American, b. 1948)
Half & Half, 2008
C-print
29 ½ × 40 in. (74.9 × 101.6 cm)

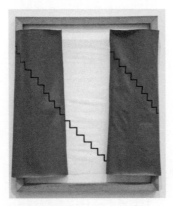

Dianna Molzan (American, b. 1972)
Untitled, 2011
Oil on canvas and silk on poplar
36 × 29 in. (91.4 × 73.7 cm)

Zanele Muholi (South African, b. 1972)
Sunday Francis Mdlankomo, Vosloorus, Johannesburg, from the series *Faces & Phases*, 2011
Gelatin silver print. 30 × 20 in. (76.2 × 50.8 cm)

Elizabeth Murray (American, 1940–2007)
Blue Shadow, 2001
Watercolor on paper
19 × 12 in. (48.3 × 30.5 cm)

Ruby Neri (American, b. 1970)
Untitled, 2011
Oil on panel
60 × 60 in. (152.4 × 152.4 cm)

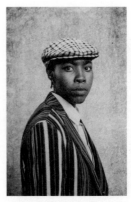

Shirin Neshat (Iranian, b. 1957)
Untitled, from the series *Rapture*, 1999
Iris print
15 × 23 in. (38.1 × 58.4 cm)

Louise Nevelson (American, b. Ukraine, 1899–1988)
December Wedding, 1984
Wood, paper, cloth, palm bark
40 × 32 in. (101.6 × 81.3 cm)

Paulina Ołowska (Polish, b. 1976)
Abstrakcyjna Choreografia, 2006
Acrylic and collage on canvas
98 × 55 in. (248.9 × 139.7 cm)

Catherine Opie (American, b. 1961)
Catherine, Melanie, and Sadie Rain, New York, New York, 1998
Chromogenic print. 40 × 50 in. (101.6 × 127 cm)

Sarah Peters (American, b. 1973)
Descendants & Believers, #3, 2010
Bronze
15 × 8 ½ × 9 in. (38.1 × 21.6 × 22.9 cm)

Sally Pettus (American, b. 1942)
Red Car, Liberty Street, 2010
Oil on canvas
36 × 36 in. (91.4 × 91.4 cm)

Elizabeth Peyton (American, b. 1965)
Kirsty at the Getty Center, 2001
Colored pencil on paper
8 ⅝ × 6 in. (21.9 × 15.2 cm)

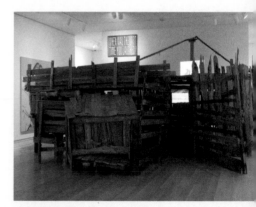

Ellen Phelan (American, b. 1943)
Gate: Westport, 2002
Gouache and watercolor on paper
20 ¾ × 28 ¾ in. (52.7 × 73 cm)

Elaine Reichek (American, b. 1943)
Sampler (Kruger/Holzer), 1998
Embroidery on linen
28 ½ × 20 in. (72.4 × 50.8 cm)

Mika Rottenberg (Argentine, b. 1976)
Cheese, 2008
Multichannel video installation (color, sound)
Dimensions variable

Valerie Rout (American, 1933–2010)
The Tip, Cozy Corner, Amenia, NY, 2004
Color photograph
29 ½ × 19 ¾ in. (74.9 × 50.2 cm)

Michal Rovner (Israeli, b. 1957)
Dahui, 2004
Steel vitrine with glass, stone, DVD video
projection (black and white, silent)
57 ⅛ × 32 × 20 in. (145.1 × 81.3 × 50.8 cm)

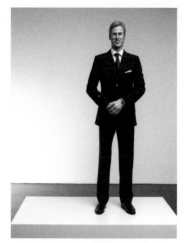

Jennifer Rubell (American, b. 1971)
*'Engagement (with Prince William sculpted by
Daniel Druet),'* 2011. Wax and resin mannequin,
wool suit, leather shoes, watch
76 ⅜ × 24 ¼ × 14 ½ in. (194 × 61.5 × 37 cm)

Lisa Ruyter (American, b. 1968)
*Dorothea Lange "Destitute peapickers in
California. Mother of seven children. Age
thirty-two. Nipomo, California,"* 2009
Acrylic on canvas. 98 ⁷⁄₁₆ × 78 ¾ in.
(250 × 200 cm)

Victoria Sambunaris (American, b. 1964)
Untitled (VS-10-05), from the series *Border,*
2010
Chromogenic print. 55 × 77 in. (139.7 × 195.6 cm)

Katy Schimert (American, b. 1963)
Untitled, 1999
Watercolor and crayon on paper
13 ½ × 19 ½ in. (34.2 × 49.5 cm)

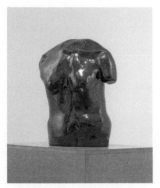

Katy Schimert (American, b. 1963)
Female Torso, 2001
Terra-cotta with black onyx
18 × 13 × 8 in. (45.7 × 33 × 20.3 cm)

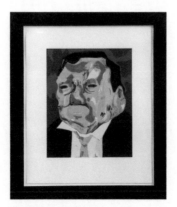

Dana Schutz (American, b. 1976)
Untitled (Poisoned Man), 2006
Woodblock and silk screen print
30 × 26 ¾ in. (76.2 × 67.9 cm)

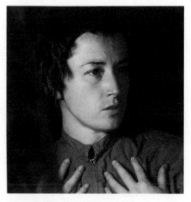

Cindy Sherman (American, b. 1954)
Untitled, 1982
Chromogenic color print
36 × 36 in. (91.4 × 91.4 cm)

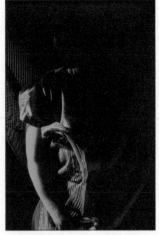

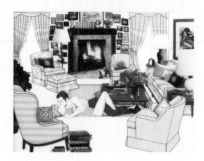

Cindy Sherman (American, b. 1954)
Untitled, 1982
Color print
44 × 29 ¼ in. (111.8 × 74.3 cm)

Laurie Simmons (American, b. 1949)
The Instant Decorator, 2001–4
Flex prints
18 prints, 30 × 40 in. (76.2 × 101.6 cm) each

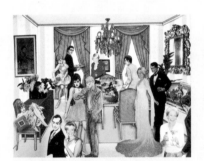

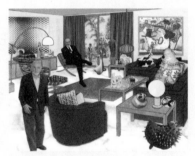

Laurie Simmons (American, b. 1949)
The Instant Decorator (Melva), 2006
Flex print
48 × 62 ½ in. (121.9 × 158.8 cm)

Laurie Simmons (American, b. 1949)
The Instant Decorator (Ray), 2010
Flex print
48 × 62 ½ in. (121.9 × 158.8 cm)

Lorna Simpson (American, b. 1960)
Summer '57/09, 2009
Gelatin silver prints
9 prints, 5 × 5 in. (12.7 × 12.7 cm) each

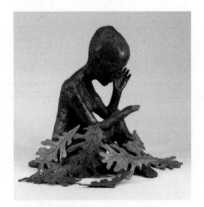

Kiki Smith (American, b. Germany 1954)
Autumn I, 2000
Silica bronze with patina
26 × 20 × 27 in. (66 × 50.8 × 68.6 cm)

Shinique Smith (American, b. 1971)
the step and the walk, 2010
Ink and acrylic on canvas over wood panel
84 × 180 in. (213.4 × 457.2 cm)

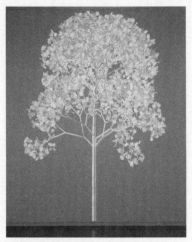

Jennifer Steinkamp (American, b. 1958)
Mike Kelley, 2007
Computer video installation
Dimensions variable

Pat Steir (American, b. 1940)
Chrysanthemum, 1982
Woodblock print
14 ½ × 20 ⅛ in. (36.8 × 51.1 cm)

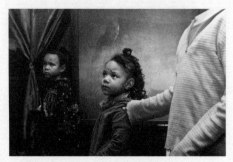

Louisa Marie Summer (German, b. 1983)
She Gets Away with Murder, 2010
Color photograph on Dibond (aluminum
composite panel)
39 × 59 in. (99.1 × 149.9 cm)

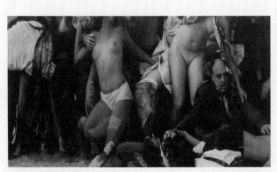

Eve Sussman (English, b. 1961)
and Rufus Corporation
Untitled (Hydra as Gomorrah), video still from
The Rape of the Sabine Women, 2006
Inkjet print. 24 × 36 in. (61 × 91.4 cm)

Ena Swansea (American, b. 1966)
Identity, 2006
Oil on graphite on linen
60 × 96 in. (152.4 × 243.8 cm)

Sarah Sze (American, b. 1969)
Untitled, 1998
Color photograph
15 ½ × 19 ½ in. (39.4 × 49.5 cm)

Mickalene Thomas (American, b. 1971)
Sandra: She's a Beauty, 2009
Mounted C-print
30 × 20 in. (76.2 × 50.8 cm)

Rosemarie Trockel (German, b. 1952)
Untitled, 1986
Watercolor on paper
13 ¾ × 9 ¾ in. (34.9 × 24.8 cm)

Su-Mei Tse (Luxembourger, b. 1973)
Swing, 2007
Neon, motor, transformer
104 ⅜ × 16 ½ × 8 ¼ in. (265 × 42 × 21 cm)

Nicola Tyson (British, b. 1960)
Man and Woman, 1997
Gouache on paper (diptych)
2 parts, 33 ⅝ × 26 ⅝ in. (85.4 × 67.6 cm) each

Jorinde Voigt (German, b. 1977)
Botanic Code—M. M. Gryshko National Botanical Garden, Kiev (August 2010), 2010
Industrial paint and ink on aluminum rods
24 parts, 118 in. (299.7 cm) each

Kara Walker (American, b. 1969)
Restraint, 2009
Etching with aquatint and sugarlift
31 × 23 ⅞ in. (78.7 × 60.6 cm)

Paloma Varga Weisz (German, b. 1966)
Untitled, 2004
Watercolor and pencil on paper
16 ½ × 11 ¾ in. (41.9 × 29.9 cm)

Paloma Varga Weisz (German, b. 1966)
Gesicht nach rechts gerückt, 2005
Aquarelle and colored pencil on paper
16 ½ × 11 ¾ in. (41.9 × 29.9 cm)

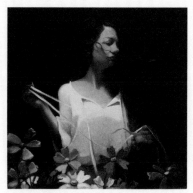

Paloma Varga Weisz (German, b. 1966)
Tumor Man, 2005
Aquarelle on paper
14 ¾ × 11 ½ in. (37.5 × 29.2 cm)

Rachel Whiteread (British, b. 1963)
Daybed, 1999
Beech wood and multidensity foams with wool upholstery
16 ¾ × 77 ½ × 33 ⅜ in. (42.6 × 196.9 × 84.8 cm)

Lisa Yuskavage (American, b. 1962)
G. with Flowers, 2003
Oil on linen
20 ½ × 21 in. (52.1 × 53.3 cm)

Complete Text of Jenny Holzer's *Stripes*

SPEARMINT (Truisms 1)

A LITTLE KNOWLEDGE CAN GO A LONG WAY A LOT OF PROFES-SIONALS ARE CRACKPOTS A MAN CAN'T KNOW WHAT IT'S LIKE TO BE A MOTHER A NAME MEANS A LOT JUST BY ITSELF A POSITIVE ATTITUDE MAKES ALL THE DIFFERENCE IN THE WORLD A RE-LAXED MAN IS NOT NECESSARILY A BETTER MAN A SENSE OF TIMING IS THE MARK OF GENIUS A SINCERE EFFORT IS ALL YOU CAN ASK A SINGLE EVENT CAN HAVE INFINITELY MANY INTER-PRETATIONS A SOLID HOME BASE BUILDS A SENSE OF SELF A STRONG SENSE OF DUTY IMPRISONS YOU ABSOLUTE SUBMISSION CAN BE A FORM OF FREEDOM ABSTRACTION IS A TYPE OF DECA-DENCE ABUSE OF POWER COMES AS NO SURPRISE ACTION CAUSES MORE TROUBLE THAN THOUGHT ALIENATION PRODUCES ECCENTRICS OR REVOLUTIONARIES ALL THINGS ARE DELICATELY INTERCONNECTED AMBITION IS JUST AS DANGEROUS AS COM-PLACENCY AMBIVALENCE CAN RUIN YOUR LIFE AN ELITE IS IN-EVITABLE ANGER OR HATE CAN BE A USEFUL MOTIVATING FORCE ANIMALISM IS PERFECTLY HEALTHY ANY SURPLUS IS IMMORAL ANYTHING IS A LEGITIMATE AREA OF INVESTIGATION ARTIFICIAL DESIRES ARE DESPOILING THE EARTH AT TIMES INACTIVITY IS PREFERABLE TO MINDLESS FUNCTIONING AT TIMES YOUR UN-CONSCIOUS IS TRUER THAN YOUR CONSCIOUS MIND AUTOMATION IS DEADLY AWFUL PUNISHMENT AWAITS REALLY BAD PEOPLE BAD INTENTIONS CAN YIELD GOOD RESULTS BEING ALONE WITH YOURSELF IS INCREASINGLY UNPOPULAR BEING HAPPY IS MORE IMPORTANT THAN ANYTHING ELSE BEING JUDGMENTAL IS A SIGN OF LIFE BEING SURE OF YOURSELF MEANS YOU'RE A FOOL BE-LIEVING IN REBIRTH IS THE SAME AS ADMITTING DEFEAT BORE-DOM MAKES YOU DO CRAZY THINGS CALM IS MORE CONDUCIVE TO CREATIVITY THAN IS ANXIETY CATEGORIZING FEAR IS CALMING CHANGE IS VALUABLE WHEN THE OPPRESSED BECOME TYRANTS CHASING THE NEW IS DANGEROUS TO SOCIETY CHILDREN ARE THE HOPE OF THE FUTURE CHILDREN ARE THE MOST CRUEL OF ALL CLASS ACTION IS A NICE IDEA WITH NO SUBSTANCE CLASS STRUCTURE IS AS ARTIFICIAL AS PLASTIC CONFUSING YOURSELF IS A WAY TO STAY HONEST

CRYSTAL YELLOW (Inflammatory Essays)

A CRUEL BUT ANCIENT LAW DEMANDS AN EYE FOR AN EYE MUR-DER MUST BE ANSWERED BY EXECUTION ONLY GOD HAS THE RIGHT TO TAKE A LIFE AND WHEN SOMEONE BREAKS THIS LAW HE WILL BE PUNISHED JUSTICE MUST COME SWIFTLY IT DOESN'T HELP ANYONE TO STALL THE VICTIM'S FAMILY CRIES OUT FOR SATISFACTION THE COMMUNITY BEGS FOR PROTECTION AND THE DEPARTED CRAVES VENGEANCE SO HE CAN REST THE KILLER KNEW IN ADVANCE THERE WAS NO EXCUSE FOR HIS ACT TRULY HE HAS TAKEN HIS OWN LIFE HE NOT SOCIETY IS RESPONSIBLE FOR HIS FATE HE ALONE STANDS GUILTY AND DAMNED BECAUSE THERE IS NO GOD SOMEONE MUST TAKE RESPONSIBILITY FOR MEN A CHARISMATIC LEADER IS IMPERATIVE HE CAN SUBORDINATE

THE SMALL WILLS TO THE GREAT ONE HIS STRENGTH AND HIS VISION REDEEM MEN HIS PERFECTION MAKES THEM GRATEFUL LIFE ITSELF IS NOT SACRED THERE IS NO DIGNITY IN THE FLESH UNDIRECTED MEN ARE CONTENT WITH RANDOM SQUALID POINT-LESS LIVES THE LEADER GIVES DIRECTION AND PURPOSE THE LEADER FORCES GREAT ACCOMPLISHMENTS MANDATES PEACE AND REPELS OUTSIDE AGGRESSORS HE IS THE ARCHITECT OF DESTINY HE DEMANDS ABSOLUTE LOYALTY HE MERITS UNQUES-TIONING DEVOTION HE ASKS THE SUPREME SACRIFICE HE IS THE ONLY HOPE CHANGE IS THE BASIS OF ALL HISTORY THE PROOF OF VIGOR THE OLD IS SOILED AND DISGUSTING BY NATURE STALE FOOD IS REPELLENT MONOGAMOUS LOVE BREEDS CONTEMPT SENILITY CRIPPLES THE GOVERNMENT THAT IS TOO POWERFUL TOO LONG UPHEAVAL IS DESIRABLE BECAUSE FRESH UNTAINTED GROUPS SEIZE OPPORTUNITY VIOLENT OVERTHROW IS APPRO-PRIATE WHEN THE SITUATION IS INTOLERABLE SLOW MODIFICA-TION CAN BE EFFECTIVE MEN CHANGE BEFORE THEY NOTICE AND RESIST THE DECADENT AND THE POWERFUL CHAMPION CONTI-NUITY —NOTHING ESSENTIAL CHANGES—THAT IS A MYTH IT WILL BE REFUTED THE NECESSARY BIRTH CONVULSIONS WILL BE TRIGGERED ACTION WILL BRING THE EVIDENCE TO YOUR DOOR-STEP DESTROY SUPERABUNDANCE STARVE THE FLESH SHAVE THE HAIR EXPOSE THE BONE CLARIFY THE MIND DEFINE THE WILL RESTRAIN THE SENSES LEAVE THE FAMILY FLEE THE CHURCH KILL THE VERMIN VOMIT THE HEART FORGET THE DEAD LIMIT TIME FORGO AMUSEMENT DENY NATURE REJECT ACQUAINTANCES DISCARD OBJECTS FORGET TRUTHS DISSECT MYTH STOP MOTION BLOCK IMPULSE CHOKE SOBS SWALLOW CHATTER SCORN JOY SCORN TOUCH SCORN TRAGEDY SCORN LIBERTY SCORN CONSTANCY SCORN HOPE SCORN EXALTATION SCORN REPRODUCTION SCORN VARIETY SCORN EMBELLISH-MENT SCORN RELEASE SCORN REST SCORN SWEETNESS SCORN THE LIGHT IT IS A QUESTION OF FORM AND FUNCTION IT IS A MATTER OF REVULSION DON'T TALK DOWN TO ME DON'T BE POLITE TO ME DON'T TRY TO MAKE ME FEEL NICE DON'T RELAX I'LL CUT THE SMILE OFF YOUR FACE YOU THINK I DON'T KNOW WHAT'S GOING ON YOU THINK I'M AFRAID TO REACT THE JOKE'S ON YOU I'M BIDING MY TIME LOOKING FOR THE SPOT YOU THINK NO ONE CAN REACH YOU NO ONE CAN HAVE WHAT YOU HAVE I'VE BEEN PLANNING WHILE YOU'RE PLAYING I'VE BEEN SAVING WHILE YOU'RE SPENDING THE GAME IS ALMOST OVER SO IT'S TIME YOU ACKNOWLEDGE ME DO YOU WANT TO FALL NOT EVER KNOWING WHO TOOK YOU? FEAR IS THE MOST ELEGANT WEAPON YOUR HANDS ARE NEVER MESSY THREATENING BODILY HARM IS CRUDE WORK INSTEAD ON MINDS AND BELIEFS PLAY INSECURI-TIES LIKE A PIANO BE CREATIVE IN APPROACH FORCE ANXIETY TO EXCRUCIATING LEVELS OR GENTLY UNDERMINE THE PUBLIC CONFIDENCE PANIC DRIVES HUMAN HERDS OVER CLIFFS AN ALTERNATIVE IS TERROR—INDUCED IMMOBILIZATION FEAR FEEDS ON FEAR PUT THIS EFFICIENT PROCESS IN MOTION MANIPULA-TION IS NOT LIMITED TO PEOPLE ECONOMIC SOCIAL AND DEMO-CRATIC INSTITUTIONS CAN BE SHAKEN IT WILL BE DEMONSTRAT-ED THAT NOTHING IS SAFE SACRED OR SANE THERE IS NO RESPITE FROM HORROR ABSOLUTES ARE QUICKSILVER RESULTS ARE SPECTACULAR FREEDOM IS IT! YOU'RE SO SCARED YOU WANT

TO LOCK UP EVERYBODY ARE THEY MAD DOGS? ARE THEY OUT TO KILL? MAYBE YES IS LAW IS ORDER THE SOLUTION? DEFINITELY NO WHAT CAUSED THIS SITUATION? LACK OF FREEDOM WHAT HAPPENS NOW? LET PEOPLE FULFILL THEIR NEEDS IS FREEDOM CONSTRUCTIVE OR IS IT DESTRUCTIVE? THE ANSWER IS OBVIOUS FREE PEOPLE ARE GOOD PRODUCTIVE PEOPLE IS LIBERATION DANGEROUS? ONLY WHEN OVERDUE PEOPLE AREN'T BORN RABID OR BERSERK WHEN YOU PUNISH AND SHAME YOU CAUSE WHAT YOU DREAD WHAT TO DO? LET IT EXPLODE RUN WITH IT DON'T CONTROL OR MANIPULATE MAKE AMENDS IT ALL HAS TO BURN IT'S GOING TO BLAZE IT IS FILTHY AND CAN'T BE SAVED A COUPLE OF GOOD THINGS WILL BURN WITH THE REST BUT IT'S OKAY EVERY PIECE IS PART OF THE UGLY WHOLE EVERYTHING CONSPIRES TO KEEP YOU HUNGRY AND AFRAID FOR YOUR BABIES DON'T WAIT ANY LONGER WAITING IS WEAKNESS WEAKNESS IS SLAVERY BURN DOWN THE SYSTEM THAT HAS NO PLACE FOR YOU RISE TRIUMPHANT FROM THE ASHES FIRE PURIFIES AND RELEASES ENERGY FIRE GIVES HEAT AND LIGHT LET FIRE BE THE CELEBRATION OF YOUR DELIVERANCE LET LIGHTNING STRIKE LET THE FLAMES DEVOUR THE ENEMY! PEOPLE MUST PAY FOR WHAT THEY HOLD FOR WHAT THEY STEAL YOU HAVE LIVED OFF THE FAT OF THE LAND NOW YOU ARE THE PIG WHO IS READY FOR SLAUGHTER YOU ARE THE OLD ENEMY THE NEW VICTIM WHEN YOU DO SOMETHING AWFUL EXPECT RETRIBUTION IN KIND LOOK OVER YOUR SHOULDER SOMEONE IS FOLLOWING THE POOR YOU HAVE ROBBED AND IGNORED ARE IMPATIENT PLEAD INNOCENT YOUR SQUEALS INVITE TORTURE PROMISE TO BE GOOD YOUR LIES EXCITE AND INFLAME YOU ARE TOO DEPRAVED TO REFORM TOO TREACHEROUS TO SPARE TOO HIDEOUS FOR MERCY RUN! JUMP! HIDE! PROVIDE SPORT FOR THE HUNTERS REJOICE! OUR TIMES ARE INTOLERABLE TAKE COURAGE FOR THE WORST IS A HARBINGER OF THE BEST ONLY DIRE CIRCUMSTANCE CAN PRECIPITATE THE OVERTHROW OF OPPRESSORS THE OLD AND CORRUPT MUST BE LAID TO WASTE BEFORE THE JUST CAN TRIUMPH OPPOSITION IDENTIFIES AND ISOLATES THE ENEMY CONFLICT OF INTEREST MUST BE SEEN FOR WHAT IT IS DO NOT SUPPORT PALLIATIVE GESTURES THEY CONFUSE THE PEOPLE AND DELAY THE INEVITABLE CONFRONTATION DELAY IS NOT TOLERATED FOR IT JEOPARDIZES THE WELL-BEING OF THE MAJORITY CONTRADICTION WILL BE HEIGHTENED THE RECKONING WILL BE HASTENED BY THE STAGING OF SEED DISTURBANCES THE APOCALYPSE WILL BLOSSOM REPRESSING SEX URGES IS SO BAD POISON DAMS UP INSIDE AND THEN IT MUST COME OUT WHEN SEX IS HELD BACK TOO LONG IT COMES OUT FAST AND WILD IT CAN DO A LOT OF HARM INNOCENT PEOPLE GET SHOT OR CUT BY CONFUSED SEX URGES THEY DON'T KNOW WHAT HIT THEM UNTIL TOO LATE PARENTS SHOULD LET CHILDREN EXPRESS THEMSELVES SO THEY DON'T GET MEAN EARLY ADULTS SHOULD MAKE SURE THEY FIND MANY OUTLETS ALL PEOPLE SHOULD RESPOND TO BIG SEX NEEDS DON'T MAKE FUN OF INDIVIDUALS AND SEND THEM AWAY IT'S BETTER TO VOLUNTEER THAN TO GET FORCED RUIN YOUR FUCKING SELF BEFORE THEY DO OTHERWISE THEY'LL SCREW YOU BECAUSE YOU'RE A NOBODY THEY'LL KEEP YOU ALIVE BUT YOU'LL HAVE TO CRAWL AND SAY THANK YOU FOR EVERY BONE THEY THROW YOU

MIGHT AS WELL STAY DRUNK OR SHOOT JUNK AND BE A CRAZY FUCKER IF THE RICH GUYS WANT TO PLAY WITH YOU MAKE THEM GET THEIR HANDS DIRTY SEND THEM AWAY GAGGING OR SOBBING IF THEY'RE SOFTHEARTED YOU'LL BE LEFT ALONE IF YOU'RE FRIGHTENING AND DEAD YOU'RE FREE! YOU CAN CHANGE THE RADIANT CHILD IN YOU TO A REFLECTION OF THE SHIT YOU WERE MEANT TO SERVE SHRIEK WHEN THE PAIN HITS DURING INTERROGATION REACH INTO THE DARK AGES TO FIND A SOUND THAT IS LIQUID HORROR A SOUND OF THE BRINK WHERE MAN STOPS AND THE BEAST AND NAMELESS CRUEL FORCES BEGIN SCREAM WHEN YOUR LIFE IS THREATENED FORM A NOISE SO TRUE THAT YOUR TORMENTOR RECOGNIZES IT AS A VOICE THAT LIVES IN HIS OWN THROAT THE TRUE SOUND TELLS HIM THAT HE CUTS HIS FLESH WHEN HE CUTS YOURS THAT HE CANNOT THRIVE AFTER HE TORTURES YOU SCREAM THAT HE DESTROYS ALL THE KINDNESS IN YOU AND BLACKENS EVERY VISION YOU COULD HAVE SHOWN HIM THE MOST EXQUISITE PLEASURE IS DOMINATION NOTHING CAN COMPARE WITH THE FEELING THE MENTAL SENSATIONS ARE EVEN BETTER THAN THE PHYSICAL ONES KNOWING YOU HAVE POWER HAS TO BE THE BIGGEST HIGH THE GREATEST COMFORT IT IS COMPLETE SECURITY PROTECTION FROM HURT WHEN YOU DOMINATE SOMEBODY YOU'RE DOING HIM A FAVOR HE PRAYS SOMEONE WILL CONTROL HIM YOU'RE HELPING HIM WHILE HELPING YOURSELF EVEN WHEN YOU GET MEAN HE LIKES IT SOMETIMES HE'S ANGRY AND FIGHTS BACK BUT YOU CAN HANDLE IT HE ALWAYS REMEMBERS WHAT HE NEEDS YOU ALWAYS GET WHAT YOU WANT WHAT SCARES PEASANTS IS THINKING THEIR BODIES WILL BE THROWN OUT IN PUBLIC AND LEFT TO ROT THEY FEEL SHAME — AS IF IT MATTERS WHAT POSITION THEIR LEGS ARE IN WHEN THEY'RE DEAD LUCKY THEY'RE SUPERSTITIOUS BECAUSE THEY'RE EASIER TO MANAGE MAKE AN EXAMPLE OF TWO OR THREE REBELS DROP THEIR BODIES BY A ROAD GET THEM FLAT AND DRY SO BONES SHOW AND THE GRASS WEARS THE CLOTHES SHOOT THE FINGERS OFF ANYONE WHO COMES TO COLLECT THE REMAINS THOSE BODIES STAY AS A SIGN OF ABSOLUTE AUTHORITY IF PEASANTS THINK THAT THEIR SOULS CAN'T REST SO MUCH THE BETTER WHEN YOU START TO LIKE PAIN THINGS GET INTERESTING PAIN IS THE COMMON RESULT OF A SUBORDINATE POSITION TRADITIONALLY SUFFERING IS UNCOMFORTABLE AND UNDESIRABLE PERHAPS IT IS MORE INTELLIGENT TO CULTIVATE PAIN AS A MEANS OF LIBERATION? IS IT POSSIBLE THAT ENJOYMENT OF PAIN CAN BE SUBVERSIVE? WHEN ONE DOES NOT FEAR PAIN ONE CANNOT BE MANIPULATED WHEN AROUSED BY SUFFERING ONE CAN CONTROL ANY RELATIONSHIP WHEN AGONY CEASES TO BE A BARRIER DEATH IS NOT FORBIDDING THE IMPLICATIONS ARE MARVELOUS PAIN IS NOT OPPRESSIVE BUT STRENGTHENING AND MOST SUBLIME IT IS NECESSARY ONLY TO DENY THE PLEASURE-PAIN DICHOTOMY YOU GET AMAZING SENSATIONS FROM GUNS YOU GET RESULTS FROM GUNS MAN IS AN AGGRESSIVE ANIMAL YOU HAVE TO HAVE A GOOD OFFENSE AND A GOOD DEFENSE TOO MANY CITIZENS THINK THEY ARE HELPLESS THEY LEAVE EVERYTHING TO THE AUTHORITIES AND THIS CAUSES CORRUPTION RESPONSIBILITY SHOULD GO BACK WHERE IT BELONGS IT IS YOUR LIFE SO TAKE CONTROL AND FEEL VITAL THERE MAY BE SOME ACCIDENTS ALONG THE PATH TO SELF-EXPRESSION AND

SELF-DETERMINATION SOME HARMLESS PEOPLE WILL BE HURT
HOWEVER G-U-N SPELLS PRIDE TO THE STRONG SAFETY TO THE
WEAK AND HOPE TO THE HOPELESS GUNS MAKE WRONG RIGHT
FAST YOU GET SO YOU DON'T EVEN NOTICE THE HALF-DEAD VA-
GRANTS ON THE STREET THEY'RE ONLY DIRTY GHOSTS THE
ONES WHO SEND SHIVERS DOWN YOUR SPINE ARE THE UNEM-
PLOYED WHO AREN'T WEAK YET THEY STILL CAN FIGHT AND RUN
WHEN THEY WANT TO THEY STILL THINK AND THEY KNOW THEY
HATE YOU YOU WON'T BE A PRETTY SIGHT IF THEY GO FOR YOU
WHEN YOU'RE OUT WALKING YOU LOOK AT THE MEN FOR SIGNS OF
LINGERING HEALTH AND OBVIOUS HATRED YOU EVEN WATCH THE
FALLEN ONES WHO MIGHT MAKE A LAST MOVE WHO MIGHT CLAW
YOUR ANKLE AND TAKE YOU DOWN YOU'RE AN AVENGER A
DEATH ANGEL YOU KILL PEOPLE WHO ASK FOR IT WHO DESERVE
TO DIE YOU'RE A WATCHDOG A PROTECTOR OF THINGS DECENT
YOUR COMFORTS ARE SACRIFICED FOR EFFICIENCY — YOU CAN'T
DO WHAT HAS TO BE DONE WITH PEOPLE MOANING AND CLINGING
TO YOU YOU CAN'T STRIKE WITH POSSESSIONS WEIGHING YOU
DOWN YOU HAVE A CLEAR HEAD AND NO REGRETS YOU CAN
TAKE OUT ANYONE BECAUSE YOU'RE STRIPPED DOWN AND YOU
DON'T DEPEND ON OR TRUST A SOUL YOU ARE EFFECTIVE BE-
CAUSE YOU DON'T LOVE ANYBODY OR ANYTHING YOU'RE A ONE-
MAN FORCE THE PERFECT INSTRUMENT OF DESTINY

MAGENTA (Truisms 2)

CRIME AGAINST PROPERTY IS RELATIVELY UNIMPORTANT DECA-
DENCE CAN BE AN END IN ITSELF DECENCY IS A RELATIVE THING
DEPENDENCE CAN BE A MEAL TICKET DESCRIPTION IS MORE
VALUABLE THAN METAPHOR DEVIANTS ARE SACRIFICED TO IN-
CREASE GROUP SOLIDARITY DISGUST IS THE APPROPRIATE RE-
SPONSE TO MOST SITUATIONS DISORGANIZATION IS A KIND OF
ANESTHESIA DON'T PLACE TOO MUCH TRUST IN EXPERTS DRAMA
OFTEN OBSCURES THE REAL ISSUES DREAMING WHILE AWAKE IS
A FRIGHTENING CONTRADICTION DYING AND COMING BACK GIVES
YOU CONSIDERABLE PERSPECTIVE DYING SHOULD BE AS EASY AS
FALLING OFF A LOG EATING TOO MUCH IS CRIMINAL ELABORA-
TION IS A FORM OF POLLUTION EMOTIONAL RESPONSES ARE AS
VALUABLE AS INTELLECTUAL RESPONSES ENJOY YOURSELF BE-
CAUSE YOU CAN'T CHANGE ANYTHING ANYWAY ENSURE THAT
YOUR LIFE STAYS IN FLUX EVEN YOUR FAMILY CAN BETRAY YOU
EVERY ACHIEVEMENT REQUIRES A SACRIFICE EVERYONE'S WORK
IS EQUALLY IMPORTANT EVERYTHING THAT'S INTERESTING IS
NEW EXCEPTIONAL PEOPLE DESERVE SPECIAL CONCESSIONS
EXPIRING FOR LOVE IS BEAUTIFUL BUT STUPID EXPRESSING
ANGER IS NECESSARY EXTREME BEHAVIOR HAS ITS BASIS IN
PATHOLOGICAL PSYCHOLOGY EXTREME SELF-CONSCIOUSNESS
LEADS TO PERVERSION FAITHFULNESS IS A SOCIAL NOT A BIO-
LOGICAL LAW FAKE OR REAL INDIFFERENCE IS A POWERFUL
PERSONAL WEAPON FATHERS OFTEN USE TOO MUCH FORCE
FEAR IS THE GREATEST INCAPACITATOR FREEDOM IS A LUXURY
NOT A NECESSITY GIVING FREE REIN TO YOUR EMOTIONS IS AN
HONEST WAY TO LIVE GO ALL OUT IN ROMANCE AND LET THE
CHIPS FALL WHERE THEY MAY GOING WITH THE FLOW IS SOOTH-
ING BUT RISKY GOOD DEEDS EVENTUALLY ARE REWARDED

GOVERNMENT IS A BURDEN ON THE PEOPLE GRASS ROOTS AGI-
TATION IS THE ONLY HOPE GUILT AND SELF-LACERATION ARE
INDULGENCES HABITUAL CONTEMPT DOESN'T REFLECT A FINER
SENSIBILITY HIDING YOUR MOTIVES IS DESPICABLE HOLDING
BACK PROTECTS YOUR VITAL ENERGIES HUMANISM IS OBSOLETE
HUMOR IS A RELEASE IDEALS ARE REPLACED BY CONVENTIONAL
GOALS AT A CERTAIN AGE

PUMPKIN (Living)

IT IS UNFAIR TO TEAR SOMEBODY APART WHEN HER HEALTH AND
EXUBERANCE THREATEN YOU THE HEART CAN STOP WHEN YOU
HEAR SOMETHING NOT MEANT FOR YOUR EARS THE CONSOLA-
TION IS THAT THIS MIGHT BE THE TRUTH YOU WONDER IF THE
PAIN IN THE SIDE YOU GET FROM MILD EXERTION WOULD GO AWAY
IF YOU WERE BEING CHASED BY SOMEONE WITH A BROKEN BOTTLE
YOU'RE HOME FREE AS SOON AS NO ONE KNOWS WHERE TO FIND
YOU MANY INDIVIDUALS PRACTICE SELF-LIMITATION THEY AT-
TEMPT LITTLE OF WHAT THEY COULD REALIZE INTELLECTUALLY OR
PRACTICALLY WHETHER THIS IS A RESULT OF OPPRESSION OR A
NATURAL PHENOMENON REMAINS UNCLEAR SOMETIMES THE
MOST DECADENT FIND PLEASURE IN GIVING AWAY THEIR PRIVI-
LEGES AND EVEN THEIR LIVES SO A BALANCE IS STRUCK YOU
HAVE A SICK ONE ON YOUR HANDS WHEN YOUR AFFECTION IS
USED TO PUNISH YOU HOW CONCISE THAT YOU CAN CRY FROM
AWFUL WOUNDS DESERTION HAPPINESS MEMORIES HUMILIATION
DISAPPOINTMENT OR GRANDEUR LARGE FORTUNES CAN BE
BUILT ON SMALL ITEMS ENOUGH CANDY CAN BE PARLAYED INTO
HOUSES FAT ANIMALS AND LANDSCAPING PETS CAN BE CHOSEN
BY THEIR ABILITY TO EXPRESS GREAT EXCITEMENT AFFECTION AND
GRATITUDE REPTILES DON'T SHOW MUCH BUT ARE VALUED AS
EXOTICA A SINGLE RELATIONSHIP CAN POISON EVERY MINUTE OF
THE DAY WAKING OR SLEEPING WHEN THIS DRAGS ON YOU HAVE
TO QUESTION THE SANITY OR THE CRIMINALITY OF THOSE IN-
VOLVED A FAMILIAR HILLSIDE LOOKS TENDER IN THE WINTER
WHEN THERE ARE BARE TREES STICKING UP THE SAME GOES FOR
A BODY WITH STUBBLE WHEN YOU'RE SENTIMENTAL ABOUT A
SHAVED PERSON FEW CAN IGNORE A BABY'S CRIES EVEN IF THE
RESPONSE IS IRRITATION THIS IS ONE OF THE BUILT-IN SAFE-
GUARDS THAT IS SUPPOSED TO GUARANTEE THE SURVIVAL OF THE
RACE UP TO A CERTAIN AGE MANY PEOPLE TAKE PLEASURE IN
MARKING AND SCARRING THEMSELVES THEN COMES A TIME
WHEN THE SAME INDIVIDUALS START TO CONSERVE THEIR
STRENGTH AND BEAUTY IT'S NICE WHEN YOU DECIDE YOU LIKE
SOMEONE AND WITHOUT DECLARING YOURSELF DO WHAT'S POS-
SIBLE TO FURTHER HIS HAPPINESS THIS CAN TAKE THE FORM OF
GIFTS LOVELY FOOD PUBLICITY OR ADVANCE WARNING WHEN
YOU'RE TRYING SOMETHING NEW YOU'RE TORN BETWEEN ANTICI-
PATING A DELIGHTFUL SURPRISE AND THINKING YOU'RE A FOOL TO
IGNORE WHAT YOU KNOW YOU LIKE SOMETIMES YOU HAVE NO
OTHER CHOICE BUT TO WATCH SOMETHING GRUESOME OCCUR
YOU DON'T HAVE THE OPTION OF CLOSING YOUR EYES BECAUSE IT
HAPPENS FAST AND ENTERS YOUR MEMORY HAVING TWO OR
THREE PEOPLE IN LOVE WITH YOU IS LIKE MONEY IN THE BANK
THE SMALLEST THING CAN MAKE SOMEBODY SEXUALLY UNAP-

PEALING A MISPLACED MOLE OR A PARTICULAR HAIR PATTERN CAN DO IT THERE'S NO REASON FOR THIS BUT IT'S JUST AS WELL YOU CAN WATCH PEOPLE ALIGN THEMSELVES WHEN TROUBLE IS IN THE AIR SOME PREFER TO BE CLOSE TO THOSE AT THE TOP AND OTHERS WANT TO BE NEAR THOSE AT THE BOTTOM IT'S A QUESTION OF WHO FRIGHTENS THEM MORE AND WHOM THEY WANT TO BE LIKE IT'S NO FUN WATCHING PEOPLE WOUND THEMSELVES SO THAT THEY CAN HOLE UP NURSE THEMSELVES BACK TO HEALTH AND REPEAT THE CYCLE THEY DON'T KNOW WHAT ELSE TO DO HANDS-ON SOCIALIZATION PROMOTES HAPPY INTERPERSONAL RELATIONS THE DESIRE FOR AND THE DEPENDENCE UPON FONDLING ENSURE REPEATED ATTEMPTS TO OBTAIN CARESSES AND THE WILLINGNESS TO RECIPROCATE THE MOUTH IS INTERESTING BECAUSE IT'S ONE OF THOSE PLACES WHERE THE DRY OUTSIDE MOVES TOWARD THE SLIPPERY INSIDE THE RICH KNIFING VICTIM CAN FLIP AND FEEL LIKE THE AGGRESSOR IF HE THINKS ABOUT PRIVILEGE HE ALSO CAN FIND THE CUT SYMBOLIC OR PROPHETIC HOW DO YOU RESIGN YOURSELF TO SOMETHING THAT WILL NEVER BE? YOU STOP WANTING THAT THING YOU GO NUMB OR YOU KILL THE AGENT OF DESIRE I SAW THEM STRIP A MAN SO THAT IN A MATTER OF SECONDS HE LAY CURLED AND NAKED ON THE SIDEWALK IF YOUR CLOTHES CATCH ON FIRE DROP DOWN IMMEDIATELY ROLL UP IN A BLANKET COAT OR RUG TO SMOTHER THE FLAMES REMOVE ALL SMOLDERING CLOTHING AND CALL A DOCTOR OR AMBULANCE YOU HAVE TO MAKE THOUSANDS OF PRECISE AND RAPID MOVEMENTS TO PREPARE A MEAL CHOPPING STIRRING AND TURNING PREDOMINATE AFTERWARDS YOU STACK AND MAKE CIRCULAR CLEANING AND RINSING MOTIONS SOME PEOPLE NEVER COOK BECAUSE THEY DON'T LIKE IT SOME NEVER COOK BECAUSE THEY HAVE NOTHING TO EAT FOR SOME COOKING IS A ROUTINE AND FOR OTHERS AN ART IF YOU'RE SMART YOU WATCH FOR CHANGES IN COLOR THIS CAN APPLY TO SEEING THAT FRUIT IS RIPE OR NOTICING THE FLUSH THAT GOES WITH FEVER DRUNKENNESS OR FURY WHEN YOU'RE ON THE VERGE OF DETERMINING THAT YOU DON'T LIKE SOMEONE IT'S AWFUL WHEN HE SMILES AND HIS TEETH LOOK ABSOLUTELY EVEN AND FALSE IT CAN BE STARTLING TO SEE SOMEONE'S BREATH LET ALONE THE BREATHING OF A CROWD YOU DON'T BELIEVE THAT PEOPLE EXTEND THAT FAR IT IS HARD TO KNOW WHAT SOMEONE WANTS BECAUSE YOU CAN'T ACTUALLY FEEL HIS NEEDS YOU DEVELOP WAYS TO READ OR ANTICIPATE DEMANDS OR YOU WAIT UNTIL YOU'RE ASSAULTED AND THEN HIS REQUIREMENTS BECOME TANGIBLE YOU REALIZE THAT YOU'RE ALWAYS SHEDDING PARTS OF THE BODY AND LEAVING MEMENTOS EVERYWHERE AFFLUENT COLLEGE-BOUND STUDENTS FACE THE REAL PROSPECT OF DOWNWARD MOBILITY FEELINGS OF ENTITLEMENT CLASH WITH THE AWARENESS OF IMMINENT SCARCITY THERE IS RESENTMENT AT GROWING UP AT THE END OF AN ERA OF PLENTY COUPLED WITH A REASSESSMENT OF CONVENTIONAL MEASURES OF SUCCESS IF SOMEONE IS WILD PUNISHMENT WILL LEAVE HIM SULLEN AND WILL ONLY MAKE HIM WAIT FOR ANOTHER CHANCE HE DOESN'T HAVE THE IDEA THAT UNACCEPTABLE BEHAVIOR CAUSES PAIN AND MUST AT ALL COSTS BE AVOIDED YOU SHOULD LIMIT THE NUMBER OF TIMES YOU ACT AGAINST YOUR NATURE LIKE SLEEPING WITH PEOPLE YOU HATE IT'S INTERESTING TO TEST YOUR CAPABILITIES FOR A WHILE BUT

TOO MUCH WILL CAUSE DAMAGE IT'S AN EXTRAORDINARY FEELING WHEN PARTS OF YOUR BODY ARE TOUCHED FOR THE FIRST TIME I'M THINKING OF THE SENSATIONS FROM SEX AND SURGERY WHEN SOMEONE IS BREATHING YOU FEEL COOL AIR PULLED ACROSS YOUR SKIN FOLLOWED BY MOIST WARM AIR PUSHED IN THE OPPOSITE DIRECTION THIS OCCURS AT REGULAR INTERVALS AND MAKES A PERFECT TEMPERATURE MORE PEOPLE WILL BE BUILDING HIDING PLACES IN THEIR HOMES SMALL REFUGES THAT ARE UNDETECTABLE EXCEPT BY SOPHISTICATED DEVICES AFTER DARK IT'S A RELIEF TO SEE A GIRL WALKING TOWARD OR BEHIND YOU THEN YOU'RE MUCH LESS LIKELY TO BE ASSAULTED YOU LEARN THE HARD WAY TO KEEP A FINGER ON YOUR NIPPLE WHEN SHAVING YOUR BREAST YOUR BODY REFUSES TO OBEY WHEN YOU'RE VERY SICK THE WORST IS WHEN YOU'RE ALERT BUT INCAPABLE OF WILLING YOURSELF ERECT IT'S AN ODD FEELING WHEN YOU TRIGGER INSTINCTIVE BEHAVIOR LIKE NURSING IN SOMEONE IT'S FUNNY TO BE IN HIS PRESENCE WHILE A DIFFERENT PART OF THE NERVOUS SYSTEM TAKES OVER AND HIS EYES GET STRANGE BY YOUR RESPONSE TO DANGER IT IS EASY TO TELL HOW YOU HAVE LIVED AND WHAT HAS BEEN DONE TO YOU YOU SHOW WHETHER YOU WANT TO STAY ALIVE WHETHER YOU THINK YOU DESERVE TO AND WHETHER YOU BELIEVE IT'S ANY GOOD TO ACT EFFIGIES LET YOU STUDY OR ACT UPON SOMEONE WITH IMPUNITY THEY ARE GOOD FOR PRACTICE A LITTLE GIRL HAD BEEN IN A COMA FOR WEEKS BUT SMILED AND CAME OUT OF IT WHEN HER FRIENDS SANG SONGS IT'S SCARY WHEN THE VEINS ARE SO CLOSE TO THE SURFACE THAT THEY'RE VISIBLE AND EVEN PROTUBERANT ACCESS IS EASY TO THE BLOOD THAT TRANSPORTS THE NECESSARY CHEMICALS EVEN WITH YOUR EYES CLOSED YOU CAN SEE SOMEONE APPROACHING HIS SHADOW SHOWS ON THE INSIDES OF YOUR EYELIDS IT MAKES A DIFFERENCE WITH WHOM YOU'RE INTIMATE AND UPON WHOM YOU DEPEND FRIENDS WILL ONLY TOLERATE CERTAIN ACTIONS AND THIS INFLUENCES WHAT YOU BELIEVE TO BE POSSIBLE OR DESIRABLE GIFTED CHILDREN -- THOSE WITH AN IQ OF 125 OR ABOVE -- ARE PRONE TO FEELINGS OF ALIENATION FRUSTRATION AND BOREDOM THESE FEELINGS CAN CULMINATE IN VIOLENCE IF THE CHILDREN ARE NOT ENCOURAGED AND CHALLENGED THERE IS A TERRIBLE PHASE WHEN ABUSED ANIMALS OR CHILDREN ACT POLITELY AND TRY TO DO EVERYTHING RIGHT BY THIS STAGE THOUGH THEY ARE SO OBVIOUSLY WEAK AND UNAPPEALING THAT THEY GET LITTLE RESPONSE IF THEY DON'T DIE THEY BECOME SAVAGE IT TAKES A WHILE BEFORE YOU CAN STEP OVER INERT BODIES AND GO AHEAD WITH WHAT YOU WERE TRYING TO DO IT'S A SAFE GAME TO PLAY WITH YOUR NOSE SHUTTING OFF THE AIR AND LETTING IT FLOW AGAIN THEN YOU CAN ESCALATE AND SEE HOW LONG YOU LAST UNTIL YOU PASS OUT YOUR HAND RELAXES AND YOU BREATHE NORMALLY AGAIN IT'S EASY FOR YOU TO FEEL BETRAYED WHEN YOU'RE WAVING YOUR ARMS AROUND AND THEY COME CRASHING DOWN ON A SHARP OBJECT JUST ONE ROTTEN SPOT IN YOUR HEAD CAN MAKE EVERY MOVEMENT PAINFUL YOU CAN'T ROLL YOUR EYES BEND DOWN OR JUMP AND LAND WITH IMPUNITY EVEN THINKING HURTS ANY NUMBER OF ADOLESCENT GIRLS LIE FACE DOWN ON THE BED AND WORK ON ENERGY HOUSING LABOR JUSTICE EDUCATION TRANSPORTATION AGRICULTURE AND BALANCE OF TRADE

THERE IS A PERIOD WHEN IT IS CLEAR THAT YOU HAVE GONE WRONG BUT YOU CONTINUE SOMETIMES THERE IS A LUXURIOUS AMOUNT OF TIME BEFORE ANYTHING BAD HAPPENS MORE THAN ONCE I'VE AWAKENED WITH TEARS RUNNING DOWN MY CHEEKS I HAVE HAD TO THINK WHETHER I WAS CRYING OR WHETHER IT WAS INVOLUNTARY LIKE DROOLING THERE IS PLEASURE IN STAYING HOME TO ADJUST EACH PHYSICAL DETAIL SO THAT WHEREVER THE EYE FALLS THERE IS HARMONY THEN YOU GO OUTSIDE AND DO THE SAME SOME DAYS YOU WAKE AND IMMEDIATELY START TO WORRY NOTHING IN PARTICULAR IS WRONG IT'S JUST THE SUSPICION THAT FORCES ARE ALIGNING QUIETLY AND THERE WILL BE TROUBLE SOMEONE WANTS TO CUT A HOLE IN YOU AND FUCK YOU THROUGH IT BUDDY IF THINGS WERE A LITTLE DIFFERENT YOU WOULD DIGEST YOURSELF THROUGH A CUT IN YOUR MOUTH IT'S A RELIEF TO KNOW THERE ARE PROVISIONS AGAINST THIS THE FOND OLD COUPLE WAS DISAPPEARING TOGETHER THROUGH SUCCESSIVE AMPUTATIONS SOMETHING HAPPENS TO THE VOICES OF PEOPLE WHO LIVE OUTSIDE THE SOUNDS ARE UNNATURALLY LOW AND HOARSE AS IF THE COLD AND DAMPNESS HAVE ENTERED THE THROAT THERE ARE PLACES THAT ARE SCARRED AND THE SKIN IS PULLED AROUND LIKE THE NAVEL OR THE HEAD OF THE PENIS THAT LEAVE YOU THINKING THE BODY IS FRAGILE IN A PARADISIAC CLIMATE EVERYTHING IS CLEAR AND SIMPLE WHEN YOU ARE PERFORMING BASIC ACTS NECESSARY FOR SURVIVAL IT CAN BE HELPFUL TO THINK OF THEM EATING THEIR FAVORITE FOODS AND OCCASIONALLY THROWING UP AND GETTING BITS STUCK IN THEIR NOSES THERE'S NO REASON TO SLEEP CURLED AND BENT IT'S NOT COMFORTABLE IT'S NOT GOOD FOR YOU AND IT DOESN'T PROTECT YOU FROM DANGER IF YOU'RE WORRIED ABOUT AN ATTACK YOU SHOULD STAY AWAKE OR SLEEP LIGHTLY WITH LIMBS UNFURLED FOR ACTION THERE'S THE SENSATION OF A LOT OF FLESH WHEN EVERY SINGLE HAIR STANDS UP THIS HAPPENS WHEN YOU ARE COLD AND NAKED AROUSED OR SIMPLY TERRIFIED MANY DOGS RUN WILD IN THE CITY SOME ARE ABANDONED BY THEIR OWNERS AND OTHERS ARE BORN TO LOST DOGS STRAYS HAVE A LIMITED LIFE EXPECTANCY EVEN WHEN THEY BAND TOGETHER IN PACKS THEY ARE PREY TO DISEASE PARASITES WEATHER AND AUTOMOBILES THEY TEND TO BE FRIGHTENED AND VICIOUS THEY ARE UNABLE TO PROTECT THEMSELVES OR ANYONE ELSE WITH SOPHISTICATED RECORD KEEPING IT IS POSSIBLE TO PROVE THAT YOU DID SOMETHING WRONG AND INCORRECT INFORMATION CAN BE STORED AND SPREAD IN BOTH CASES YOU HAVE LESS OF A CHANCE TO SAY THERE WAS A MISTAKE HOW DO YOU FIND THE RIGHT POSITION TO LIE DOWN WITH PEOPLE OR EVEN ANIMALS? OFTEN ONE OF THE PARTNERS IS SMOTHERED OR CONTORTED WHEN DONE PROPERLY THOUGH EVERYONE IS VERY HAPPY POSSIBLY THE WORLD'S YOUNGEST MURDERER IS A TWO-YEAR-OLD BOY WHO CRUSHED HIS PLAYMATE'S SKULL GOING WHERE YOU'RE NOT SUPPOSED TO GO ALWAYS IS ENTERTAINING BUT SOMETIMES YOU'RE STUCK WITH SOMEBODY WHO REFUSES TO COME ONCE YOU KNOW HOW TO DO SOMETHING YOU'RE PRONE TO TRY IT AGAIN AN UNHAPPY EXAMPLE IS COMPULSIVE MURDER THIS IS NOT TO BE CONFUSED WITH USEFUL SKILLS ACQUIRED THROUGH YEARS OF WORK DAMAGE IS DONE BY THE TACIT UNDERSTANDING THAT CERTAIN ASPIRATIONS

ARE UNSUITABLE FOR PARTICULAR GROUPS OF PEOPLE TWO CREATURES CAN WANT TO MOVE AND REST IN CLOSE PROXIMITY EVEN IF THEY ARE AFRAID OF EACH OTHER I'M THINKING OF A WILD ANIMAL FOLLOWING SOMEONE IN THE WOODS TUNNELING IS GOOD FOR TRANSPORTATION CLANDESTINE MOVEMENT AND THE DUAL PROSPECT OF SAFETY AND SUFFOCATION USUALLY YOU COME AWAY WITH STUFF ON YOU WHEN YOU'VE BEEN IN THEIR THOUGHTS OR BODIES WHAT A SHOCK WHEN THEY TELL YOU IT WON'T HURT AND YOU ALMOST TURN INSIDE OUT WHEN THEY BEGIN WHEN YOU'VE BEEN SOMEPLACE FOR A WHILE YOU ACQUIRE THE ABILITY TO BE PRACTICALLY INVISIBLE THIS LETS YOU OPERATE WITH A MINIMUM OF INTERFERENCE WITH BLEEDING INSIDE THE HEAD THERE IS A METALLIC TASTE AT THE BACK OF THE THROAT WITHOUT WARNING YOUNG ADULTS CAN HEMORRHAGE AND DIE ANEURYSMS -- WEAK BALLOON-LIKE SECTIONS OF ARTERIES -- ARE THE CAUSE IF THE BALLOON BREAKS UNCONTROLLABLE BLEEDING OCCURS A PARTICULARLY DANGEROUS ANEURYSM IS FOUND IN THE HEAD YOU CAN MAKE YOURSELF ENTER SOMEWHERE FRIGHTENING IF YOU BELIEVE YOU'LL PROFIT FROM IT THE NATURAL RESPONSE IS TO FLEE BUT YOU DON'T ACT THAT WAY ANYMORE EXERCISE BREAKS AT STRATEGIC POINTS DURING THE DAY ENHANCE PRODUCTIVITY AND PROVIDE SIMULTANEOUS SENSATIONS OF RELIEF AND REJUVENATION IF YOU WISH TO LIVE ANONYMOUSLY SUCCESS IS CONTINGENT ON FOREGOING THE MANY BENEFITS ATTACHED TO IDENTIFICATION AND YOU MUST NEVER BE SCRUTINIZED OR CAPTURED

GREEN LAGUNE (Truisms 3)

IF YOU AREN'T POLITICAL YOUR PERSONAL LIFE SHOULD BE EXEMPLARY IF YOU CAN'T LEAVE YOUR MARK GIVE UP IF YOU HAVE MANY DESIRES YOUR LIFE WILL BE INTERESTING IF YOU LIVE SIMPLY THERE IS NOTHING TO WORRY ABOUT IGNORING ENEMIES IS THE BEST WAY TO FIGHT ILLNESS IS A STATE OF MIND IMPOSING ORDER IS MAN'S VOCATION FOR CHAOS IS HELL IN SOME INSTANCES IT'S BETTER TO DIE THAN TO CONTINUE INHERITANCE MUST BE ABOLISHED IT CAN BE HELPFUL TO KEEP GOING NO MATTER WHAT IT IS HEROIC TO TRY TO STOP TIME IT IS MAN'S FATE TO OUTSMART HIMSELF IT'S A GIFT TO THE WORLD NOT TO HAVE BABIES IT'S BETTER TO BE A GOOD PERSON THAN A FAMOUS PERSON IT'S BETTER TO BE LONELY THAN TO BE WITH INFERIOR PEOPLE IT'S BETTER TO BE NAIVE THAN JADED IT'S BETTER TO STUDY THE LIVING FACT THAN TO ANALYZE HISTORY IT'S CRUCIAL TO HAVE AN ACTIVE FANTASY LIFE IT'S GOOD TO GIVE EXTRA MONEY TO CHARITY IT'S IMPORTANT TO STAY CLEAN ON ALL LEVELS IT'S JUST AN ACCIDENT THAT YOUR PARENTS ARE YOUR PARENTS IT'S NOT GOOD TO HOLD TOO MANY ABSOLUTES IT'S NOT GOOD TO OPERATE ON CREDIT IT'S VITAL TO LIVE IN HARMONY WITH NATURE JUST BELIEVING SOMETHING CAN MAKE IT HAPPEN KEEP SOMETHING IN RESERVE FOR EMERGENCIES KILLING IS UNAVOIDABLE BUT IS NOTHING TO BE PROUD OF KNOWING YOURSELF LETS YOU UNDERSTAND OTHERS KNOWLEDGE SHOULD BE ADVANCED AT ALL COSTS LABOR IS A LIFE-DESTROYING ACTIVITY LACK OF CHARISMA CAN BE FATAL LEISURE TIME IS A GIGANTIC SMOKE SCREEN LISTEN WHEN YOUR BODY

TALKS LOOKING BACK IS THE FIRST SIGN OF AGING AND DECAY LOVING ANIMALS IS A SUBSTITUTE ACTIVITY LOW EXPECTATIONS ARE GOOD PROTECTION MANUAL LABOR CAN BE REFRESHING AND WHOLESOME MEN ARE NOT MONOGAMOUS BY NATURE MODERATION KILLS THE SPIRIT MONEY CREATES TASTE MONOMANIA IS A PREREQUISITE OF SUCCESS MORALS ARE FOR LITTLE PEOPLE

LIGHT LAVENDER (Survival)

YOU ARE TRAPPED ON THE EARTH SO YOU WILL EXPLODE WHAT URGE WILL SAVE US NOW THAT SEX WON'T? PUT FOOD OUT IN THE SAME PLACE EVERY DAY AND TALK TO THE PEOPLE WHO COME TO EAT AND ORGANIZE THEM SAVOR KINDNESS BECAUSE CRUELTY IS ALWAYS POSSIBLE LATER DANCE ON DOWN TO THE GOVERNMENT AND TELL THEM YOU'RE EAGER TO RULE BECAUSE YOU KNOW WHAT'S GOOD FOR YOU THE BREAKDOWN COMES WHEN YOU STOP CONTROLLING YOURSELF AND WANT THE RELEASE OF A BLOODBATH SPIT ALL OVER SOMEONE WITH A MOUTHFUL OF MILK IF YOU WANT TO FIND OUT SOMETHING ABOUT HIS PERSONALITY FAST MOTHERS WITH REASONS TO SOB SHOULD DO IT IN GROUPS IN PUBLIC AND WAIT FOR OFFERS OUTER SPACE IS WHERE YOU DISCOVER WONDER WHERE YOU FIGHT AND NEVER HURT EARTH IF YOU STOP BELIEVING THIS YOUR MOOD TURNS UGLY DIE FAST AND QUIET WHEN THEY INTERROGATE YOU OR LIVE SO LONG THAT THEY ARE ASHAMED TO HURT YOU ANYMORE TRUST VISIONS THAT DON'T FEATURE BUCKETS OF BLOOD IN A DREAM YOU SAW A WAY TO SURVIVE AND YOU WERE FULL OF JOY IF YOU'RE CONSIDERED USELESS NO ONE WILL FEED YOU ANYMORE WHEN YOU EXPECT FAIR PLAY YOU CREATE AN INFECTIOUS BUBBLE OF MADNESS AROUND YOU YOU ARE SO COMPLEX THAT YOU DON'T ALWAYS RESPOND TO DANGER MEN DON'T PROTECT YOU ANYMORE WITH ALL THE HOLES IN YOU ALREADY THERE'S NO REASON TO DEFINE THE OUTSIDE ENVIRONMENT AS ALIEN WHEN SOMEONE BEATS YOU WITH A FLASHLIGHT YOU MAKE LIGHT SHINE IN ALL DIRECTIONS FINDING EXTREME PLEASURE WILL MAKE YOU A BETTER PERSON IF YOU'RE CAREFUL ABOUT WHAT THRILLS YOU USE A STUN GUN WHEN THE PERSON COMING AT YOU HAS A GOOD EXCUSE IT IS IN YOUR SELF-INTEREST TO FIND A WAY TO BE VERY TENDER THE BEGINNING OF THE WAR WILL BE SECRET THE CONVERSATION ALWAYS TURNS TO LIVING LONG ENOUGH TO HAVE FUN WHAT COUNTRY SHOULD YOU ADOPT IF YOU HATE POOR PEOPLE? USE WHAT IS DOMINANT IN A CULTURE TO CHANGE IT QUICKLY PROTECT ME FROM WHAT I WANT YOU ARE CAUGHT THINKING ABOUT KILLING ANYONE YOU WANT IT'S HARD TO KNOW IF YOU'RE CRAZY IF YOU FEEL YOU'RE IN DANGER ALL THE TIME NOW YOU CAN'T REACH THE PEOPLE WHO CAN KILL YOU ANYTIME SO YOU HAVE TO GO HOME AND THINK ABOUT WHAT TO DO THE FUTURE IS STUPID HIDE UNDERWATER OR ANYWHERE SO UNDISTURBED YOU FEEL THE JERK OF PLEASURE WHEN AN IDEA COMES SOMEONE ELSE'S BODY IS A PLACE FOR YOUR MIND TO GO WHEN THERE IS NO SAFE PLACE TO SLEEP YOU'RE TIRED FROM WALKING ALL DAY AND EXHAUSTED FROM THE NIGHT BECAUSE IT'S TWICE AS DANGEROUS THEN IT'S EASY TO GET MILLIONS OF PEOPLE ON EVERY CONTINENT TO PLEDGE ALLEGIANCE TO EATING AND EQUAL OPPORTUNITY GO WHERE PEOPLE SLEEP AND SEE IF THEY'RE SAFE HANDS ON YOUR BREAST CAN KEEP YOUR HEART BEATING TURN SOFT AND LOVELY ANY TIME YOU HAVE A CHANCE IT IS FUN TO WALK CARELESSLY IN A DEATH ZONE YOU LIVE THE SURPRISE RESULTS OF OLD PLANS LET YOUR HAND WANDER ON FLESH TO MAKE POSSIBILITY MULTIPLY IT IS EMBARRASSING TO BE CAUGHT AND KILLED FOR STUPID REASONS SHOOT INTO INFINITE SPACE TO HIT A TARGET IN TIME AND CALL IT INEVITABLE YOU HOVER NEAR LOVELY UNCONSCIOUS LIFE FORMS THAT OFFER NO IMMEDIATE RESISTANCE PEOPLE LOOK LIKE THEY ARE DANCING BEFORE THEY LOVE BODIES LIE IN THE BRIGHT GRASS AND SOME ARE MURDERED AND SOME ARE PICNICKING SILLY HOLES IN PEOPLE ARE FOR BREEDING OR FROM SHOOTING YOUR MODERN FACE SCANS THE SURPRISE ENDING

BLUE LAGUNE (Truisms 4)

MOST PEOPLE ARE NOT FIT TO RULE THEMSELVES MOSTLY YOU SHOULD MIND YOUR OWN BUSINESS MOTHERS SHOULDN'T MAKE TOO MANY SACRIFICES MUCH WAS DECIDED BEFORE YOU WERE BORN MURDER HAS ITS SEXUAL SIDE MYTHS CAN MAKE REALITY MORE INTELLIGIBLE NOISE CAN BE HOSTILE NOTHING UPSETS THE BALANCE OF GOOD AND EVIL OCCASIONALLY PRINCIPLES ARE MORE VALUABLE THAN PEOPLE OFFER VERY LITTLE INFORMATION ABOUT YOURSELF OFTEN YOU SHOULD ACT LIKE YOU ARE SEXLESS OLD FRIENDS ARE BETTER LEFT IN THE PAST OPACITY IS AN IRRESISTIBLE CHALLENGE PAIN CAN BE A VERY POSITIVE THING PEOPLE ARE BORING UNLESS THEY'RE EXTREMISTS PEOPLE ARE NUTS IF THEY THINK THEY ARE IMPORTANT PEOPLE ARE RESPONSIBLE FOR WHAT THEY DO UNLESS THEY'RE INSANE PEOPLE WHO DON'T WORK WITH THEIR HANDS ARE PARASITES PEOPLE WHO GO CRAZY ARE TOO SENSITIVE PEOPLE WON'T BEHAVE IF THEY HAVE NOTHING TO LOSE PHYSICAL CULTURE IS SECOND-BEST PLANNING FOR THE FUTURE IS ESCAPISM PLAYING IT SAFE CAN CAUSE A LOT OF DAMAGE IN THE LONG RUN POLITICS IS USED FOR PERSONAL GAIN POTENTIAL COUNTS FOR NOTHING UNTIL IT'S REALIZED PRIVATE PROPERTY CREATED CRIME PURSUING PLEASURE FOR THE SAKE OF PLEASURE WILL RUIN YOU PUSH YOURSELF TO THE LIMIT AS OFTEN AS POSSIBLE RAISE BOYS AND GIRLS THE SAME WAY RANDOM MATING IS GOOD FOR DEBUNKING SEX MYTHS RECHANNELING DESTRUCTIVE IMPULSES IS A SIGN OF MATURITY RECLUSES ALWAYS GET WEAK REDISTRIBUTING WEALTH IS IMPERATIVE RELATIVITY IS NO BOON TO MANKIND RELIGION CAUSES AS MANY PROBLEMS AS IT SOLVES REMEMBER YOU ALWAYS HAVE FREEDOM OF CHOICE REPETITION IS THE BEST WAY TO LEARN RESOLUTIONS SERVE TO EASE YOUR CONSCIENCE REVOLUTION BEGINS WITH CHANGES IN THE INDIVIDUAL ROMANTIC LOVE WAS INVENTED TO MANIPULATE WOMEN ROUTINE IS A LINK WITH THE PAST ROUTINE SMALL EXCESSES ARE WORSE THAN THE OCCASIONAL DEBAUCH SACRIFICING YOURSELF FOR A BAD CAUSE IS NOT A MORAL ACT SALVATION CAN'T BE BOUGHT AND SOLD SELF-AWARENESS CAN BE CRIPPLING

◉

Phenomenal Woman

Pretty women wonder where my secret lies.
I'm not cute or built to suit a fashion model's size
But when I start to tell them,
They think I'm telling lies.
I say,
It's in the reach of my arms
The span of my hips,
The stride of my step,
The curl of my lips.
I'm a woman
Phenomenally.
Phenomenal woman,
That's me.

I walk into a room
Just as cool as you please,
And to a man,
The fellows stand or
Fall down on their knees.
Then they swarm around me,
A hive of honey bees.
I say,
It's the fire in my eyes,
And the flash of my teeth,
The swing in my waist,
And the joy in my feet.
I'm a woman
Phenomenally.
Phenomenal woman,
That's me.

Men themselves have wondered
What they see in me.
They try so much
But they can't touch
My inner mystery.
When I try to show them,
They say they still can't see.
I say,
It's in the arch of my back,
The sun of my smile,
The ride of my breasts,
The grace of my style.
I'm a woman
Phenomenally.
Phenomenal woman,
That's me.

Now you understand
Just why my head's not bowed.
I don't shout or jump about
Or have to talk real loud.
When you see me passing,
It ought to make you proud.
I say,
It's in the click of my heels,
The bend of my hair,
The palm of my hand,
The need for my care,
'Cause I'm a woman
Phenomenally.
Phenomenal woman,
That's me.

Maya Angelou

Acknowledgments

To all the artists represented in our collection, whose work gives us so much joy and inspiration, and particularly to the artists whose work is featured in the exhibition for their assistance in the creation of this catalogue.

To Tom Zoufaly and Jerry Rivera and their team at Art Installation Design.

To all the people who assisted in the installation of the exhibition, particularly Henry Klimowicz, Richard Bloes, Mika Rottenberg, Natalie Campbell, David Penney, Brien Clark, Nick Cuccia and John Nau.

To all the individuals who have assisted in the care of our collection past and present: Elizabeth Kujawksi, Vlasta Odell, Brett Dolin, Valentina Spalten, Patience Marmer, Christina Bevacqua, Christina Bradley, Pat Gessman, Mike Greaves, Rick Dennert, Margaret Folga, Katrina Dee, Joyce McCollum, and the staff at MB Investments.

To the galleries that we visit, which have introduced us to the artists whose work we so admire, and particularly to all the galleries whose artists are represented in *The Distaff Side* for their assistance with this project.

To all the curators and museum directors who have introduced me to artists and helped to expand my knowledge of art, particularly Jim Demetrion, Peggy Patrick, Neil Benezra, Joan Simon, Julia Brown, Mike Danoff, Jeff Fleming, Susan Talbott, Amy Worthen, Lisa Dennison, Thelma Golden, Lisa Phillips, Heidi Zuckerman Jacobson, Larry Rinder, Max Anderson, David Ross, Adam Weinberg, Donna De Salvo, Elisabeth Sussman, David Kiehl, Chrissie Iles, Carter Foster, and Scott Rothkopf.

To the Bucksbaum Award winners: Paul Pfeiffer, Irit Batsry, Raymond Pettibon, Mark Bradford, Omer Fast, and Sarah Michelson and all the jurors who have served on the award panels.

To Sarah Charlesworth and Evelyn Lauder for artistic talent and personal friendship that have provided me so much enjoyment during their lifetimes and beyond.

To all our collector friends, who continually inspire us.

To the catalogue contributors and team for their talent and thoughtful dedication to this project: Hans Cogne, Ryan Frank, Joan Simon, Caitlin Smith, Elisabeth Sussman, Steven Learner, Karen Jacobson, Danny Frank, Flora Irving, Karly Wildenhaus, and Brian Wilcox.

To Ann Butler, Barry Rosenberg, Moira Kelly, Bennett Chinn, Jill and Paul Choma, Kate Powell, Ally Walton, Jean Nihoul, Morgan Wilcox, Delaney Bailey, and Donna Christensen.

To our outstanding personal team: Laurie Wilcox, Beth Rybczyk, Alan McRoberts, Russ Bailey, Kaitlyn Karcheski, Brian Wilcox, and Glen Adamson.

To Caitlin Smith and Ryan Frank, the two people who know the collection better than I do and who worked with me persistently and diligently for a year helping me with this project.

And to Ray, my loving husband, who teased me throughout the process about "the girlie show"—until he saw it. Then he not only encouraged me but almost demanded that I produce a catalogue.

Melva Bucksbaum

Index of Illustrations

A view from The Granary

This catalogue is published on the occasion of the exhibition *The Distaff Side*, curated by Melva Bucksbaum, which opened at The Granary on April 21, 2013.

Published by
The Granary
P.O. Box 36
Sharon, CT 06069
thedistaffside@gmail.com

Printed and bound in the United States of America

ISBN: 978-0-615-90549-5
Library of Congress Control Number: 2013919248

The Granary
Ryan Frank, director
Caitlin Smith, registrar and archivist

Editor: Joan Simon
Designer: Hans Cogne
Project manager: Flora Irving
Copy editor: Karen Jacobson
Proofreader: Karly Wildenhaus
Photographer: Brian Wilcox

Front cover: Adriana Duque: *Felipe*, from the series *Infantes*, 2010, digital photograph, 67 ½ × 56 ½ in. (171.5 × 143.5 cm)

Back cover: Elaine Reichek: *Sampler (Kruger/Holzer)*, 1998, embroidery on linen, 28 ½ × 20 in. (72.4 × 50.8 cm).

All artworks are © the artist(s). Most artworks are reproduced courtesy of the artists or their representatives. The following list applies to photographs for which additional acknowledgment is due.

Andersson: © 2014 Artists Rights Society (ARS), New York / BUS, Stockholm; courtesy David Zwirner, New York/London: 186–87. Courtesy Amy Arbus: 100. Courtesy Irit Batsry Studio: 152. © 2014 Lynda Benglis / Licensed by VAGA, New York, NY: 213. Photo Hans Cogne: 72–73, 156, 204, 238. Courtesy Adriana Duque: cover. Photo Elizabeth Felicella: 10–11, 15, 201, 202–3, 206–7. © 2014 Stephen Flavin / Artists Rights Society (ARS), New York; digital image © Whitney Museum of American Art, New York: 144 (Flavin). Courtesy Gladstone Gallery, New York and Brussels; Blum & Poe, Los Angeles; and neugerriemschneider, Berlin: 171. Courtesy Isca Greenfield-Sanders: 43. © Guerrilla Girls; courtesy www.guerrillagirls.com: 96. © 2014 Jenny Holzer, member Artists Rights Society (ARS), New York: 108 (photo Adam Heller), 109. Courtesy James Kelly Contemporary, Santa Fe: 218 (Horn). Klein: © 2014 Artists Rights Society (ARS), New York / PICTORIGHT, The Netherlands: 218. Kollwitz:

© 2014 Artists Rights Society (ARS), New York / VG Bild-Kunst, Bonn: 154. © 2014 Rosa Loy / Artists Rights Society (ARS), New York / VG Bild-Kunst, Germany; courtesy André Schlechtriem: 31. Courtesy Vera Lutter: 52–53. Courtesy Marian Goodman Gallery, New York, Paris: 20. Courtesy Malerie Marder Studio: 184–85. © 2014 Agnes Martin / Artists Rights Society (ARS), New York: 14. Courtesy Mary Boone Gallery, New York: 23. Courtesy Murray Guy: 215. © 2014 The Murray-Holman Family Trust / Artists Rights Society (ARS), New York: 221 (Murray). © 2014 Estate of Louise Nevelson / Artists Rights Society (ARS), New York: 81. Courtesy Pace Gallery, New York, London, Beijing: 224 (Kiki Smith). Courtesy The Phillips Collection, Washington, DC: 140. © 2014 Michal Rovner / Artists Rights Society (ARS), New York; courtesy Pace Gallery, New York, London, Beijing: 223. © 2014 Robert Ryman / Artists Rights Society (ARS), New York: 144. Courtesy Laurie Simmons Studio: 94. Courtesy Susan Inglett Gallery, New York: 90. © 2014 Mickalene Thomas / Artists Rights Society (ARS), New York: 92. Courtesy 303 Gallery, New York: 161. © Kara Walker; courtesy Sikkema Jenkins & Co., New York: 33. Photo Steven White: 24–25.

We would also like to acknowledge the following for assistance with this project:

Alexander and Bonin, New York; Andrea Rosen Gallery, New York; Shari Applebaum; Amy Arbus Studio; Carla Arocha and Stéphane Schraenen; Baldwin Gallery, Aspen, CO; Irit Batsry; Meghan Boody; Delia Brown; Caren Golden Fine Art, New York; Carolina Nitsch, New York; Tina Chandler; Cheim and Read, New York; Jessica Craig-Martin; David Kordansky Gallery, Los Angeles; David Nolan Gallery, New York; David Zwirner, New York/London; E. V. Day; Adriana Duque; envoy enterprises, New York; Judy Fox; Francis M. Naumann Fine Art, New York; Fredericks & Freiser, New York; FreedmanArt, New York; Gagosian Gallery, New York, Beverly Hills, London, Rome, Paris, Athens, Geneva, Hong Kong; Galerie Lelong, New York; Gavin Brown's enterprise, New York; Gladstone Gallery, New York; April Gornik; Greene Naftali Gallery, New York; Isca Greenfield-Sanders; Hauser & Wirth, Zurich, London, New York; Jenny Holzer Studio; James Cohan Gallery, New York; Janet Borden, Inc., New York; Lisa Kereszi, Inez van Lamsweerde and Vinoodh Matadin; Lehmann Maupin, New York; Mary Lydecker; Marian Goodman Gallery, New York, Paris; Malerie Marder; Marina Abramović Archives; Marlborough Gallery, New York, London, Madrid, Monaco, Barcelona; Mary Boone Gallery; Rachel Mason; Matthew Marks Gallery, New York; McKee Gallery, New York; Metro Pictures, New York; Morgan Lehman Gallery, New York; Mitchell-Innes & Nash, New York; Murray Guy, New York; Estate of Louise Nevelson; Nicole Klagsbrun Gallery, New York; Ober Gallery, Kent, CT; Overduin & Kite, Los Angeles; Pace Gallery, New York, London, Beijing; Paula Cooper Gallery, New York; Peter Blum Edition, New York; Sarah Peters; Sally Pettus; Petzel Gallery, New York; Ellen Phelan; P·P·O·W Gallery, New York; Regen Projects, Los Angeles; Elaine Reichek; Lisa Ruyter; Sabine Production; Salon 94, New York; Sean Kelly Gallery, New York; Sikkema Jenkins & Co, New York; Laurie Simmons Studio; Stephen Friedman Gallery, London; The Suzanne Geiss Company, New York; Tanya Bonakdar Gallery, New York; Winkleman Gallery, New York; Yancey Richardson Gallery, New York.

The Distaff Side

was designed by Hans Cogne and printed at Meridian Printing,
East Greenwich, Rhode Island, under the supervision of Daniel Frank,
and bound by AcmeBinding, Charlestown, Massachusetts.
It is bound in Iris 101/817 Coffee. Two papers were used for the body
of the book: Mohawk Superfine Ultrawhite Eggshell 100 lb Text
and Scheufelen Phoenix Motion Xantur 100 lb Text.
The endpapers are Rainbow Cape Cod 80 lb.

The main text is composed in Mrs Eaves, and the captions
and back matter are composed in PTL Roletta Sans.

Mrs Eaves was designed by Zuzana Ličko in 1996.
The typeface is based on Baskerville, designed by John Baskerville
in the 1750s. Mrs Eaves, as Ličko wrote, "is named after Sarah Eaves,
the woman who became John Baskerville's wife.
As Baskerville was setting up his printing and type business,
Mrs. Eaves moved in with him as a live-in housekeeper, eventually
becoming his wife after the death of her first husband, Mr. Eaves.
Like the widows of Caslon, Bodoni, and the daughters of Fournier,
Sarah similarly completed the printing of the unfinished volumes
that John Baskerville left upon his death."

PTL Roletta Sans was created by the Berlin-based
type designer Andrea Tinnes between 2004 and 2010
and is noted for combining functionality and playfulness.
The name of the typeface grew out of the process of designing it,
as Tinnes has stated: "Because I was designing a round typeface,
I started to play with the words 'round' and 'rolling' and 'letter'
and after a while 'Roletta' was born."

The Distaff Side was printed
in an edition of 1,500
in January
2014

✳